Monet Carla Rachman

ART & IDEAS

Φ

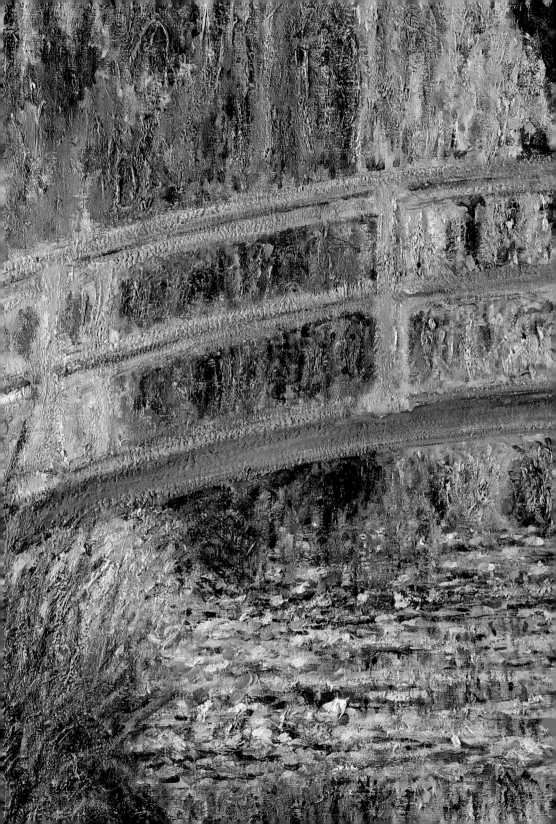

Monet

Opposite
The Japanese Bridge
(detail of 1),
1899.
Oil on canvas;
89 × 92 cm,
35 × 36¹₄ in.
National
Gallery,
London

Introduction

Claude Monet is one of the most familiar and best loved of all
Western artists. His images of poppy fields, poplar-trees, water-lilies
and elegant ladies in blossoming gardens are familiar to people who
have never seen the original paintings and may never have visited
an art gallery; they have won a place in the affection of the general
public that seems almost without parallel. In the decades since his
death in 1926, Monet's work has also been intensively studied. This
phenomenon began during the artist's lifetime; the first substantial
study of his work, an essay by the critic Théodore Duret, was
published in 1880. What began as a steady trickle of writing in the
nineteenth century has turned into a torrent of books, articles and
exhibition catalogues.

This book is intended for readers who are not familiar with the many
detailed publications on Monet. I have tried to capture in it the
salient aspects of the more important studies, and to present an
overview of Monet in the context of his time. Fashions in Monet
interpretation have come and gone since the 1880s, and a range of
interpretations including psychobiography, institutional history and
nationalist polemic have all found fertile ground in his work. The
first and strongest image of the artist, the unworldly creator of
exquisite images labouring in a garret for an unappreciative public,
was promoted by Monet himself and by many of the writers who
were his friends during the second half of his life. It has been altered,
since the 1970s, by Daniel Wildenstein's study of his letters and
account books, which show him to have been also a shrewd busi-
nessman with expensive tastes and a considerable income. The
Romantic notion of the starving and misunderstood hero has been
replaced by a much more entrepreneurial figure, appropriate to the
free-market culture of the end of the twentieth century. The fact that
we now have a generation of young artists who have been taught to
publicize and sell their work from the first year of art school certainly

1
*The Japanese
Bridge,*
1899.
Oil on canvas;
89×92 cm,
35×36¼ in.
National
Gallery,
London

plays a part in our perception of the 'mercantile Monet'.

Each new audience approaches Monet's work with a different set of interests. In the light of current scholarship, I have attempted to give a clear account of the manner in which the artist's development was shaped by the relationship between his personal needs and desires and the possibilities open to him as a painter in nineteenth- and twentieth-century France. From the deliberate use of 'modern-life' scenes in the 1860s to the exclusive focus on the surface of his lily-pond in the 1910s and 1920s, Monet's painting always responded to contemporary ways both of seeing the world and of understanding what was seen.

When I was writing this book, I spent an afternoon standing in a London street, stopping passers-by and asking them to identify four postcards – a Leonardo da Vinci, a van Gogh, a Monet and a Turner. The vast majority could identify Monet and van Gogh but were lost with the other works – pictures which are by no means obscure and were on public view at the National Gallery near by. When I asked them which they would like to own, they opted almost universally for Monet. It is possible that I would have got different results in Amsterdam, Birmingham or Tokyo – but I doubt it. Judging by the

constant international exhibitions of the artist's work, Monet's popularity is a world-wide phenomenon, and it seems to cut across all age-groups. When I asked why they liked *The Japanese Bridge* (1), their replies were essentially variations on 'Because I find it beautiful'. While there is of course far more to Monet's work than that, it is perhaps the central achievement of his art that such a response should seem simple and obvious and that a harmonious arrangement of colours and forms, visually attractive and apparently subjectless, should be generally accepted as both beautiful and sufficient.

This way of looking at pictures, which concentrates on line, colour and visual harmony, is often termed 'formalism' . The move away from a concern with subject and story towards a dominant interest in form was a major watershed in the history of Western art. Monet's work was both a product and a producer of that change, a change which led to the twentieth-century fashion for 'abstract' or non-representational works. His paintings, and those of his colleagues at the Impressionist group exhibitions of the 1870s and 1880s, helped to establish the formalist or 'aesthetic' viewpoint as a valid way of looking at pictures. During his early career Monet was criticized both for his supposedly sketchy technique, and also for depicting inappropriate or inadequate subjects. His pictures were considered too banal, too contemporary, or too empty by spectators whose primary interest in paintings was generally the behaviour and motivation of the figures, or the location of a landscape. If such matters seem quite irrelevant to most of his modern audience, this is not simply because we no longer have the same social sensitivities as a Parisian of the 1860s, it is also because ideas about the role of art have changed so substantially, and with them our expectations of artists themselves.

The shift from looking at pictures in terms of their political or moral content to looking at them in 'purely aesthetic' terms denies art the ability to change the external world, but allows it limitless scope to affect the private realm of the individual's imagination. It also transforms the artist from businessman, performer or social commentator into a magician or sage – and in his time Monet filled each one of

2
Interior of the Orangerie, Paris, showing the Water-lilies series

these roles. From the modern-life figure-scenes and landscapes he produced during the 1860s and early 1870s to the repeated treatment of a single subject in the 1890s, Monet's paintings share an openness that allows the audience to become involved in the painting in a manner that is primarily emotional and physical rather than intellectual. Using a relatively restricted series of motifs across an active career spanning over sixty years, the artist delved further and further into the experience of seeing – a personal experience that he wished to transmit to the viewer in a manner free from convention or prejudice. By the late 1880s he had managed to win acceptance for his pictures and for the way of seeing that they represent, evoking rather than describing their subject.

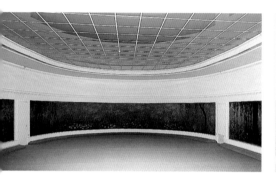 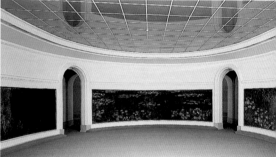

This is exemplified by Monet's late works from the 1890s onwards, which seem designed to encourage reverie and contemplation. His final enterprise, the great Water-lilies series installed in two basement rooms the Orangerie in Paris (2), encloses the spectator completely, as though submerged in a world created and controlled by the artist, excluding the world outside. The gallery itself is virtually an artistic flotation-tank. Little visited by the public when it was first installed in the 1920s, the Water-lilies series is now a popular attraction all year round, which suggests that it meets a deep need of the contemporary public. The work of art has become an all-embracing experience, as the painter offers us a new world to replace our own. Nevertheless, Monet's work was intimately tied up with the society around him, even when he appeared to be rejecting it most overtly. Despite the fact that he had led a professional life largely

outside the official system (he did not attend the national art school, the École des Beaux-Arts, and was largely rejected from the state-sponsored Salon exhibitions), the Water-lilies series to which he devoted the last decades of his life was effectively a scheme of public paintings intended as a monumental legacy to France.

After his death Monet became part of the 'national heritage', and in order to understand the special place that he carved out for himself it is important to know something about the French art world, and the nature of its relationship to society as a whole. Tracing the way in which Monet has been promoted over the years – with the active assistance of the artist, during his lifetime – can help to illuminate his work, which has become both a symbol of France and one of its most successful exports. The growth of Monet's career was directly related to the history of his country, in his role both as a self-made entrepreneur and as an artist who became internationally famous as a painter of the French countryside.

Monet lived to the age of eighty-six, and his lifetime spanned a period of exceptionally rapid change. In 1840, when he was born, France was almost entirely an agricultural nation. The bulk of its population lived on the land in conditions that had changed little since the abolition of feudalism during the great Revolution of 1789. Travel was by horse and cart or sailing-boat; a postal system had not yet been instituted; houses were heated by coal and wood and lit by candlelight, with gas an astonishing novelty. By the time of his death in 1926 air-travel was the latest fashion and well-off homes were lit by electricity, centrally heated and connected by telephone. Women wore short skirts and drove cars. The country was immeasurably wealthier and better educated, although still riven by battles between Church and state, and between social classes. Monet lived through one successful and one unsuccessful coup, three attempted revolutions, a monarchy, an empire, two republics, a civil war and a world war in which his country lost over a million men.

Art in France has always held an important place in public life, and this was especially true in the nineteenth century when the country underwent a series of tremendous social and political upheavals.

After the Revolution in 1789 and the dynamism of the Napoleonic period, the defeat of the French army at Waterloo in 1815 seemed to announce the end of France as the conqueror and liberator of Europe. The loss of this great role left a vacuum, and for the rest of the century debate raged over France's place in the new Europe and as a world power. The nation was deeply split, by politics and by religion. Until the last decade of the century it was racked by conflict between Republicans and Monarchists of various complexions, and Catholicism, the main French faith, had been bitterly attacked during the Revolutionary period. Church and state were often opposed over issues such as the control of education; Catholicism was associated by many intellectuals with backward peasants and reactionary attitudes. In a country struggling to achieve military glory, political coherence or economic miracles, the arts came to fill an important symbolic as well as practical role, unifying the country around an acceptable notion of French cultural supremacy. Narrowly defined at the start of the century, the idea of truly French art gradually came to include and then to embrace the work of Monet.

For several centuries the fine arts in France had been nurtured and controlled by state or royal institutions. Their aim was to encourage the production of painting and sculpture which would enrich and ennoble the nation and win it admirers abroad. The Academy, founded by Louis XIV as the Académie Royale de Peinture et de Sculpture, and the Ministry for Fine Arts were responsible for encouraging officially approved art through a combination of training and rewards, including state purchases of suitable work. The belief that certain subjects were inherently more important than others was fundamental to the academic idea of the public function of art, a tool for civic or religious instruction. 'High art' required a clear narrative and a lofty subject; history, religion or classical literature were considered worthy of depiction on a large scale, generally in an idealizing manner that produced a uniformly smooth surface and a set type of figure. Scenes from everyday life, landscape or the humble still life deserved only small 'cabinet' paintings. 'Cabinet' pictures, as the name suggests, were thought suitable for small rooms in private houses, while works on a more grandiose scale

might well be bought for the state collection, which sent out pictures to adorn churches and public buildings throughout the country.

The kind of painting fostered by a system that encouraged artists to attempt to provide models for emulation is exemplified by *Oath of the Horatii* (3) by Jacques-Louis David (1748–1825). It was painted in 1784–5 shortly before the collapse of the royal establishment and the ancien régime, the old order. It depicts an inspiring subject from classical history, showing a group of brothers, the Horatii or sons of Horace, swearing to defend Rome against its enemies. The story is easy to follow and the moral message is clear; the first duty of a patriot is to serve his country. After the Revolution David used his art to glorify the heroes of the First Republic, and then the emperor Napoleon Bonaparte. After the downfall of the latter in 1815 David

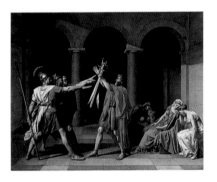

3
Jacques-Louis
David,
*Oath of the
Horatii*,
1784–5.
Oil on canvas;
330×425 cm,
130×167¹₂ in.
Musée du
Louvre, Paris

went into exile in Brussels, and the French tradition of 'high art' continued throughout the nineteenth century in the hands of far less distinguished artists. The state went on buying contemporary art, and every year the Academy awarded prizes for pictures in the 'grand style'. Alongside this official sector, which worked to promote high art or 'history painting', there was also a separate private market which preferred more intimate subjects, painted on a smaller scale. The consummation of this rival trend away from civic morality and towards individual perceptions can be seen in *The Japanese Bridge* (1). With its swirling paintwork and enclosed, figureless world, it is easy to imagine it in a domestic setting. It is a painting to live with and look at every day; unlike David's immense and stirring scene, it does not harangue the viewer.

Between the time of David and that of Monet a gulf emerged between the preferences of private buyers, looking for 'pictures to live with', and academic practice, which encouraged artists to aim at didactic high art. As the number of painters grew and the official Salon exhibitions swelled from under five hundred works in 1801 to between four and five thousand in the 1860s, the commercial rather than the subsidized sector came to dominate the market. The official establishments fought to continue the idea that history painting was the greatest and most valuable type of art, but from the 1840s onwards they were swimming against the tide. The state sector could only mop up so many scenes from classical authors, and figure-painters had to make a living. Some turned from serious histories to anecdotal 'human interest' stories in fancy dress. Many abandoned the figure altogether. Throughout the nineteenth century this change was hotly discussed. Some contemporary observers, mainly conservative, considered that French art was becoming trivial and degenerate; others viewed the new trends as an indication of health and liveliness. What was incontestable was that a major shift was taking place. By the middle of the century landscape painting, which had not been highly considered by the Academy, began to dominate, and in 1859 Jules-Antoine Castagnary (1830–88), a left-wing critic, could declare that traditional values had been not only challenged but effectively reversed: 'Landscape, once the lowest genre, now holds first place, and history-painting, once at the top, exists in name only.' This reversal of the established hierarchy was closely related to Monet's rise to fame.

As a tightly controlled system of government subsidy and patronage gave way to a much more open market-place, the relative impor-tance of paintings ceased to be determined by what they depicted. It was during this period of dissolving certainties, shifting tastes and expanding markets that Monet made his mark as a landscape painter, selling to private buyers and developing independent exhi-bitions outside the control of the official artistic establishment. He was not alone in this. In the early and middle years of his career, between the 1860s and the 1880s, he associated with a group of other artists who became known collectively as 'Impressionists'. They

displayed their work together at a series of eight independent exhibitions, held between 1874 and 1886, which did much to create publicity for the artists and helped them to establish an identity outside the official market. The composition of the group varied and Monet's adherence to it fluctuated, but he was happy to refer to himself as an Impressionist – even, especially after the end of the group shows, as *the* Impressionist. Beyond his fellow Impressionists, however, he had other models for a career outside the mainstream for French art, notably the leading figures of the loosely termed 'Realist' movement, Édouard Manet (1832–83) and Gustave Courbet (1819–77), who had begun to establish the idea of an alternative art world during the middle years of the century.

All accounts of the past are partial and this book is no exception. I have chosen to treat the subject in a manner that emphasizes the material nature of Monet's *oeuvre* – his pictures are discussed here as paint on canvas, designed for sale. I have said more about his market strategy than his inner life largely because we have more evidence about it. Although Monet was a prolific correspondent and over 2,600 of his letters have survived, his statements about his work were always calculated for an audience, whether he was attempting to win admiration or borrow money. In the later part of his career, when he was emerging as a newsworthy national figure, he gave a large number of interviews, and many of his friends and colleagues recorded their recollections of the painter. Often the writers are remembering distant events, and quite often they are reporting Monet's own edited version of his life and working practices; they therefore have to be treated with a certain amount of caution.

Monet emerges from the documentary evidence as a man with a shrewd notion of the value of his work and the importance of good public relations in achieving recognition. In effect claiming to paint as naturally as a tree putting forth its leaves, he was taking up a rhetorical position, grounded in a Romantic notion of art in which ease of production was seen as a guarantee of sincerity. His statements should not be taken as spontaneous outpourings; nor should his paintings.

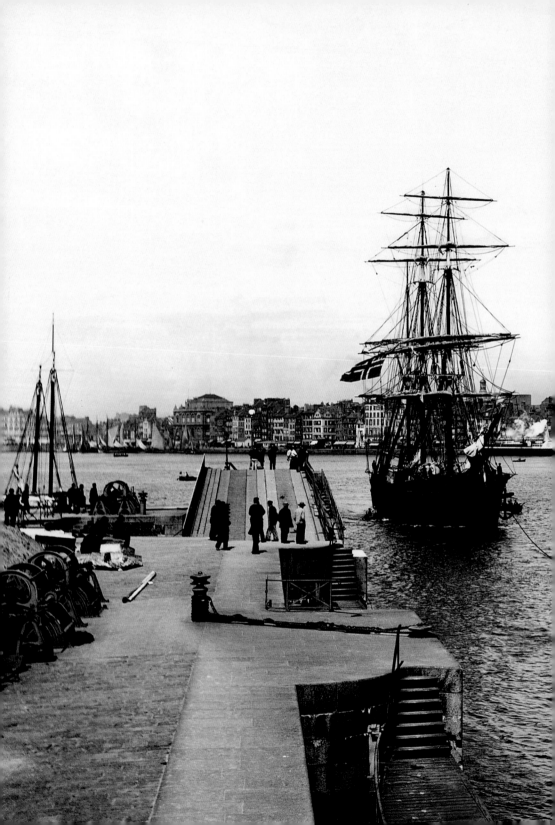

Monet's parents were members of the lower middle class, the 'petite bourgeoisie'. His father, Claude Adolphe Monet, had been enrolled in the merchant navy at the channel port of Le Havre, but in 1835, when he married the widowed Louise-Justine Aubry, he was living in Paris. The couple's first son, Léon, was born in 1836, and their second and last child was born on 14 November 1840 and baptized Oscar-Claude in the church of Notre-Dame de Lorette, in the area of Montmartre. These days Montmartre attracts the tourists, but for most of the nineteenth century it was rather down at heel, a fringe district with a raffish and working-class population. Monet's parents seem to have kept a shop there, but the business evidently did not flourish, and around 1845 they left Paris for Le Havre. Here Claude Adolphe had a half-sister who had married into a prosperous merchant family. Marie-Jeanne Lecadre was some years older than Monet's father, and her husband Jacques was willing to employ him in their grocery and chandlery business. Childless, artistic and comparatively wealthy, Madame Lecadre was to be an important source of assistance to her nephew during his early years as a painter.

The Montmartre of the 1840s was still semi-rural; in contrast, Le Havre was poised to become a boom town (4). Stimulated by its position as a major port for goods from Britain, then the most industrially advanced nation in the world, the Norman town began to expand its harbour and develop commercially. Le Havre was conveniently placed to profit from the exchange of goods between London and Paris as well as transatlantic trade, and the Monet–Lecadre family participated in the burgeoning prosperity of the region as a whole. Their grocery and chandlery business throve, and Claude Adolphe Monet shared in this rising fortune; after Jaques Lecadre's death in 1858 he effectively took over the business. Oscar-Claude therefore grew up in relative comfort and security. The family inhabited a large house at 30 rue d'Epréménil at Ingouville, near

4
The Port of
Le Havre, late
19th century

the harbour and the business. They took in lodgers when necessary and led a pleasant life of respectable, hard-working prosperity. Monet's mother was musical, and a visitor from 1853 remembered 'improvised concerts and balls' in the evenings.

This peaceful, industrious life was made possible by a period of national economic growth. After Waterloo and the fall of Napoleon, the International Congress of Vienna had restored the French monarchy under Louis XVIII. The absolutist ambitions of his successor, Charles X, proved highly unpopular, however, and unrest culminated in the July Revolution of 1830. Charles abdicated in favour of the more liberal 'citizen king', Louis-Philippe d'Orléans, and Monet's early years were lived under the relative calm of the so-called July or Bourgeois Monarchy. Louis-Philippe had been chosen to bring peace and quiet to a country exhausted after forty years of upheaval, and his rule favoured the fortunes of the 'haute bourgeoisie' or upper middle class. The King grew increasingly auto- cratic, however, and by the mid-1840s an economic downturn had lost him the crucial allegiance of the middle classes. It was during this period that Monet's family left Paris for Le Havre.

In 1848 Louis-Philippe was forcibly removed in the February Revolution, a popular uprising uniting the middle classes and the workers of Paris. Fleeing to England, he was replaced by the short- lived Second Republic, based on a universal male franchise. Elections in April brought gains for moderate and conservative factions, and in December Louis-Napoleon Bonaparte, nephew of Napoleon, was elected president. By 1852 France was an empire once again – following a *coup d'état* in December 1851 Louis-Napoleon had engineered his own installation as Emperor Napoleon III. A populist politician who traded on his uncle's name, he ruled the country for eighteen years, throughout Monet's boyhood and youth. During this period the 'second Emperor' employed a combination of repression, coercion and economic liberalism to modernize France. A railway network grew across the country, making the transport of goods and raw materials easier and allowing the population far greater mobility. The middle class, including Monet's family, had

5
Victor Joseph Chavet,
Le Louvre de Napoléon III,
1857.
Oil on canvas; 212×222 cm, 83¹₂×87 in.
Musée National du Château de Compiègne

16 Monet

more money and more free time than ever before. Tourism began to develop, bringing a new industry to the coastal regions – especially Normandy. The luxury goods trade throve and the art market grew. The cities expanded as peasants left the land to seek work, and the countryside began to change from a place of constant toil to one of industrialized labour and urban holiday activities.

Monet therefore grew up in an unsettled nation, rocked by political change and undergoing speedy economic development. By his teenage years in the 1850s the process of industrialization was proceeding rapidly. While encouraging wide-ranging modernization, however, the imperial establishment kept a firm grip on political power: the press was censored, the parliament tightly controlled

and the unruly capital virtually taken apart and rebuilt as a monument to the Emperor (5). Paris was the centre of political power, but the economic strength of the country was to be found in the east and the north, in towns like Le Havre, and there was also a thriving provincial art scene; when Monet decided to become a painter, he found local patrons.

Monet's early training as an artist seems to have been confined to conventional drawing lessons at the school he attended in Le Havre. He and his brother were sent to the local secondary school, the *collège communal*, which provided a traditional education in classical languages and commerce. Léon went on to study chemistry,

a serious and solid profession in which he did well, but Oscar-Claude was less of a credit to his parents; he claimed that 'school always felt like a prison'. As an elderly man he insisted that he had never paid any attention to lessons, spending his time doodling and playing truant – 'I drew garlands in the margins ... and covered the blue paper of my exercise books with the most bizarre ornaments, which included highly irreverent drawings of my masters, full-face or profile, with maximum distortion.' Part of the deliberate creation of an image of the artist as a self-taught rebel, this boast also holds some truth, and surviving works show Monet to have been a precociously accomplished caricaturist (6). However, he also produced conventional pencil drawings that suggest familiarity with one of the many artists' textbooks in use at this period.

At some time between 1855 and 1857 he left school – perhaps without taking the leaving-exam, the Baccalauréat – and expressed the wish to become a painter. Although he never mentioned the fact, the college had an unusually accomplished drawing master, François-Charles Ochard (1800–70). Ochard had been taught by the great Neoclassical master Jacques-Louis David, and at least two other pupils of his became professional artists of some standing. Monet's future path seemed clear; he should train with a local painter, assemble references, funds and a portfolio, and then continue his studies in Paris.

By the time he was seventeen Monet was already making money from his work and had won a local reputation for his caricatures. Skilful and amusing, they were displayed in the window of a local frame-maker, Monsieur Gravier, where they drew crowds of appreciative viewers – after all, it was still a small town and most of the figures would have been recognizable to passers-by at Gravier's busy shop near the waterfront. Monet would stand on the pavement, incognito, listening to the praise and, as he later remembered, 'bursting with pride'. There were so many people able to pay 20 francs for a sketch that he soon built up a considerable kitty – 2,000 francs, kept for him by his Aunt Lecadre. The most important benefit of these exhibitions, however, was not financial but artistic.

6
Caricature of Mario Uchard, 1857.
Pencil on paper;
31·8 × 24·6 cm,
121$_2$ × 93$_4$ in.
The Art Institute of Chicago

7
Eugène Boudin,
The Beach at Trouville, 1865.
Oil on card;
265 × 405 cm,
1043$_8$ × 1595$_8$ in.
Musée d'Orsay, Paris

Gravier also displayed paintings by the landscape painter Eugène Boudin (1824–98), who was an old friend of his (7). Monet was not impressed by these small beach scenes – they were too different from the conventional painting he knew and, as he later recalled, they seemed inadequate compared with the 'false and arbitrary colour and fantastical arrangement of the painters then in fashion'. Boudin was more open-minded, however, and he saw sufficient talent in Monet's work to introduce himself one day when they happened to be in the shop at the same time. Boudin admired the talent of the conceited boy some fifteen years his junior, and after overcoming his initial resistance he began to take him on sketching trips out-of-doors.

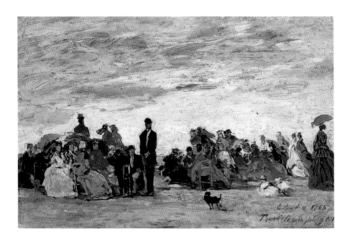

Some of Monet's first sketchbooks survive, and they show that even before encountering Boudin he was already interested in landscape (10). The pages are filled with meticulous pencil-drawings of trees, boats, tumbledown cottages and other countryside scenes. They show the technical competence of the teenage artist; they also show that, despite his later disclaimers, he had studied in the traditional manner, copying plates from books of engravings and essentially acquiring both facility in drawing and a vocabulary of stock 'picturesque' motifs, such as the wind-blown tree, many of which were to reappear in later life (8). Monet's earliest work was clearly related to the well-established tradition of the 'picturesque' rural scene, practised by such artists of the previous century as François

8
Antibes,
1888.
Oil on canvas;
65×92 cm,
25⁵⁸×36¹₄ in.
Courtauld
Institute
Galleries,
London

9
**François
Boucher**,
*The Gallant
Fisherman*,
1768.
Oil on canvas;
49·5×64·5 cm,
19¹₂×25³₈ in.
Manchester
City Art
Galleries

10
*Study of Trees,
Honfleur*,
1857.
Page from
sketchbook.
Pen on paper;
30×23 cm,
11⁷₈×9 in.
Musée
Eugène
Boudin,
Honfleur

Boucher (1703–70; 9). Where Boucher's pictures are prettified, essentially a fantasy vision of rural life, Boudin's work was based on observation of the world around him. What he taught Monet was much more up-to-date – the essentials of *plein-air* ('open-air') painting, working out-of-doors and developing a personal response to the subject.

In the seventeenth century French artists such as Nicolas Poussin (1594–1665) and Claude Lorrain (1600–82) had developed landscape painting out of history painting, using the same subjects but with a different balance between figures and setting (11). The story or subject lent meaning and dignity to the landscape, which existed as

11
Nicolas
Poussin,
*Summer, or
Landscape
with Ruth and
Boaz*,
1660–4.
Oil on canvas;
118×160 cm,
46$\frac{1}{2}$×63 in.
Musée du
Louvre, Paris

12
Jules Breton,
*The
Benediction
of the Wheat
in Artois*,
1857.
Oil on canvas;
130·2×320 cm,
51$\frac{1}{4}$×126 in.
Musée des
Beaux-Arts,
Arras

landscape (essentially pastoral or agricultural) only because of the presence of man. Landscape subjects, painted for urban audiences, tend to reflect contemporary dreams about rural life and it is no coincidence that the period of most rapid industrialization, the nineteenth century, saw the great flowering of landscape art, including depictions of traditional country life (12). Boucher's pastoral idylls, the court art of the *ancien régime*, had been followed by a number of different landscape styles. By the 1850s the most modern was the Barbizon School, sometimes known as 'The School of 1830', which took its name from a village on the edge of the Forest of Fontainebleau, where a

number of painters settled including Théodore Rousseau (1812–67) and Charles-François Daubigny (1817–78).

In the early years of the July Monarchy this generation of young artists had begun to develop a new type of landscape, recognizably French and visibly modern. This new art challenged and then supplanted the landscape tradition of Poussin, Claude and their followers, who had drawn their subjects from the area around Rome, which was considered to be both ideally beautiful and satisfyingly linked to classical antiquity. By contrast, the Barbizon School artists painted contemporary local scenes; their relatively small-scale works typically depict wood or river scenes rather than fertile fields,

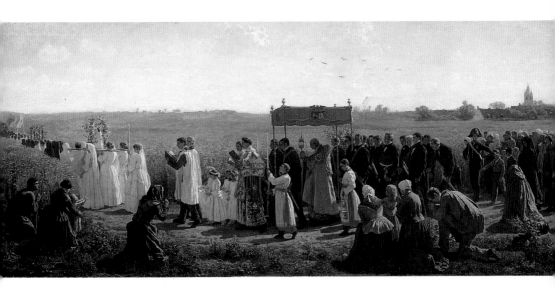

with few figures and a general air of tranquil melancholy replacing the activity of Poussin's pictures (13). This is the countryside as town-dwellers see it, a secluded place of rest and pleasure rather than labour. This revaluation of the rural landscape was a direct result of the gradual alteration and eventual shrinking of that landscape under the twin forces of industrialization and increasing prosperity.

During the July Monarchy the modest pictures of the Barbizon School gradually found an audience. Regularly though inconsistently rejected from the Salon, they were nonetheless popular with buyers, who varied from the bankers of the new establishment to junior

members of the royal family. A split was appearing between the grandiose figure subjects of 'official' art and these quiet, private rural scenes, and the Revolution of 1848 brought about a further change in the preferences of the official art world. More landscapes were shown at the Salon, and there was a greater emphasis on the labour of the peasants who had been briefly given the vote in 1848, only for many of them to lose it when the law was changed in May 1850.

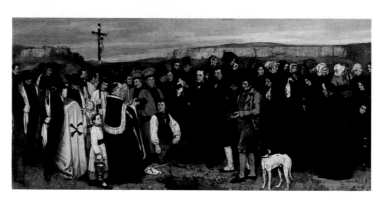

13
Charles-François Daubigny, *The Banks of the Oise*, 1859. Oil on canvas; 80×182 cm, 36×71½ in. Musée des Beaux-Arts, Bordeaux

14
Gustave Courbet, *A Burial at Ornans: Historical Painting*, 1849–50. Oil on canvas; 315×668 cm, 124×263 in. Musée d'Orsay, Paris

15
Jean-François Millet, *Man with a Hoe*, 1860–2. Oil on canvas; 80×99 cm, 31½×39 in. J Paul Getty Museum, Malibu

Two painters, Jean-François Millet (1814–75) and Gustave Courbet, were seen as leaders of a new tendency, which came to be termed Realism. The former was essentially a Barbizon artist and the latter an ambitious young figure painter, but they were associated in public perception through two images of peasant life which became icons for the next few decades of French art. Courbet's *A Burial at Ornans* (14) and Millet's *Man with a Hoe* (15) were seen as truthful representa-

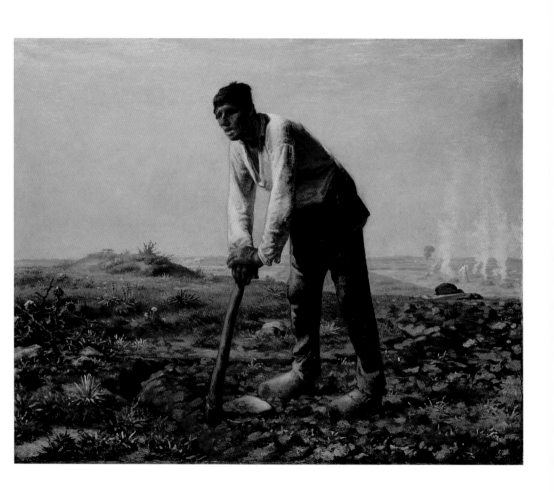

tions of the reality of rural life. 'Realism' in landscape rejected both classical idyll and Romantic solitude, and it generally took the form either of a new treatment of the figure – Millet's grimy and heavy-limbed peasant replacing the elegantly robed figures of Poussin's *Summer* – or the appearance of modernity in the form of factory tower or passing train. Work, poverty and industry shattered the image of the countryside as unchanging and idyllic. In this context Boudin's beach scenes, with their fashionable hordes of smartly dressed ladies and their distant steamboats, were a less

16
A Painter Working in the Open Air, c.1857. Drawing on paper; 30 × 22 cm, 11^7/$_8$ × 8^5/$_8$ in. Musée Eugène Boudin, Honfleur

aggressive version of the same assault on conventional ideas. By 1868 the assault had been so successful that the Realist writer Émile Zola (1840–1902) was able to pronounce, 'Classical landscape is dead, murdered by Life and Truth.'

This was not quite the case in 1858, however, when Boudin began to introduce his young companion to the *plein-air* method of working. Landscape was rising, but the informality and brightness of Boudin's work had yet to win general approval. His taste and working practice

were still considered unusual; sketching out-of-doors had long been established, but the idea of actually working on an oil-painting *en plein air* was something of a novelty.

By turning his attention to the contemporary landscape Boudin was helping to put Monet on the track that was to ensure his fame and fortune in later years. Although the older painter was not well established and his pictures sold for low prices, Monet had little doubt about the importance of what Boudin had taught him, and he always considered their meeting a key event in his life. He later described watching Boudin paint and feeling that 'a veil had been torn away'. Working by his side on the beach, he began to produce lively sketches and confirmed his intention to become an artist (16). In the late summer of 1858 both painters exhibited at the Le Havre exhibition of art. Monet's painting (17) was very similar to those shown by the older artist, and it indicates the profound and lasting effect of Boudin's tutelage that Monet was still painting similar subjects more than thirty years later (18). His talent was evident, and his desire to study painting in Paris cannot have come as a surprise to his family.

Monet's mother had died in 1857, and her place was partly taken by his aunt, who was interested in contemporary art. She painted – Monet borrowed her studio – and she had bought a picture by the Barbizon artist Daubigny, which was a bold though not outrageous acquisition. After her husband died in 1858 she had money of her own to assist her nephew. Monet's relations with his father do not seem to have been very close even in his early life, and they were to come near to a total rupture in later years, but there is no firm evidence to support Monet's later claim that he was obstructed by him from the start. There was really no reason for Claude Adolphe to dislike the idea of his second son making a career as an artist; painting could be a very lucrative pursuit, and there were plenty of perfectly respectable painters who made an excellent living. The Romantic notion of the talented artist, refusing to follow convention and starving in a garret only to be recognized posthumously as a genius, is a nineteenth-century creation that became common currency with the publication of Henri Murger's novel *Scènes de la vie*

17
*View of
Rouelles,*
1858.
Oil on canvas;
46×65 cm,
18¹⁄₈×25⁵⁄₈ in.
Maranuma
Art Park,
Japan

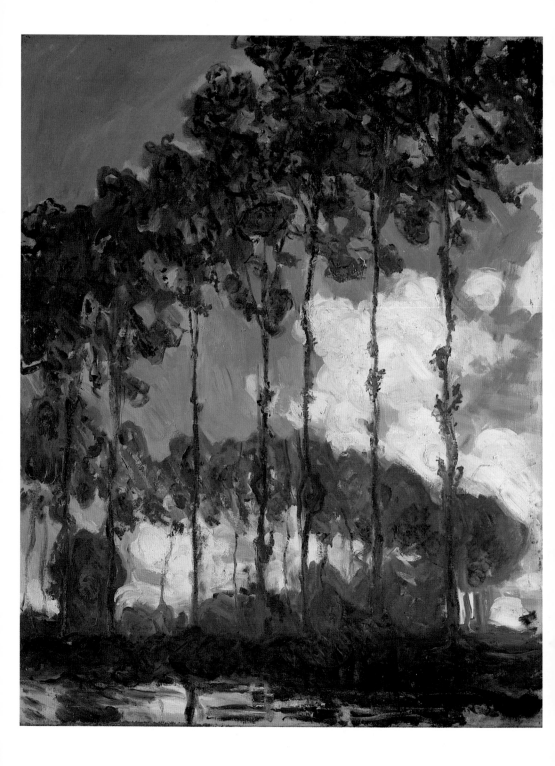

de Bohème in 1848. It was indeed partly lived out by Monet and the other 'bohemian' members of the Impressionist group, but in the late 1850s when his aunt and father considered Claude's future, they probably imagined something much more secure and bourgeois. Madame Lecadre knew several successful artists, including the well-established and prosperous Amand Gautier (1825–94). A fashionable artist at this period could become even wealthier than a successful merchant. The path was well laid out – the École des Beaux-Arts or some reputable studio in Paris, followed by a prize in a state-spon-sored competition, perhaps the coveted Rome scholarship, leading to an establishment in Paris and a thriving practice as a portraitist, say, or a painter of historical genre scenes. Talent was needed of course, but Monet clearly had that. He also had the acumen to see how the system worked, and the courage to buck it in later years when his artistic interests and practical needs led in different directions.

18
Poplars on the Banks of the River Epte, 1891. Oil on canvas; 92×73 cm, 36$\frac{1}{4}$×28$\frac{3}{4}$ in. Tate Gallery, London

In 1859 he applied for a local scholarship to study painting in Paris (Boudin had been awarded one in 1851), and Claude Adolphe was clearly willing to do what he could to further his son's wishes. He wrote in support of the application for the funds, which were available to sculptors, painters and architects:

I have the honour to state to you that my son Oscar Monet, aged eighteen years, having worked with Messieurs Ochard, Vasseur and Boudin, wishes to become a candidate for the title of Pensioner of Fine Arts for the city of Le Havre. His natural inclination and his taste, which he definitely fixed on painting, oblige me not to turn him away from his vocation but since I have not the necessary means to send him to Paris to attend the courses of the important masters I hereby beg you to be so kind as to accept favourably my son's candidacy.

The city council, however, was familiar with Monet's caricatures, and rejected him on the grounds that he was insufficiently serious to deserve municipal liberality.

Not waiting for the outcome of the application, Monet had already set off for Paris. Paying his way with the 2,000 francs saved from the

sale of his caricatures, he set himself up in the city with supreme confidence. Having found a suitable lodging, he then visited the 1859 Salon to inspect the opposition, conveying his considered opinion in letters to Boudin. He did not hesitate to criticize the work of the most eminent artists – that year's pictures by the great Romantic painter Eugène Delacroix (1798–1863) disappointed him. He assessed the exhibition in commercial as well as artistic terms, spotting the proliferation of sub-specialties and advising Boudin to plug a gap in the market for marine painting. Armed with letters of introduction, he visited established artists – Gautier, Constant Troyon (1810–65), Charles Monginot (1825–1900) and Thomas Couture (1815–79) – to ask their opinion of his work. They admired the examples that he had brought and recommended further study.

When Monet made this first visit to Paris there was a recognized system of artistic training and professional examinations and awards which was regulated and promoted by the government. Louis-Philippe's administration had put a great deal of money into sponsoring and buying the work of contemporary painters and, despite the changes of government since then, in the late 1850s the notion of state support for painters was still deeply embedded. Centralized and authoritarian, the French state continued to see public support for the arts as legitimate and indeed important. Despite his failure to secure a municipal grant from Le Havre, there was therefore nothing to discourage Monet's family from assisting Claude to become an artist. The disapproval that they viewed him with in later years was probably due to his financial extravagance and imprudent private life, combined with his refusal to follow a recognizable career path. Supplementing the 2,000 francs with an allowance, Monet's father gave the young man permission to stay in Paris and enrol in a studio.

In February 1860 he entered the Académie Suisse at 4 quai des Orfèvres. This was a liberal establishment loosely run by Monsieur Suisse. Previous members of the studio included Delacroix, Jean-Baptiste-Camille Corot (1796–1875) and, more recently, Courbet, all well-known artists by the time that Monet put his name down. Unlike

most art schools, at Suisse there was no formal curriculum and no supervision – the students paid for the use of a nude model and learned from each other. They must have been a self-selected group of unusually confident – or lazy – young men. One of Monet's fellow students, with whom he probably became acquainted at this time, was Camille Pissarro (1830–1903), later to become a close friend and a co-founder of the Impressionist group. While very few pictures survive from this period, in a letter to Boudin Monet said that they had all chosen to specialize in landscape although their studio work clearly stressed the figure.

Monet had made money early from his painting and had caught the habit of spending lavishly, a habit that was to prove ruinous in later, leaner years. He moved to the rue Pigalle, on the Right Bank of the city, where a group of Realist artists was forming. They met in cafés, and soon Monet was selling anything he could to finance his evenings at the Brasserie des Martyrs, an establishment frequented by writers and artists eager to live Murger's 'vie de Bohème' – indeed Murger himself lived in that very street. Monet dropped his prices to 10 francs a picture or less and drew 'portraits of concierges' to pay his bills. He also sold Madame Lecadre's Daubigny, which she had let him keep. Fulfilling the prediction of the council of Le Havre, he does not appear to have been studying seriously, and looking back on this period he proclaimed, 'I used to go to the notorious brasserie in the rue des Martyrs, where I wasted a lot of time; it did me the greatest harm.'

This period of bohemian indulgence, however, came to an abrupt end in the spring of 1861 when, out of 228 eligible young men in his district of Le Havre, Monet was among the seventy-three who drew an unlucky number in the army lottery. He seems to have been quite enthusiastic about the idea of a military life and even enlisted in a crack cavalry regiment, the Chasseurs d'Afrique, despite his apparent inexperience of horses. The length of service was seven years. Charles Lhuillier (1824–98), a fellow pupil of Ochard who had successfully established himself in Paris, portrayed Monet posing in his uniform, every inch the romantic hero (19). Perhaps his interest

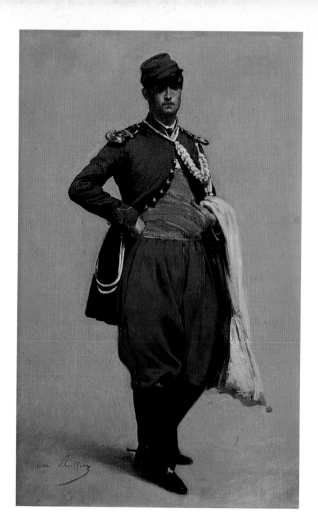

19
Charles
Lhuillier,
*The Soldier
(Monet in
Military
Garb)*,
1861.
Oil on canvas;
37×24 cm,
14⁵⁸×9¹₂ in.
Musée
Marmottan,
Paris

in Delacroix made the idea of a trip to Algeria irresistible – some of
the older artist's most stirring scenes were set in desert landscapes.
In any case, Monet's African adventure did not last long; within a
year he had caught typhoid. Invalided home, he was bought out by
his aunt at a higher price than would have originally been charged.
He apparently painted some portraits of the officers and at least
one desert scene, but they have disappeared – like many of his
early pictures they were probably unsigned. He never visited the
region again, but as an old man he lauded the African light and
said that it had been an important experience for him as an artist.
By the summer of 1862 he was back in Le Havre and, as soon as he
had fully recovered, he returned to painting.

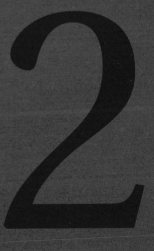

When Monet returned to France after his spell in the army (20), he
went to his family's home in Sainte-Adresse, a chic suburb known
as the Nice of Le Havre. Convalescing rapidly, he soon returned to
painting and found plenty of subjects around him. The district he
had grown up in was changing fast; it had been affected by the rapid
growth that had followed the establishment of rail links between
Paris and Normandy, and the coast was developing a string of
resorts. Inland, the woods near Honfleur were shedding their rural
character and becoming 'beauty-spots', popular with painters and
day-trippers from the nearby seaside resorts. From the 1860s until
the last decade of the century the Normandy coast was France's most
fashionable holiday area. Its breezy atmosphere and relative cool-
ness appealed to a clientele who sat upon the sand fully dressed and
saw a tanned skin as a mark of low social class, while its closeness
to Paris made it convenient for wealthy businessmen who wished
to commute to their offices during the summer months. The same
factors attracted artists, many of whom followed their customers
to Trouville or Deauville for July and August. *Plein-air* painting was
becoming associated with the coast, just as it had been with the area
around the village of Barbizon in the 1850s.

20
Étienne Carjat,
Claude Monet
aged 20

Monet found congenial company at the Ferme Saint-Siméon, a
picturesque establishment which had once been a farm but by 1862
had become a thriving inn. Boudin was among the visitors, and
over the summer Monet also got to know the Dutch artist Johan
Barthold Jongkind (1819–91), who became as important an influence.
For Monet artistic influence and personal contact were inseparable;
just as his initial suspicion of Boudin had been converted to enthu-
siasm on acquaintance, having dismissed Jongkind as 'dead to art'
in 1860, daily contact on painting trips in the Norman countryside
now brought him to appreciate the fresh and vigorous qualities of
his landscapes. Recollecting the period forty years later, Monet

commented: 'Complementing the teaching that I received from Boudin, Jongkind was my true master from that moment onwards, and it is to him that I owe the final education of my eye.'

While Boudin had encouraged Monet to look at the sky and to capture the precise feeling of a fleeting moment, Jongkind was more interested in the manner in which different lights altered the appearance of a scene. He consequently tended to sketch outside and finish in the studio. Contact with Jongkind encouraged Monet to experiment; the pictures of this period show a more structured approach and a closer viewpoint, concentrating on the subject, the buildings, sea, or ships, rather than the sky.

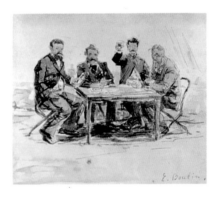

21
Eugène Boudin, *At the Ferme Saint-Siméon*, 1862. Watercolour; 14×18 cm, 5¹₂×7 in. Private collection

Boudin recorded one of the simple meals at the Ferme in a drawing (21). Although this appears to be a relatively temperate scene, Jongkind was virtually an alcoholic. Monet's aunt, who admired his work, had invited him to a family dinner; it did not go well, and she was dismayed to see her once-promising nephew entrenched in this group of artistic and social undesirables. Boudin, Jongkind and the Saint-Siméon set were not the fashionable and successful painters that Monet's family saw as suitable models for a young artist, and that August, when Madame Lecadre had agreed to pay the sum necessary to release him from the army, it was made clear that he should pursue a more conventional painter's training in Paris. His aunt wrote anxiously to Gautier, 'His behaviour is infinitely better than it used to be, but I know him to be so weak that despite all his promises I tremble at the thought of giving him his freedom.'

In her effort to keep Monet on the right track Madame Lecadre insisted that he take the advice of Auguste Toulmouche (1829–90), an established artist who had recently married into the Monet–Lecadre clan. Toulmouche was encouraging but emphatic; Monet had talent, but it needed forming in a traditional studio. He recommended Charles Gleyre (1808–74), a retired painter of mythological scenes who taught in the building where Toulmouche had his studio. Gleyre's virtues were not confined to his proximity; not only had he set Toulmouche on the path to success, but his tuition fees were also the lowest in Paris. As Monet would henceforth be reliant on his family and they had just paid over 3,000 francs to buy him out of the army, cheap fees may well have been an important consideration.

By the time he enrolled in Gleyre's atelier in the rue Notre-Dame-des-Champs in the autumn of 1862, Monet had already decided to become a landscape painter, to work out-of-doors direct from the motif and to ignore the traditions governing the official art world. Nudity and antiquity were of little interest to him and spending the next two years notionally training under Gleyre did little to change his views. Although he may not have received much in the way of academic instruction, however, Monet's time in the studio was profitably spent. As Gleyre's studio was liberally run and the pupils were allowed considerable leeway, like Suisse's it attracted the less conventional students. Their company was immensely stimulating, and it was here that Monet met the artists whose careers were to be linked to his in the future Impressionist group. In addition to Pissarro, who had also studied at Suisse's, he now met Pierre-Auguste Renoir (1841–1919), Alfred Sisley (1839–99) and Frédéric Bazille (1841–70), who became his closest friend. Together with Edgar Degas (1834–1917), who trained elsewhere, they were to make up the core of the new movement that crystallized during the 1870s.

In the early 1860s, however, they were still novices, living a student life and hoping to gain recognition through the normal channels. Monet was probably the most self-confident of the group; Renoir famously described the impression made by his lace cuffs and his 'magnificent appearance'. He was known in the studio as 'the dandy';

he was a dandy without funds, however. Bazille provided vital support for Monet throughout their period with Gleyre and into the second half of the 1860s, and both Monet and Renoir frequently used his studios. Bazille's *The Studio in the Rue de la Condamine* (22) is an informal group portrait, painted in 1870, some years after Gleyre's studio had closed down. To the far left, Renoir is sitting on a table talking to Émile Zola, the enthusiastic defender of Impressionism, Realism and modernity in art. On the right the musican Edmond Maître is at the piano, while in front of the window the lanky Bazille stands beside his easel, awaiting the judgement of Manet (in the hat) and Monet.

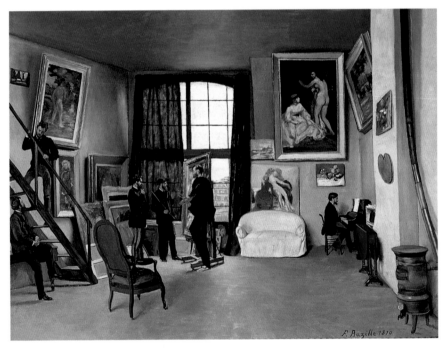

22
Frédéric Bazille,
The Studio in the Rue de la Condamine,
1870.
Oil on canvas;
204×273 cm,
$80^3_8×107^1_2$ in.
Musée
d'Orsay, Paris

23
The Salon Carré at the Salon of 1863.
Engraving in *Le Monde Illustré*

Monet's attendance at Gleyre's may have been irregular, but he was clearly a hard worker. After the studio closed for good in the summer of 1864 he continued to work on his own, spending several months on and around the coast of Normandy painting landscapes. The wealthier Bazille referred frequently in his letters to the inspiring example of his friend, whose energy and application shamed Bazille out of his natural laziness. When Monet returned to Paris in the winter of 1864,

they shared a studio and Monet prepared two subjects for his first Salon submission.

Boudin had decided to return to Le Havre after the expiry of his municipal scholarship, but Monet was much more ambitious. Having won local success and fortune at an early age, by his mid-twenties he was determined to conquer Paris. In 1865 there was still really only one place in which a young artist could make a reputation – the government-sponsored Salon. The Salon's relationship to the government line was rarely entirely straightforward and it varied considerably over time. The power of the Academy of Fine Arts had been strengthened by Louis-Napoleon after the coup of 1852. For the first ten years of his reign he was an absolutist monarch, exerting tight control over all aspects of cultural life from newspapers to art exhibitions. The Catholic Church had allied itself with Louis-

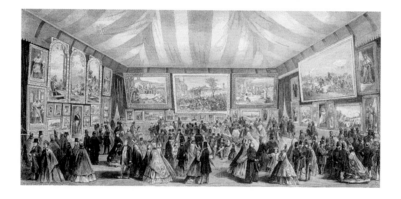

Napoleon in 1852, and religious art was consequently encouraged; landscape was a less obvious target for state purchases. In the middle and late years of the Second Empire, however, when Monet was attempting to have his work shown there, the government and the Academy were less closely associated. The rules changed from year to year and much depended on the composition of the jury, which was usually dominated by conservative painters. The Second Empire grew less restrictive during the 1860s, and as it became more pluralist in political terms it also became more inclusive artistically. Genre, landscape and stylistically challenging work began to find a place in the market.

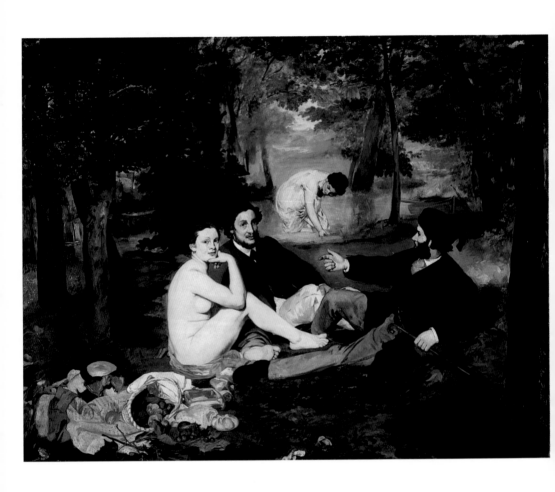

Nevertheless, until the end of the 1870s that market continued to centre on the Salon, often described as the largest and most prestigious shop-window in France. During the 1860s audiences were enormous – up to 400,000 visitors for a single exhibition (23) – and the publicity generated by a good Salon review could make an unknown painter rich and fashionable within a year. Without public exposure, on the other hand, it was almost impossible to find buyers.

The imperial couple had no strong taste of their own; the Empress Eugénie liked vapid decorative works, the Emperor portraits glorifying himself or his uncle, but as far as style went they were impartial – or perhaps indifferent. In 1863 the Salon jury refused so many pictures that artists petitioned Napoleon III to allow a separate 'Salon des Refusés', or show of rejected works. On viewing the pictures which had not been accepted the Emperor remarked that he could see no difference between them and those selected for the Salon and the exhibition of rejected works went ahead, indicating the complexity of the relationship between the ruler, his servants at the Academy and the Ministry of Fine Arts, and the individuals who composed the Salon jury.

24
Édouard Manet, *Le Déjeuner sur l'herbe*, 1863. Oil on canvas; 208×264·5 cm, 82×104¼ in. Musée d'Orsay, Paris

25
Édouard Manet

The double Salon of 1863 is a fascinating historical episode. Although most of the paintings in the Salon des Refusés were apparently as conventional and mediocre as those in the official Salon, it is chiefly known now for a picture which was altogether exceptional – Édouard Manet's *Déjeuner sur l'herbe* (originally entitled *The Bath*; 24). Manet (25) had an enormous influence on the younger generation, and this picture was particularly important for Monet. In it Manet brought together an extraordinary combination of Old Master references and a new style of painting. The poses of the figures are taken from an engraving after Raphael (1483–1520), the most admired artist of the Italian Renaissance. However, the juxtaposition of a nude female figure – a highly acceptable subject in academic art – with clothed men in modern dress scandalized the audience. The strong contrasts and overall flatness of the composition were designed to make the viewer aware of the illusions manipulated by the painter. A work of great complexity, it is often seen as the first modernist picture; at the

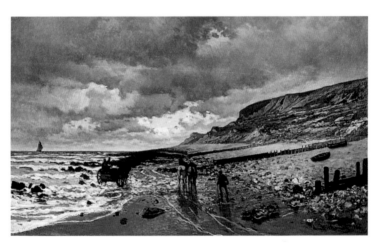

26
*The Pointe
de la Hève
at Low Tide*,
1864–5.
Oil on canvas;
90·2×150·5 cm,
$35\frac{1}{2}\times59\frac{1}{4}$ in.
Kimbell Art
Museum,
Fort Worth

27
Édouard Manet,
Olympia,
1863.
Oil on canvas;
130·5×190 cm,
$51\frac{3}{8}\times74\frac{7}{8}$ in.
Musée d'Orsay,
Paris

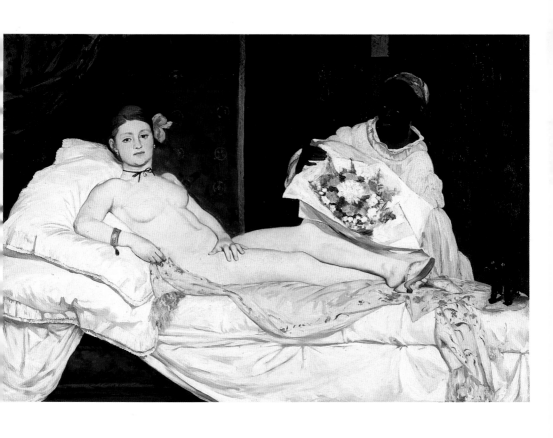

time the word most used was 'Realist'. For the audience of 1863, Manet's work was generally considered both insulting and incompetent. For young artists who wished to break away from the safe mediocrity of the artistic establishment it was to become a talisman.

Despite its shortcomings, the Salon offered unparalleled publicity, and from 1865 onwards Monet submitted regularly, trying to balance his wish to be noticed with the need to sell. From the beginning he confronted one of the practical problems resulting from the Salon's dual role as a display of governmental patronage and a market-place. While large ambitious works, risky and expensive, were most likely to attract critical interest, small, safe subjects were easier to sell. Monet was a careful strategist; having advised Boudin of a gap in the market for marine paintings as early as his first Salon visit in 1859, the pictures Monet himself submitted in 1865 were indeed marines, standard beach and harbour scenes, brightly treated in a relatively traditional manner. *The Mouth of the Seine at Honfleur* and *The Pointe de la Hève at Low Tide* (26) were very well received, for the work of a young unknown. As works were arranged alphabetically that year, they hung on either side of the most notorious picture at the Salon, Manet's next real scandal, *Olympia* (27), which again subverted the tradition of the classical nude. This fortuitous placement, and the confusion caused by the similarity of the artists' names, helped to generate publicity for Monet, whose works seemed undemanding in comparison with their neighbour. The two artists quickly became acquainted and by the end of the decade they were working side by side; indeed, by the next year Monet's salon entries were to be much closer to Manet, both in subject matter and ability to shock.

Even in 1865, however, there was something in Monet's work that made it stand out from other Salon seascapes. The conservative critic Paul Mantz commented, 'Now we are interested in following the fortunes of this sincere seascape painter', and *The Pointe de la Hève at Low Tide* was sold to the print publisher and dealer Alfred Cadart for 300 francs. It was the first time Monet had sold a serious work in Paris, and it had gone into good company; Cadart also bought works by Boudin, Jongkind and Manet.

Although the coast of Normandy continued to interest Monet throughout his life he quickly grew dissatisfied with straightforward views and turned to much more contentious subjects. Having established his competence, he moved away from landscape and began to concentrate on figure painting, a change of tack that may well have been due to the excitement generated by the work of Courbet and Manet. Like the two older artists Monet treated his figures in a manner that was far from conventional. As the 1865 Salon opened, he began to plot an entry for the following year which would eclipse even the much-discussed works of Manet and Courbet – a colossal picture on the same theme as the *Déjeuner sur l'herbe*, almost as big as *A Burial at Ornans* (see 14), but posed and painted almost entirely out of doors. He was simultaneously taking on both the leading figures of the Realist movement.

The subject of this grand work, a group of middle-class picnickers in the Forest of Fontainebleau near Paris, seems unexceptionable, and quite unlike Manet's enigmatic scene. The area in which Monet was painting had become increasingly accessible to urban day-trippers and artists, and his figures would have been readily recognizable as contemporary pleasure-seekers. There was nothing terribly original in his choice of setting or subject – both had eighteenth-century and contemporary precedents, such as *The Picnic* by Auguste-Barthélemy Glaize (1807–93; 29). Monet's picture was nevertheless astonishingly ambitious. After his Salon success he had decided to tackle something uniquely difficult – the representation of figures in natural light on a life-size scale. The original canvas was huge (over $4·6\times6$ m, 13×20 ft). Two sections (30, 31) and a largish painted sketch (28) survive. Monet cut the picture up in 1884 after he had retrieved it, rotting, from the cellar in which it had lain for many years. It was not only the size of the work that was intended to astonish but also the manner in which the everyday subject was treated.

The four female figures were largely based on one young woman, Camille Doncieux, who was to become Monet's first wife. Little is known about her; she came of the same kind of bourgeois stock as Monet. Bazille posed for most of the male figures, after a stream of

28 Overleaf
Sketch for *Le Déjeuner sur l'herbe*, 1865.
Oil on canvas; 130×181 cm, $51^{1}4\times71^{3}8$ in.
Pushkin Museum of Fine Arts, Moscow

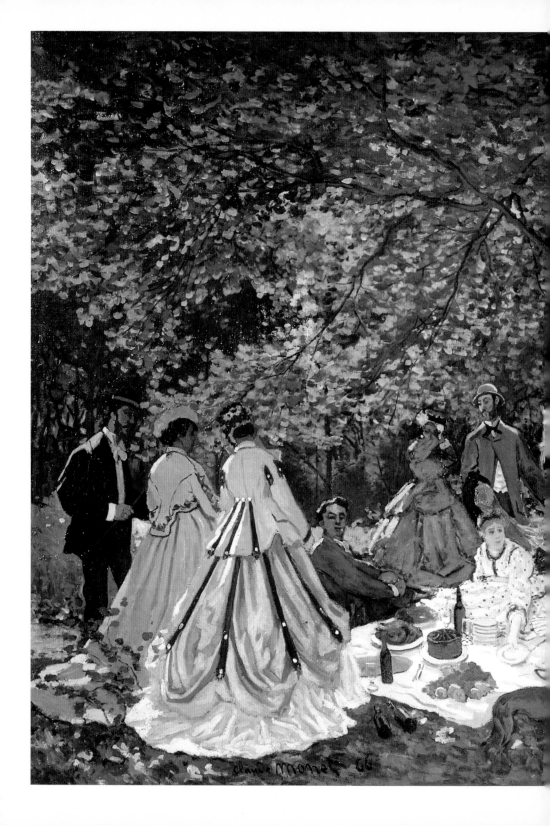

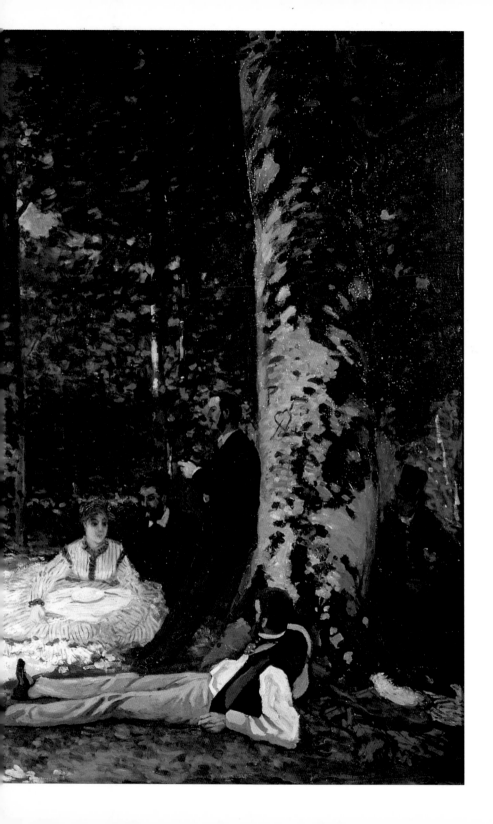

49 Making a Name in Paris

29
Auguste-
Barthélemy
Glaize,
The Picnic,
1850.
Oil on canvas;
145×114 cm,
571$_8$×447$_8$ in.
Musée Fabre,
Montpellier

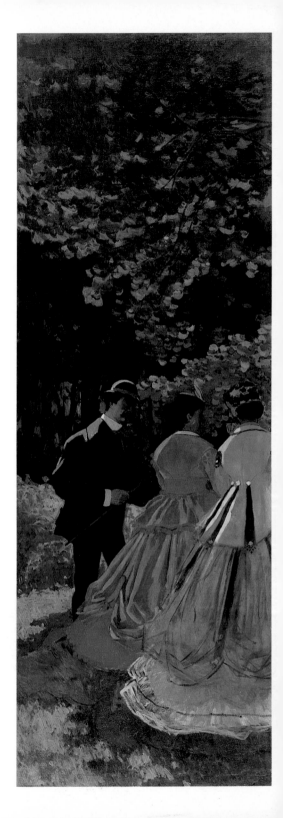

30
*Le Déjeuner sur
l'herbe* (left
section),
1865.
Oil on canvas;
418×150 cm,
164⅝×59⅛ in.
Musée d'Orsay,
Paris

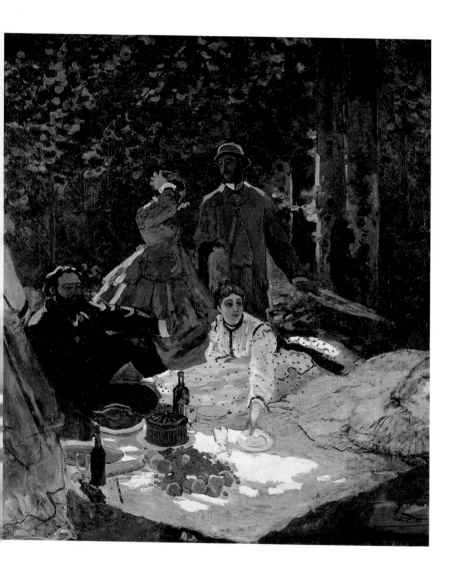

31
*Le Déjeuner
sur l'herbe*
(central
section),
1865.
Oil on canvas;
248×217 cm,
97¾×85½ in.
Musée
d'Orsay, Paris

imploring letters had brought him down from Paris. Unluckily, shortly after Bazille's arrival in Chailly Monet was laid up with an injured leg. Unable to move, he became the model for *The Improvised Ambulance* (32). Bazille had studied medicine, in tandem with painting, for a few years and the contraption suspended over Monet's leg is an ingenious device to keep it cool with a continuous drip of water. It is quite possible that painting Monet was the only way of keeping him still; he looks distinctly sullen at this unintended role-reversal.

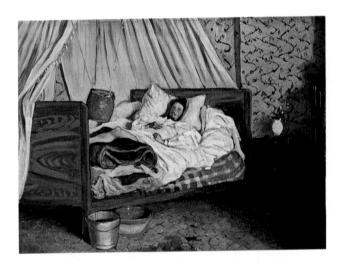

32
Frédéric
Bazille,
*The
Improvised
Ambulance*,
1865.
Oil on canvas;
47×65 cm,
18¹₂× 25⁵₈ in.
Musée
d'Orsay, Paris

The vast size of the *Déjeuner sur l'herbe* made it quite impossible to paint out-of-doors, and the painted studies that survive show that the picture was far from being a spontaneous *plein-air* sketch. Monet was striving to give the appearance of instantaneity – a snapshot with an eight-month exposure. The landscape painter's concern with the idea of precise truth to nature has been transferred to figure painting in a manner that almost effaces the distinction between the landscape and the figures inhabiting it. Although these well-dressed picnickers are clearly not locals of the kind painted by the Barbizon School artists, they are treated with a sort of blank indifference reminiscent of Millet's peasant studies. Where *Man with a Hoe* (see 15) can be seen as a part of the bleak landscape around him, Monet's elegant pleasure-seekers are clearly not in their native environment, but we are given no cogent reason or incident to associate them with the

forest. The lack of a story or a psychological link between the figures is emphasized by the uncentred composition, in contrast to Glaize's picnic, where the cluster of figures around the toastmaster gives animation to the scene.

While Manet's *Déjeuner* remains a difficult picture – its jarring combination of clothed and naked figures and its stiff poses suggest a meaning beyond the surface – Monet's picture seems straightforwardly pretty to modern viewers. It was not intended to be decorative or restful, however, and it is an indication of the complexity of the project that Monet abandoned the painting shortly before the 1866 Salon. In order to have something new to show he rapidly produced *Camille*, or *The Green Dress* (33). Significantly, although the model is painted from life, she is posed in an interior and the background is left dark and empty. His other submission, the *Road to Chailly*, was a Fontainebleau Forest scene from 1864 – effectively the missing landscape. The challenge of integrating the two, placing a full-scale figure in an outdoor setting, was postponed for another year.

As in 1865 the Salon audience again confused Monet with Manet, and both artists attracted considerable attention. A contemporary weekly newspaper, *La Lune*, published a cartoon by the satirist Gill (34) guying a number of the pictures, including *Camille*. The caption reads 'Monet or Manet? Monet! But we owe this Monet to Manet. Well done, Monet! Thank you, Manet!' Monet could only have been pleased and flattered by this comparison. A more significant tribute may have been paid by Manet. In 1863 he had exhibited the picture now known as *Déjeuner sur l'herbe* under the title *The Bath*. In 1867 it appeared with the same name as Monet's picture, and it is possible that Manet chose to retitle it after seeing the work of the younger artist. *Camille* and the *Road to Chailly* were both well received. Few people knew of the abortive *Déjeuner* and critics began to consider Monet a promising young Salon painter. His main submission 1867 was to change all that forever.

Women in the Garden (36) was started in the summer of 1866 after the Salon had opened. It was the second of Monet's large and ambitious

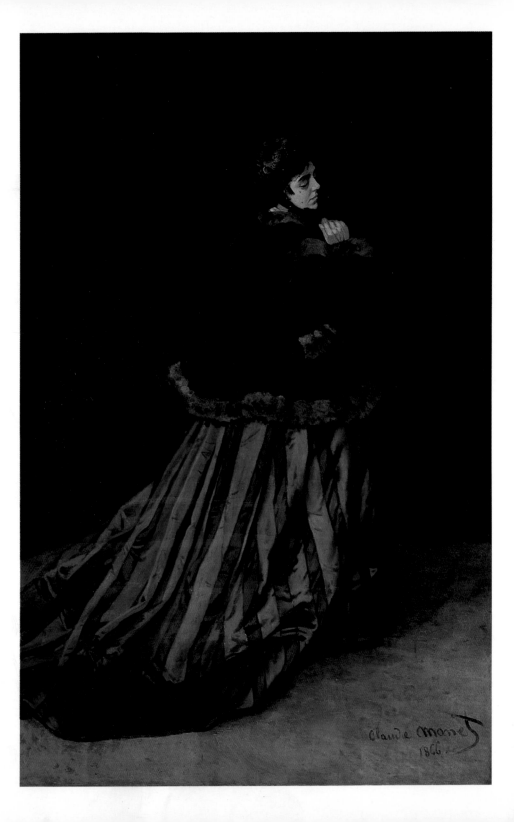

33
Camille, or
*The Green
Dress,*
1866.
Oil on canvas;
231×151 cm,
91×59½ in.
Kunsthalle,
Bremen

34
Gill,
Caricature of
Camille
(centre row).
La Lune,
13 May 1866

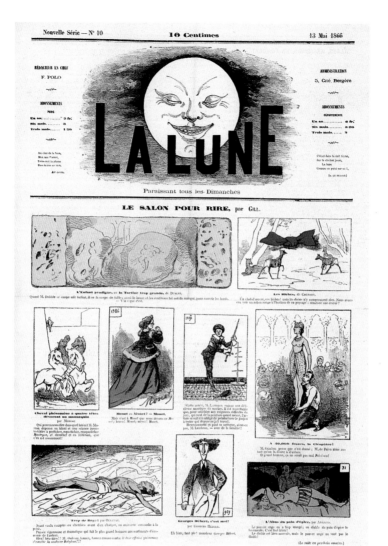

contemporary scenes, and this time he was determined to produce a finished work suitable for exhibition. He had reassessed the scale of the project; the number of figures was cut down from twelve in the *Déjeuner* to a more manageable four, and the size of the picture reduced. In one critical aspect, however, this was a more radical painting than its failed predecessor; it was to be painted entirely out of doors, in natural light.

At over 2·5 m (8 ft) high, however, it was far larger than the average Salon offering. Monet and Camille were living in a small house at

35
Women in the Garden,
(detail of 36)

Sèvres, in the Parisian hinterland, and the artist later claimed that he had dug a trench in the garden in order to reach all parts of the painting. Like many other accounts which emphasize the artist's physical exertions, this oft-repeated anecdote lends a kind of heroic machismo to the act of painting, a guarantee of labour and effort. In the case of this picture it was hardly necessary to stress the fact

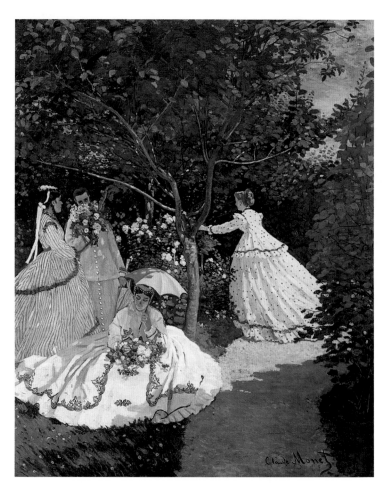

36
Women in the Garden,
1866.
Oil on canvas;
256×208 cm,
100⁷₈×82 in.
Musée
d'Orsay, Paris

that it was not a conventional studio work. The blinding sun of a late summer day flattens the figures, effaces detail and gives a blocky, almost crude feeling to the four women placed against the brilliant green grass and foliage (35). The picture was shockingly unconventional in itself, and the *plein-air* method had never been used for a figure-scene of this size. The style of the painting was astonishing

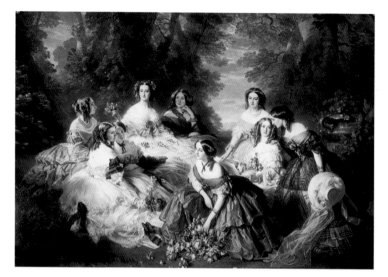

37
Franz Winterhalter,
The Empress Eugénie with her Ladies,
1855.
Oil on canvas;
300×420 cm,
118¹⁄₄×165¹⁄₂ in.
Musée National du Château de Compiègne

38
Fashion-plate from *La Mode illustrée*,
1865

39
Bertall,
The caption reads: 'When I tell you that it is a dress from Worth, it is because I recognize the style'.
Cartoon in *La Comédie de notre temps*

LA MODE ILLUSTRÉE.

in itself, and the discrepancy between its monumental size and modest subject was a rebuttal of academic notions of a hierarchy of subject matter.

Women in the Garden did not just lack an improving subject, it scarcely had a subject at all. Scenes from middle-class life were popular with the Salon public, if not with the Academy, but they were normally far smaller and always had some anecdotal element. 'Women, in a garden' had actually figured on a list of potential modern themes published in 1859 by Anatole de Montaiglon, a critic hoping to vary the stale Salon fare with some 'subjects of our time'. However, despite its anodyne subject, Monet's picture is oddly disquieting. The women are in physical proximity but there is no sense of contact between them; each one seems stiff and isolated in her splendid robe. It is often compared with *The Empress Eugénie with her Ladies* (37) by the court artist Franz Winterhalter (1805–93), in which the women are arranged like a tasteful bouquet of flowers in harmonious blended tones with the Empress dominant in white satin. The light is clear and even and the faces are shown in crisp detail; although there is no action, the sweep of the composition gives the painting a sense of unity. In *Women in the Garden* a tree occupies the centre, and much of the foreground is in shadow. One figure presents her back to the viewer and the other three, although crowded together, show no sign that they are aware of each other. They look almost as if they had been cut out and pasted on to the canvas.

Both the flatness of the figures and the elaborate detail of the cos- tumes are similar to the fashion-plates in contemporary magazines, though there is no evidence that Monet used a particular image for the basis of his painting. The variety of the figures' stances – full-face, standing, seated, in profile and back view – is typical of fashion- plates, as are the garden setting and the bouquets carried by the women (38). *Haute couture* became a major Paris industry during the Second Empire, fuelled by the extravagances of the court and the desire of the new rich to imitate it. In the fluid, plutocratic society which had replaced the old hierarchy of birth, fashion gained a new

importance as an index of wealth. In his famous essay 'The Painter of Modern Life' (1863), the poet and critic Charles Baudelaire (1821–67) urged contemporary artists to study dress seriously, even suggesting that fashion-plates could replace antique statues as a source of poses. A cartoon by the caricaturist Bertall (39) shows the dangers of taking this advice too much to heart.

Popular graphics, caricatures, posters and the colourful Japanese prints that had started to circulate with the opening up of Japan to Western trade all attracted a new generation of artists in their attempt to break away from the academic repertoire, and it would have been natural for Monet to turn to the enticing images of wealth provided by fashion-plates while planning his picture. Each of his figures appears to have been posed by Camille in dresses that may have been hired – they would certainly have been clearly recogniz-able as smart town-wear, not countrified or dowdy. Nevertheless, Monet's depiction of his unmarried companion in the garb of a wealthy middle-class woman in a chic suburban garden would have been difficult for a contemporary Salon audience to make sense of. Both technique and composition would have appeared incoherent, suggesting the work of an artist who was either incapable or aggres-sively rebellious. When *Women in the Garden*, which had taken half a year's work, was rejected, the penniless artist was rescued by Bazille, who bought it for 2,500 francs to be paid in instalments of fifty francs a month. The irregularity of the payments became a source of great friction between the two and contributed to the souring of their relationship.

The 1867 Salon jury was exceptionally conservative, rejecting both Monet's submissions, *Women in the Garden* and a much more conventional marine scene. Renoir, Sisley and Bazille also had their work refused. Two members of the jury, Corot and Daubigny, resigned in protest. Anger over the restricted choice was widespread among far more conventional artists – two-thirds of the submitted works had been turned down and one unhappy painter who had been selected for years caused a scandal by committing suicide after his rejection. Although the young artists thought of holding an

independent show of their own, the scheme failed through lack of funds, and it was not until 1874 that they were to exhibit as a group. In autumn 1867 the jury system was reformed, but despite letters of petition there was no repeating the experiment of a Salon des Refusés. The imperial establishment was on show that summer, for Paris was holding a second great Universal Exposition. Criticism, or anything which could possibly attract criticism, was suppressed.

The 1867 Universal Exposition was part of France's continuing battle for supremacy in Europe. In 1851 the Great Exhibition of the Arts and Industry of All Nations had been staged in London's Hyde Park. It was an enormous success, highlighting Britain's role as the world's major industrial nation. The French visitors were awed and irritated by this display of Anglo-Saxon confidence, and in 1855 a similar event had

40
Universal Exposition, 1867. Engraving

41
Les Étrangers à Paris. Paris Illustré, 1863

been held in Paris. The French had included the fine arts, which they believed to be their winning suit; in London paintings had been admitted only as examples of paint-manufacturers' skills. In 1862 London had another go, and in 1867 it was France's turn once again.

Political tension between the two countries remained high during the Second Empire; neither the British nor the French had forgotten the pan-European ambitions of the first Napoleon. Despite the fact that the great exhibitions were dedicated to 'peace among nations', they can be seen as an unarmed form of belligerent competition. For the French, clearly outstripped on the manufacturing front despite the advances of the previous decade, Gallic superiority could never-

PARIS ILLUSTRÉ

Bertall

theless be asserted in matters of taste and design, and the Fine Arts section of the 1867 Exposition was therefore a matter of national importance (40). It was to run concurrently with that year's Salon, and no effort was spared to ensure that both would enhance the image of imperial France.

Exclusion from the official exhibitions was tantamount to virtual disappearance from the scene. Manet and Courbet, the two most eminent outcasts, refused to disappear. They set up their own pavilions near each other at the junction of the avenue de l'Alma and the avenue Montaigne. Close to the exhibition ground and well positioned to catch the passing trade, they both received critical attention, though not a great deal in the way of sales.

42
Clearing the area in front of the Opera in 1867

43
Boulevard Haussmann, Paris, 1877. Engraving

Being relatively established artists, however, they could afford to be content with the admiration of a few and notoriety among the many. In the introduction to his exhibition Manet wrote: 'To exhibit is to find friends and allies in the struggle.' This was the aim of all the young artists whose work had been rejected.

Although the Exposition was much discussed, for the millions of visitors who poured into Paris the transformed city itself was the biggest attraction of all (41). One of the first projects of the new emperor had been the virtual rebuilding of the capital; he personally drew up a map of the changes he wished to see and put Baron Haussmann in change of their execution. Entire districts were

demolished and the medieval heart of the city was destroyed (42). In its place rose a modern Paris, with its wide boulevards (43), uniform buildings, majestic public gardens and monuments, riverside walks and graceful bridges; canals, road and rail links revolutionized communications. The old Paris had been dirty, crowded, infested, impoverished and revolutionary; the new Paris was well-lit, well-paved, well-cared for and well-off. In its centre, the destruction of the old artisans' quarters in the Île de la Cité, the

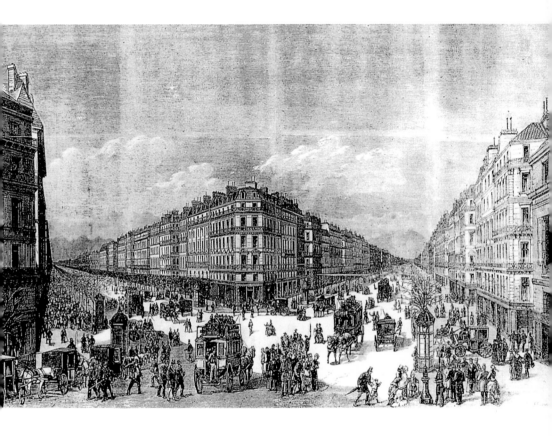

Faubourg St Antoine and Faubourg St Denis had resulted in mass evictions. The grand apartment blocks which replaced the old tenements were beyond the means of even the most successful of the workmen who had previously lived in these areas; they and their families were forced to move, often beyond the city walls to the cheap suburbs such as Belleville which mushroomed around the periphery of the capital. Paris became a much richer city and a model for urban development all over Europe.

It was probably in response to the potentially lucrative wave of interest generated by visitors to the 1867 Exposition that both Monet and Renoir began to paint views of Paris. They were not alone in this; the tourists provided a steady market for souvenirs, both painted and photographic. When Monet moved to Paris in the 1860s he was interested in contemporary artists; he does not appear to have sketched the city's ancient monuments, and when he visited the Louvre it was to paint contemporary Paris from its balcony, a symbolic rejection of the Old Masters in favour of the modern world. He was later notable among the Impressionists in his flagrant indifference to the art of the past; this attitude, which would seem remarkable in a student today, was extraordinary in a period when training was heavily based on tradition perpetuated

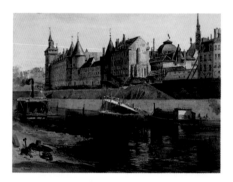

by copying the works of the Old Masters. Monet's exclusive interest in the present, however, could be seen as typical of the Second Empire Parisian. His pictures of the city are intimately linked with the social and physical alterations that took place from the 1850s to the 1870s.

These changes dismayed some, such as the exiled writer Victor Hugo (1802–85), whose novel *Les Misérables* (1862) charged the imperial government with calculated vandalism and social brutality. Monet, however, may have seen the developments as thrilling and associated change with progress, like many among the bourgeois population of the city. The new Paris was a spectacular city, filled with grand open spaces and sparkling limestone façades. Light, air and modernity were central to the art of the new generation of painters, and Monet's

44
Adrien
Dauzats,
*The Palais de
Justice and the
Conciergerie*,
c.1858.
Oil on canvas;
54·5×73 cm,
21¹₂×28³₄ in.
Musée
Carnavalet,
Paris

45
*The Garden of
the Princess*,
1867.
Oil on canvas;
91·8×61·9 cm,
36¹₈×24³₈ in.
Oberlin
College, Ohio

choice of subjects makes his interest in the character of the modern
city quite clear. Unlike many contemporary artists who made a living
with scenes of the old quarters of Paris (44), he chose to depict the
latest developments as well as the hallowed monuments of previous
centuries. *The Garden of the Princess* (45) shows the central area
around the old royal palace, the Louvre, which had become the great
national art museum. Its high viewpoint gives more than half of the
picture over to empty space – a thickly clouded sky at the top,
reminiscent of those Monet had painted with Boudin on the coast,

and in the foreground the smooth grass of the new public gardens, complete with passers-by. In this picture the old city of cramped lanes and sharp divisions between rich and poor has been replaced by public spaces where everyone seems middle-class. If there are differences between these tiny figures, we are too distant to observe them; this is not a Paris of quaint types but of anonymous black-suited manikins, with here and there the pink skirt of some unclassifiable woman.

The critic Robert Herbert has analysed this picture very cogently, showing the link between subject and style. Monet is rejecting the picturesque tradition, and his unorthodox composition, with its blank spaces and complex pattern of angles, is both geometrical and informal. Its unconventionality is also a question of what is depicted. Everything in the foreground is new; the riverside area had been recently cleared. On the far side of the jade-green river, looking towards the Left Bank, we see a more crowded cityscape, anchored and balanced by the dome of the Pantheon. This national monu-ment, a shrine to the great Frenchmen of past ages, is flanked by the tower of an ancient church to the left and the smaller dome of the Sorbonne University to the right. The distances between these three contrasting symbols of Paris are symmetrical – the entire picture is held in place by a calculated framework of great precision. Comparison with Manet's work of the same year, *View of the Paris Universal Exposition* (46), demonstrates the care with which Monet ordered his painting, bringing rhythm and clarity from the jumble of the city. Manet observes the buildings of the Exposition simply as a backdrop for an apparently random group of figures; the composi-tion appears ragged and offhand, the city scruffy and disorganized.

The links between the two artists were to become closer in the following decade, and Courbet was also personally friendly with Monet, whom he knew well enough to give him advice on *Women in the Garden* (which was disregarded) and to be touched for a loan. The story of Courbet's comments on Monet's picture is often told; seeing that the younger artist had ceased work because the sun had gone in, the master of Realism asked, 'Why don't you just work on the

landscape?' He had grasped Monet's interest in capturing outdoor light on a figure, but he did not understand or share his desire to convey the atmosphere of the scene as a whole, integrating the women, the tree, the bushes and the grass into a single coherent whole.

Despite the clear continuities between Manet, Courbet and Monet, the older artists' approach was very different from that being developed by the future Impressionists. The two outcasts of the avenue de l'Alma shared a Realist concern with the concrete representation of the visible world, without idealization. Like the earlier Barbizon School artists, they had helped to create the concept of the 'avant-garde', a type of painting which opposed the values of the official art world and found support among a small group of artistic insiders.

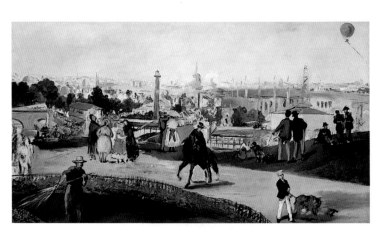

46
Édouard
Manet,
View of the
Paris
Universal
Exposition,
1867.
Oil on canvas;
108×196.5 cm,
42^1₂×77^3₈ in.
Nasjonal-
galleriet,
Oslo

By the 1860s the Barbizon School had been more or less accepted by the public, and the same slow shift could be seen in critical reactions to Courbet and Manet. This helped to encourage Monet's generation to stick to their guns when rejected by the Salon. The model of rejection followed by gradual critical acceptance and final commercial success was becoming sufficiently familiar for Zola to review Monet's work rather like a racing-tipster; in 1866 he asserted: 'I am so sure that Monet will be one of the masters of tomorrow that I believe I would make a good bargain if I had the money to buy all his canvases today. In fifty years they will sell for fifteen or twenty times more.' The existence of a permanent avant-garde depended on constant innovation, and by the second half of the 1860s Monet's work clearly

struck a new note. While Realists were interested in physical reality, Monet wanted to paint the atmosphere – what he was later to call the 'envelope'.

It was also clear that the French art scene generally was becoming more diverse. Economic prosperity meant that the pool of potential buyers was growing, with the private market increasingly replacing the state as the source of artists' incomes. The new patrons tended to prefer pictures of modest size and unassuming subject. The Salon was an unsuitable place to exhibit small paintings: the crowded hang favoured the 'grandes machines', the huge pictures named after

47
**Honoré
Daumier**,
*Landscapists
at Work*. The
caption is:
'The first
copies nature,
the second
copies the
first.'
Lithograph in
Le Charivari,
12 May 1865

the machinery required to roll them around the galleries. In 1867 Courbet and Manet's separate pavilions had allowed potential buyers to see their work in a setting chosen by the artist, which not only made individual pictures more attractive, but also helped to establish the artist's identity. With the emergence of a broadly defined avant-garde, ways of working outside the state system became increasingly attractive to artists, buyers and critics. Works shown in the Salon which stood out in some way from the rest of the submissions were often simply lumped together, making their similarities more apparent than their differences. Courbet, Manet and Monet, for example, were all described as Realists because of their use of modern-life scenes.

The new element Monet brought to images of contemporary life was a particular visual sensitivity which had grown out of painting landscapes out-of-doors, catching quick changes and fleeting effects. Because landscape had been regarded as a minor genre, the weight of tradition was less crushing, and there was more room for individuality – although as the caricaturist Honoré Daumier (1808–79) suggested in 1865, a host of imitators were quick to arrive on the scene (47). By the 1860s, too, the distinction between prepared sketch and finished work was being eroded, and pictures which would have been considered incomplete even a decade earlier were finding a market among buyers who valued their apparent spontaneity. *Plein-air* painting, which had hitherto been seen as a preparation for landscapes finished in the studio, had taken on a new importance, and pictures which preserved the qualities of freshness and physicality were increasingly prized. These changes in aesthetic sensibilities were mirrored in social realities; as the French capital developed into a centre of trade and industry, the countryside around Paris disappeared beneath bricks and mortar, making rural idylls increasingly attractive to the urban gallery-goer. Simple local scenes executed outdoors were seen as more truthful and closer to nature than the grand classical compositions of the French landscape tradition. Monet's paintings of the 1860s can be seen as a suburban updating of the Realist work of the previous generation. Millet had replaced Poussin's biblical patriarchs with peasants; Monet replaced peasants with day-trippers.

In the summer of 1867 Monet compounded his lack of artistic success by committing a social sin. He was still dependent on his family for money, and Camille was expecting a child. Typically, he seems to have announced the news to his father and then left it to Bazille to explain the full situation. Despite, or perhaps because of the fact that he had produced an illegitimate child of his own seven years earlier, Monet's father was disinclined to sympathize. The wayward son was offered board and lodging at Sainte-Adresse, provided that Camille was left to her own devices in Paris. Monet moved back to his family, entrusting Camille to Bazille. She gave birth that August, in her one-roomed lodging. Monet came down to see them and found,

apparently to his surprise, that he loved his child (48). The infant was named Jean-Armand-Claude and registered as the legitimate offspring of Monsieur and Madame Monet. When he was baptized some months later Bazille became his godfather.

During these turbulent events, Monet continued to paint. His best-known work from this period is the *Terrace at Sainte-Adresse* (50), painted from the window of an upper storey room in the family house. Four figures look out towards a brilliant green sea; the seated couple in the foreground are Monet's father and Madame Lecadre, while the younger couple by the railing are the artist's cousin, Jeanne-Marguerite Lecadre, and an unknown man. As in *The Garden of the Princess* an apparently informal view is held in place by a strict geometrical framework. The picture divides horizontally into three stripes – terrace, sea and sky. On either side of the terrace the flower-beds, crammed with scarlet nasturtiums and gladioli, create a strong sense of recession. Two poles, flying the flags of France and Le Havre, peg out the centre and direct our attention to the pair of figures by the railing. Beyond them the sea is thronged with commercial and pleasure boats – the source of the town's wealth, and the family's. This scene is as modern as the Paris cityscapes – the estuary had been embanked very recently and the steamships were the most recent marine technology. Even the suburb was relatively new. Monet's interest in novelty can also be seen in the unconventional composition, which is often traced to the influence of photography and of Japanese woodblock prints. Monet himself referred to this work as his 'Chinese painting with flags in it'; as John House has shown, 'Chinese' and 'Japanese' were often confused by a French public interested in the appearance of the prints rather than their ancestry. Their strong colours, stylized shapes and lack of Western perspective all appealed to Monet, and he formed a personal collection which still hangs in his house at Giverny. One print by Hokusai from his collection (49) has clear similarities to the *Terrace at Sainte-Adresse*.

The two works which Monet submitted to the Salon in 1868 were both scenes of Le Havre. Reform of the system in autumn 1867 included

48
Jean Monet in his Cradle, 1867. Oil on canvas; 116×89 cm, 45³⁴×35 in. National Gallery of Art, Washington, DC

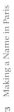

a democratically elected jury, and the 1868 Salon was much more liberal. Daubigny was among the judges; he had exhibited a land-scape entirely painted out-of-doors in 1864, and he may well have pushed for the acceptance of at least one of Monet's paintings. Zola praised the force and freshness of *Boats Setting Out from the Port of Le Havre*, but the cartoonist Bertall caricatured it with the comment 'Monsieur Monet was four and half years old when he painted this.' It did not find a buyer, and was seized by debt collectors after the Salon closed.

Although the Salon picture did not bring success, Monet also showed five paintings at an exhibition in Le Havre in the summer of 1868.

49
Katsushika Hokusai, *Fuji Viewed from the Sazaido in the Temple of the 500 Rakan, Edo.* Woodblock print from *Thirty-six Views of Mount Fuji*, 1829–33. 23.9×34.3 cm, $9^3\!/_8 \times 13^1\!/_2$ in. British Museum, London

50
Terrace at Sainte-Adresse, 1867. Oil on canvas; 98.1×129.9 cm, $38^5\!/_8 \times 51^1\!/_8$ in. Metropolitan Museum of Art, New York

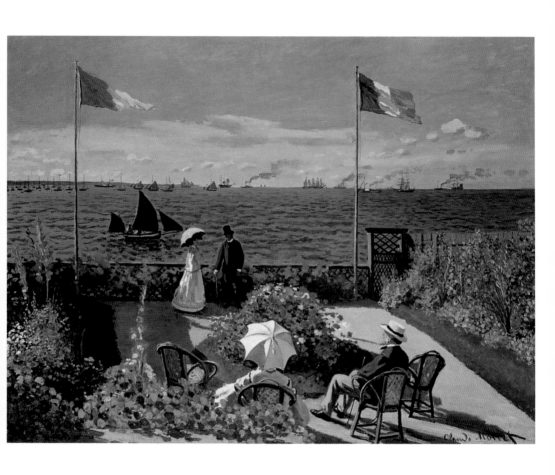

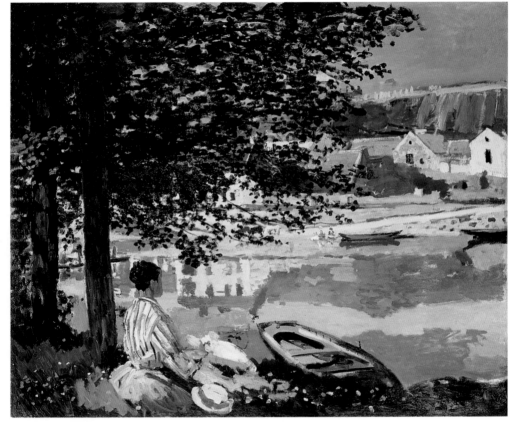

He won a silver medal and found buyers. *Camille* was re-exhibited, and was eventually sold to a Parisian critic, Arsène Houssaye, for 800 francs. Monsieur Gaudibert, a local businessman who had bought from Monet before, commissioned a portrait of his wife in the same manner. Despite these small triumphs, however, his financial situation was bleak. The fact that he had been living far beyond his means was pointed out to him by the long-suffering (and compara-

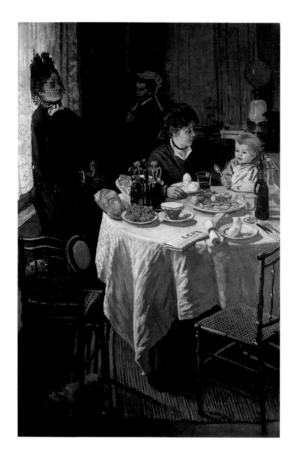

51
On the Bank of the Seine at Bennecourt, 1868.
Oil on canvas; 81·5×100·7 cm, 32^1⁄$_8$×39^5⁄$_8$ in.
The Art Institute of Chicago

52
The Luncheon, 1868.
Oil on canvas; 230×150 cm, 90^5⁄$_8$×59^1⁄$_8$ in.
Städelsches Kunstinstitut, Frankfurt

tively wealthy) Bazille, who was fed up with a constant stream of aggressive demands for loans, advances and payments for *Women in the Garden*. Monet's reaction was to claim that he had tried to drown himself in the Seine. Self-dramatization was always part of Monet's character, but it must have been galling to have had the pictures unsold at the Le Havre exhibition seized by his creditors and auctioned (they were bought by the same Monsieur Gaudibert).

Later Monet was to slash other pictures to prevent them from seizure and forced sale.

Money problems dogged Monet and Camille constantly. Running a family household was expensive and Monet liked to live well, although the irregularity of his income meant that they frequently moved to rooms in village inns and cheap hotels. Given the opportunity, he considered it reasonable and proper to rent an entire house and employ a maid, and he ran up endless bills with grocers, wine merchants, laundresses, innkeepers and tailors. When he had no income he lived like a wealthy man, and when he became a wealthy man he was in no hurry to pay off old debts: some of his creditors had to wait twenty years to get their money back. His financial dealings have been well chronicled, and it sometimes seems that for Monet drinking inferior claret was virtual starvation. His habitual exaggeration and the 'early hardships' which have become a required element in the biography of any self-respecting artist do not mean that he was never in difficulty, however. He did have several periods of real financial need, and the summers of 1868 and 1869 were among the worst. This is not apparent in his paintings; the intimate pictures in which Jean and Camille appear seem almost idyllic.

On the Bank of the Seine at Bennecourt (51) shows Camille sitting on the bank of the river, gazing out at the inn where they were staying; it is reflected in the still water, glinting in the sunlight. Next door is a house inhabited by their 'friend and ally in the struggle', Émile Zola. A white dog lies in Camille's lap; X-ray examination of the picture shows that it was originally intended as little Jean. The mood is one of detached but benevolent contemplation. The same quiet content-ment appears in the domestic interior, painted in Etretat during the winter of 1868–9 (52). Although it is always tempting to see pictures as a reflection of the inner life of the artist, Monet's works carry little suggestion of the difficulties he was experiencing at this time.

His 1869 Salon submissions were refused, and in the spring of that year the family moved to cheaper quarters in the village of Saint-Michel, close to Paris (54). That summer marked a new departure.

Working side by side, Monet and Renoir produced some of their most adventurous paintings. Renoir, who came from a poor working-class background, was staying with his parents nearby. In later years both artists claimed that crusts from the Renoirs' table had saved the Monet family from starvation. The sumptuous *Still Life with Flowers and Fruits* (53) seem to show that they had grapes, if not bread.

53
Still Life with Flowers and Fruits,
1869.
Oil on canvas;
100×80·7 cm,
39³⁄₈×31³⁄₄ in.
J Paul Getty Museum, Malibu

Whatever the practical details, the close companionship was stimulating for both artists. Pooling their resources, both painted the same still-life subject and set up their easels together by the Seine. They chose a fashionable bathing-spot, 'La Grenouillère' – the frog-pond. La Grenouillère and its hordes of pleasure-seekers had already begun to interest painters and illustrators (55). It was an attractive subject;

it included fashionable dress, semi-nudity and modern life. It even had the imperial seal of approval – Napoleon III and the Empress Eugénie had visited during a trip down the Seine in early summer 1869. As with the pictures of Fontainebleau and Normandy, Monet was trying to impress not by depicting original subjects but by treating them in a startlingly unconventional manner. Although Monet's two surviving pictures of La Grenouillère are both sketches (the finished painting is lost, presumed destroyed), it is clear that he was starting to work in a manner which was strikingly different from even such recent works as *On the Bank of the Seine at Bennecourt*.

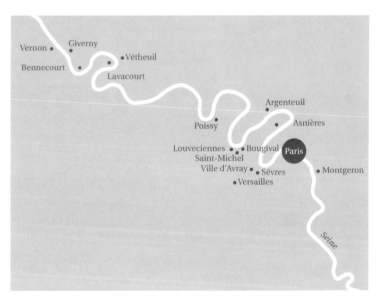

54
Map of the Seine basin showing the places where Monet lived and worked

55
Miranda,
La Grenouillère,
1869.
Engraving

Three clear changes of technique appear (56) in these pictures: the colours are sharper and stronger, the brushstrokes broader and the drawing is more abbreviated. The figures are treated in a cursory manner, as a series of squiggles and dots; seen at close quarters they look almost like stick-figures. A top-hatted gentleman stands on the plank that leads from the café to the central island, which was nicknamed the 'Camembert'. To the left swimmers can be seen bobbing in the water. Renoir's people are far more detailed; his picture is filled with incident and a delight in the liveliness of the scene that is quite absent from Monet's work (57). It is easy to see that the two artists' interests led in different directions; over the next few decades Monet

was to specialize in landscape, while Renoir never ceased to react to the human figure with pleasure and desire. At this point they were very close and the La Grenouillère paintings have been described as 'the essence of Impressionism' in their combination of modern-life scene and advanced technique. Monet's pictures are dominated by the water, the reflections of the trees and boats and the light skipping off the top of the wavelets. If we compare the smooth, continuous surface of *On the Bank of the Seine at Bennecourt*, painted one year earlier, with this multicoloured river dappled like a mackerel-skin, it is clear that the difference is due not to the weather or other

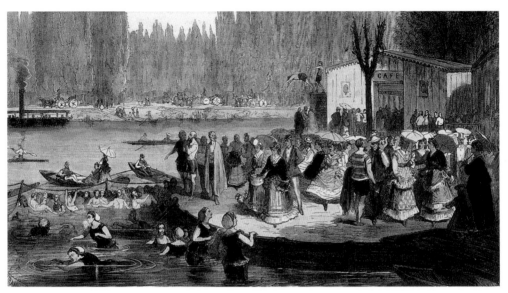

external forces but to a deepening of the artist's fascination with the fall of light. The problems he encountered with the *Déjeuner sur l'herbe* and *Women in the Garden* have been overcome and in these pictures, perhaps for the first time, the artist seems to have developed a technical freedom that allows him to convey fully his sense of the 'envelope', the physical quality of the atmosphere at a particular time. The surface of the water seems as solid as the banks; it is taking on a life of its own, something which was to become virtually a Monet trade mark in coming decades. Both the lost, finished work and the earlier *Luncheon* were rejected from the Salon the following May.

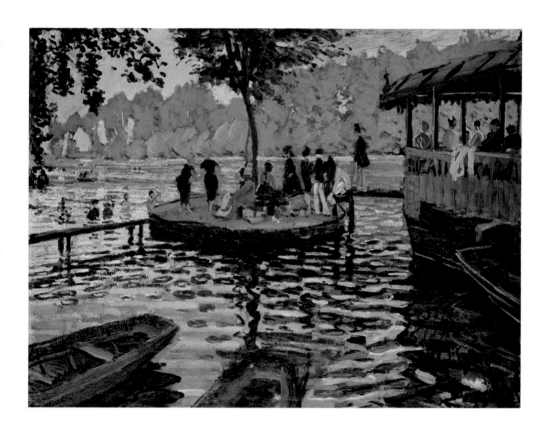

56
La Grenouillère,
1869.
Oil on canvas;
74·6×99·7 cm,
29⅜×39¼ in.
Metropolitan
Museum of
Art, New York

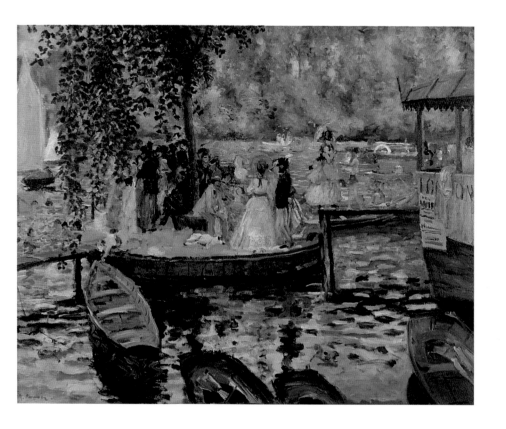

57
Pierre-
Auguste
Renoir,
La
Grenouillère,
1869.
Oil on canvas;
66 × 86 cm,
26 × 34 in.
National-
museum,
Stockholm

While Monet was deeply absorbed in his work political events were developing in a manner which was to threaten his livelihood and even his life. The imperial regime was weak; the Emperor was seriously ill and power had been dispersed among a number of factions. Squabbling, indecisive and deluded by memories of French military glories, the government was tempted to allay mounting domestic tensions with a quick little war. Lured into taking an offensive stance over the threat by the Prussian chancellor, Otto von Bismarck, to place a German prince on the vacant Spanish throne, France managed to find itself at loggerheads with the most efficient army in Europe – the Prussian. Trouble was brewing from early June

58
Trouville,
1878.
Engraving

59
The Hôtel des Roches-Noires,
1870.
Oil on canvas;
80×55 cm,
$31^1\!2 \times 21^5\!8$ in.
Musée
d'Orsay, Paris

1870 onwards and, as an ex-conscript, Monet was in danger of compulsory mobilization. Married men were called up last, and on 28 June he made Camille his wife (Courbet was a witness at the ceremony which took place in the town hall of the 8th arrondissement in Paris). The family then moved again, leaving Paris for the fashionable resort of Trouville on the Channel coast (58). This was a pleasant place to spend the holiday months and conveniently close to England should war break out. The newly legitimate family stayed in the Tivoli, a fairly cheap hotel off the seafront, and left without paying their bill. The Boudins joined them in Trouville, and both men painted beach scenes while their wives posed or sat on the sands.

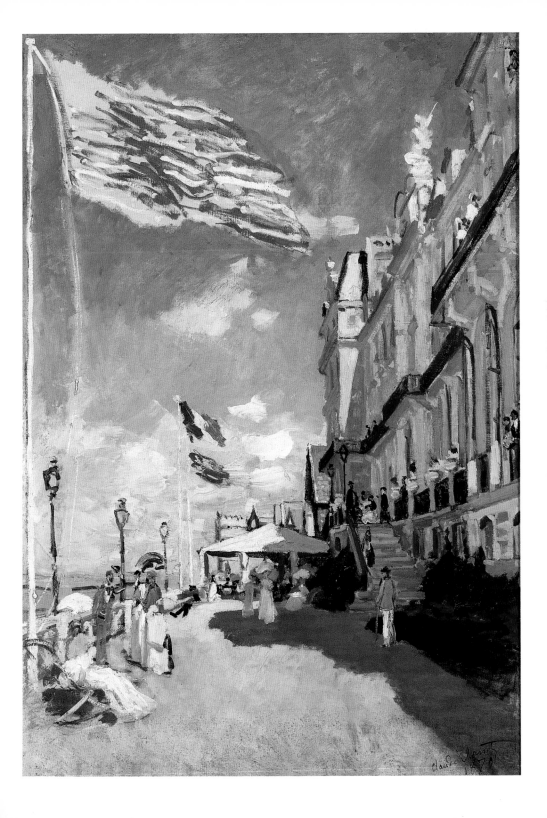

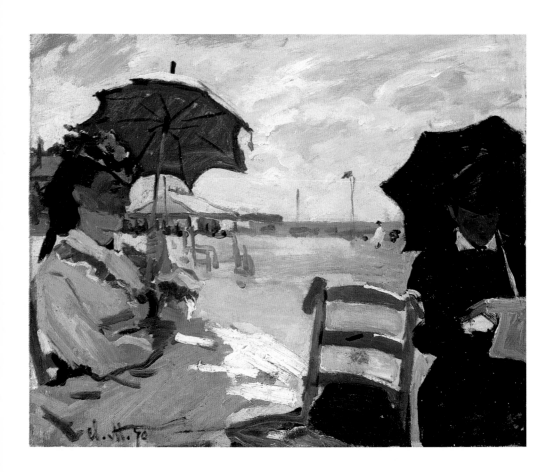

Monet produced nine pictures during this period. Some share the glamorous surroundings of fashionable Salon pieces, but their handling is astonishingly abrupt. The hotel building in one (59) is clearly recognizable – it was the grandest in Trouville – but the figures are as cursory as the bathers in *La Grenouillère*. All of them are faceless and some do not even have heads. The brilliance of the colouring, with the green lamps against a bright blue sky and the airy atmosphere of flags whipped by the wind, echo Boudin's irritable comment in a letter of 1867:

This beach at Trouville which used to be my delight now seems like a frightful masquerade. One would have to be a genius to make something of this bunch of do-nothing poseurs … fortunately the Creator has spread out everywhere his splendid and warming light, and it is less this society that we reproduce than the element which envelopes it.

Unlike Boudin's scenes, which tended to take a long view, with elegant promenaders dotted along the horizon, the 'enveloping element' is starting to outweigh the figures in Monet's painting. His pictures force the viewer into uncomfortably close proximity with the figures, and the poseurs have been made to pose by the skill of the caricaturist, seen at odd angles, cropped and expressionless. This blankness is repeated in a close-up of far more familiar faces in *The Beach at Trouville* (60), which is composed in an extraordinary fashion, with the two women framing a blank stretch of sand. The isolation of the figures in *Women in the Garden* is repeated – here mesdames Monet (in white) and Boudin (in black) seem to be ignoring each other. This picture is not simply without anecdote, it is unsettlingly empty. In the centre, placed between the two women, sits an empty chair – perhaps Jean Monet had been there earlier, as a single child's shoe hangs from the back.

Such cropped and apparently random images are sometimes described as 'snapshots' and attributed to the influence of photography. It is true that 'instantaneous' images had recently become

possible with technical improvements in cameras, but Monet's studied avoidance of compositional conventions was an essential aspect of his 'naturalism', his determination to depict his own experience without ordering it into a familar shape. The emphasis on open-air working was part of this insistence on the transmission of the artist's own experience, which in *The Beach at Trouville* is almost tangible; sand and fragments of shell can be seen embedded in the paint (61). Like the La Grenouillère sketches, it was clearly painted out-of-doors, but in this case the picture is signed and dated, which shows that the artist considered it finished. Even in terms of the *plein-air* attitude to landscape, these are astonishingly adventurous paintings; they flout all the conventions governing subject matter, composition, lighting and the distinction between preparatory sketch and finished work. Boldly composed and freely painted, they set the pattern for Monet's pictures of the next decade.

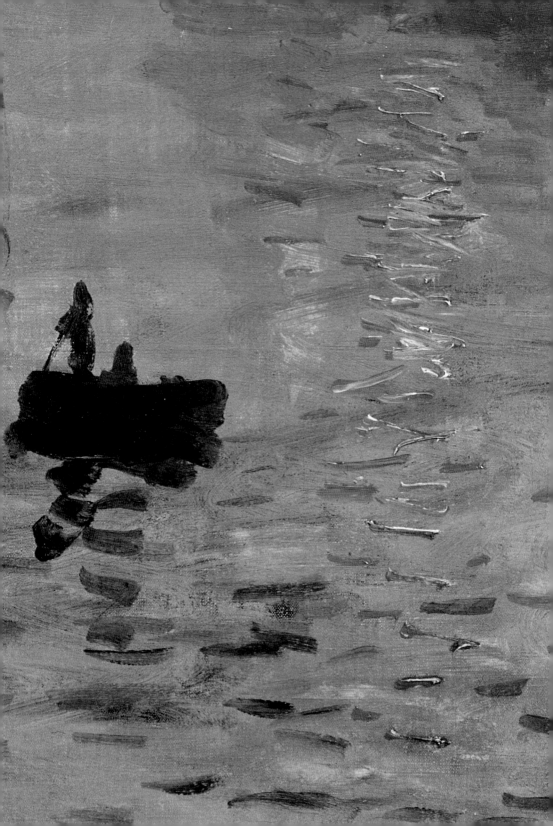

France declared war on Prussia on 19 July 1870. The conflict that followed marked a turning-point for France; the fall of the Second Empire and the birth of the Third Republic convulsed the established order, in art as in society as a whole. The collapse of the army was correctly seen as symptomatic of the rotten state of the imperial regime. Military defeat and partial occupation by Prussian troops left the country humiliated and disillusioned with its leaders, while the left-wing coup in Paris – the Commune – ended in bloody internal conflict leaving most people with little appetite for political activity. The court was gone and the capital, which had been badly damaged, lost its pre-eminent place. Suburban life began to develop, and postwar France was dominated by bourgeois businessmen rather than the imperial élite. Revulsion against the centralized, authoritarian rule of the old regime led to a general reaction against state control; a flourishing 'independent sector' began to develop in the postwar economy. The market for art adjusted accordingly, and Impressionism was able to emerge and even thrive in this new environment. Zola was to refer to 1870 as 'La Débâcle', the collapse. It marked a turning point for Monet, who managed to avoid direct experience of the war – unlike Bazille, who joined up and was killed in November.

Mobilization began in July. A string of French defeats in August culminated in early September with Napoleon III's capitulation at Sedan. The Second Empire fell and the Third Republic was proclaimed on 4 September. In the same month the Prussians laid siege to Paris. Trouville was far from the scene of war, but not far enough and, after hovering nervously on the coast, watching refugees embark at Le Havre, in the early autumn Monet crossed over to England. He took lodgings in London, while Camille was left to pack and follow. By December the family was reunited in rented rooms off Piccadilly Circus in the heart of the city. One of Monet's few

62
*Impression,
Sunrise*
(detail of 77)

paintings from this period, *Meditation, Madame Monet on the Sofa* (63), shows Camille reclining on a *chaise-longue* in a gloomy London interior. It is a strikingly intimate, small-scale work, very different from the sunlit outdoor scenes of the previous summer, and it is unusually meticulous in style. Unlike *The Beach at Trouville* (60), this could truly be seen as a portrait of Madame Monet. The famous London fogs, especially dense at that time of year, would have made prolonged posing out of doors most unappealing, and perhaps the legendary obscurity of the city's atmosphere in the winter months forced the artist to look closely at what was in front of his nose – after all, not much would have been visible beyond it. In 1918, discussing his experience of London with the picture-dealer René Gimpel,

63
Meditation, Madame Monet on the Sofa,
1871.
Oil on canvas;
48×75 cm,
18⁷⁸× 29¹₂ in.
Musée d'Orsay, Paris

64
Hyde Park, London,
c.1871.
Oil on canvas;
40·5×74 cm,
16× 29¹₈ in.
Rhode Island School of Design, Providence

Monet commented on the contrast between his manner of painting the city and that practised by contemporary English artists: 'How could the English artists of the nineteenth century have painted houses brick by brick? They painted bricks they couldn't see; they couldn't possibly have seen them!'

The city itself does not seem to have held much interest for Monet; as spring arrived he produced a couple of pictures of the parks (64) and three riverside scenes. Later in his life he was to return to London specifically to embark on a magnificent series of Thames views, but in 1870 he lacked either the time or the inclination to explore. The news from home was disquieting; the Prussians had rapidly overrun France, and during the siege of Paris many of the

small towns and villages nearby were occupied. Enemy soldiers were billeted in Pissarro's house at Louveciennes, where Monet had stored many of his canvases (Pissarro had also fled to England). For a while it looked as if Monet had lost virtually the whole of the previous year's work. In January 1871 an armistice was signed imposing humiliating terms and vast territorial losses on the French. Following this perceived failure of the right-wing government, Paris declared itself an autonomous republican commune on 18 March. The Paris Commune was short-lived, and its defeat by government troops in May was followed by reprisals that turned out to be far bloodier and more shocking to national self-esteem than the victory of the Prussians (65). For the exiles, news from Paris was unreliable and infrequent – balloons and carrier-pigeons were the only means of communication with the besieged city. It is hard to know about Monet's attitude to the turmoil in France, but the destruction of Paris must have distressed him. He rarely mentioned political events in his letters, although he wrote to Pissarro expressing horror at the (inaccurate) rumour that Courbet had been shot for his role in the Commune and at the behaviour of the Versailles government.

Although London was not an immediate source of artistic inspiration, the months spent there did turn out to be immensely important for Monet's career. The war had brought large numbers of Frenchmen across the Channel, and an émigré network soon sprang up. In addition to Monet and Pissarro, Daubigny had also decided to take refuge in London. Better established than Monet and Pissarro, he was able to introduce them to the picture dealer, Paul Durand-Ruel (1831–1922). Durand-Ruel had been one of the first dealers to invest in the Barbizon School. Having done well out of their gradual rise in popularity, he was now ready to look at the work of the younger painters who could be seen as their successors. Monet's work was, unsurprisingly, refused at the London equivalent of the Salon, the Royal Academy, but Durand-Ruel showed his pictures at his New Bond Street gallery in December, and after the return to France he became the artist's main source of support. In the 1920s Monet commented of the dealer, 'Without him, we would have all starved', and the accounts bear him out; in the coming decade Durand-Ruel

provided the household not only with bread and butter but also with fine wines, cigars and Parisian luxuries.

After the defeat of the Commune in the spring of 1871 the exiles began to drift back to Paris. Monet left England with his family in May but did not return directly to France, preferring to spend several months in Holland in the small town of Zaandam near Amsterdam. The length of his stay indicates the pleasure with which he tackled the flat, open countryside, the canals, and the local architecture. Boats and reflections in water had been his first serious subjects, and neither London nor Paris had provided quite the right combination

65
Communards Defending the Elysée Palace. Engraving in *Illustrated London News,* 3 June 1871

of elements. In Holland he settled down for a solid and satisfying painting campaign, producing twenty-four works in four months. A legacy from Monet's father, who had died in January, combined with Camille's income from teaching French, allowed the family a comfortable and relaxed life; in a letter to Pissarro, Monet claimed that Zaandam offered everything necessary for enjoyment.

The works produced during this prolific period are both more numerous and more adventurous than those from London. Pictures such as *A Windmill at Zaandam* (66), with its dappled water and

blocky shapes, may be the result not only of the diffuse, luminous light of the canal and seaside areas but also of a renewed interest in oriental art. Holland was a major centre for trade with the Far East, and Monet bought a set of blue-and-white plant-pots in The Hague, where he may also have acquired some of his Japanese prints.

Coming back to Paris must have been a depressing experience. *The Pont-Neuf* (67) was painted shortly after their return in November 1871. Sparse and simple in composition, with its rain-slicked pavements and its dabs of figures, the boldness of the picture may well be the result of looking at Japanese prints in Holland. It might also spring from the shock of seeing the devastation of the city which had been Monet's home for many years. The capital was shattered, physically and psychologically, and large areas of the centre were in ruins (68). The precision with which the parade of monuments is presented in *The Garden of the Princess* (see 45) of 1867 suggests a certain sense of civic pride; in *The Pont-Neuf* the scattered pedestrians scurry over the bridge, clutching their umbrellas against the wintry rain which blurs the houses in the background and gives the scene an anonymous dreariness. It was the only picture of Paris he painted that year, and he chose an area which had not been badly damaged by the siege.

An estimated 25,000 people had been killed or had disappeared during the 'bloody week' of government reprisals in late May, and the war between Frenchmen left profound scars. No longer the focus of national pride and aspirations, Paris was disowned by conservatives as 'un-French', and the new parliament was established at Versailles. The embellished Paris which had been the greatest achievement of Napoleon III had been badly damaged during the Prussian siege and the Commune and, as Monet quickly realized, it was no longer the place to be. Within a few months he followed the example of many of his fellow citizens and moved out of the capital to a small town nearby.

Argenteuil lay about 10 km (6 miles) to the northwest of Paris. For two hundred years it had been a peaceful rural town, producing wine, plaster and excellent asparagus for export to the capital. Under

66
A Windmill at Zaandam,
1871.
Oil on canvas;
48·5×73·5 cm,
19^18×29 in.
Collection of
The Earl of
Jersey

67
The Pont-Neuf,
1872.
Oil on canvas;
53·2×72·4 cm,
20^78×28^12 in.
Dallas
Museum
of Art

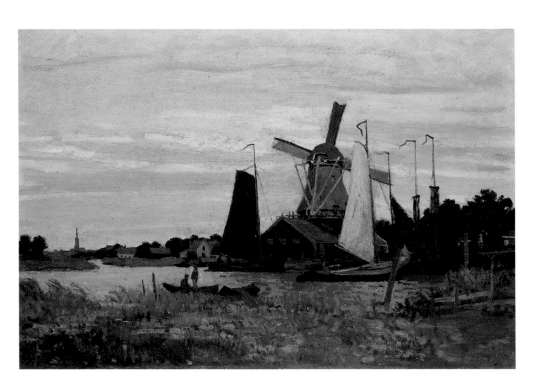

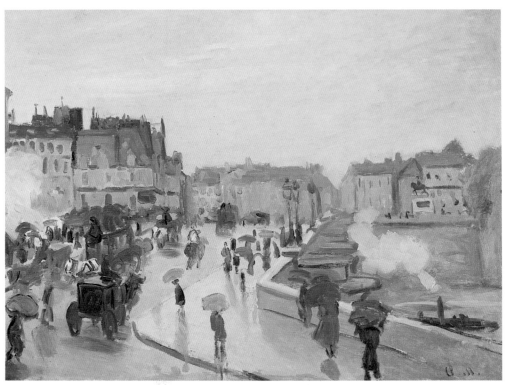

the Second Empire, it had begun to acquire industries; its position on the Seine facilitated the transport of goods. Monet probably knew the place already. It was on the main Paris–Le Havre line, and it seemed ideally situated for an artist who wished to retain contact with Paris without actually living there. More than that, the town itself was to prove a rich source of new subjects, presenting the opportunity to combine traditional rural scenes with the painting of contemporary life. These factors contributed to Argenteuil's important place in the development of Impressionism; although Monet was the only Impressionist to live there throughout the year, Manet and Gustave Caillebotte (1848–94) both had property nearby and Renoir and Sisley regularly visited to paint (71). Monet's enormous enthusiasm for

68
The Ruins of Paris: Porte Maillot and the Avenue de la Grande Armée. Engraving in *Illustrated London News*, 24 June 1871

69
Souvenir d'Argenteuil. Postcard

the place was clearly contagious, and its tourist-board sobriquet, 'The Cradle of Impressionism', is a reasonable one (69).

Monet's time in Argenteuil has been studied in great depth by Paul Tucker, who has argued very convincingly that the artist's interest in the town was closely bound up with its shifting status half-way between market town and industrial dormitory-suburb. In 1851 a railway station was opened, and access to Paris became simple and rapid. The journey took 15 minutes, once the railway bridge had been rebuilt after being destroyed by retreating French troops in 1870. The countryside offered a range of Monet's favourite subjects, as well as fresh material. Tucker suggests that such paintings as *Path in the*

Vineyards, Argenteuil (70) present the two sides of Argenteuil in the same coolly observant fashion. The composition can be seen as depicting a natural progression from agriculture to industry.

Factories were an extremely unusual subject for painters at this period, although they regularly appeared in illustrated journals and guidebooks, and it is possible that Monet was consciously selecting 'low art' subjects for 'high art' treatment. But there may have been other reasons, too; patriotism, and a guess at the taste of the new art-buying classes. In the years immediately following the war, factories had a particular national importance as evidence of France's ability to rebuild after the catastrophes of 1870–1. The Prussians had annexed the disputed eastern provinces of Alsace and Lorraine, the most industrialized areas of France. They had also stationed troops across the country and demanded a massive sum – five billion francs

– as the price for their total withdrawal from French territory. They had expected many years of profitable occupation; in fact, the entire sum was repaid within thirty months by public subscription to government bonds. This triumphant display of French resilience was made possible by the extreme rapidity of postwar reconstruction. It was the expansion of small industries, such as those centred in Argenteuil, that fuelled the postwar boom. Monet might reasonably have expected such factory subjects to sell to patriotic, liberal• patrons, and Durand-Ruel bought them for stock.

Monet had lived in eleven different places in the preceding nine years; Argenteuil was to be his first settled home and the location of some of his most memorable works. Although he was later to represent the 1870s as a period of great privation, in fact it was a highly successful decade, at least until around 1878. Comfortably

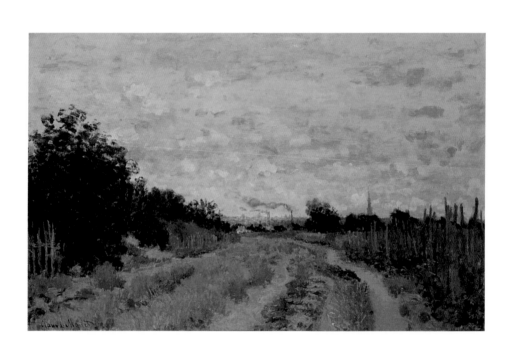

established in a substantial house with a maid, a nanny and a gardener, Monet was living the life of a suburban bourgeois (72, 73). It clearly suited him; his letters of the period show that he was confident about his work and happy in his first real home, even though the habits of the 1860s died hard and he regularly pestered all his correspondents with requests for loans. It is not easy to understand how he contrived to be permanently in debt, even during this prosperous period. Within two years of moving to Argenteuil his income was more than double that of Parisian professionals and over

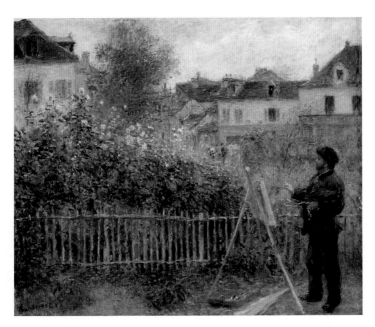

70
Path in the Vineyards, Argenteuil,
1872.
Oil on canvas;
48·3×74·9 cm,
19×29½ in.
Private collection

71
Pierre-Auguste Renoir,
Monet Painting in his Argenteuil Garden,
1873.
Oil on canvas;
50·3×106·7 cm,
19¾×42 in.
Wadsworth Atheneum, Hartford

the six years that he lived in the town he averaged 14,000 francs a year. He lived well and managed to spend everything he earned, so that when hard times came again he was utterly unprepared.

Monet's prosperity during the 1870s can be ascribed to a number of factors. First, his work had matured; the Argenteuil paintings are strikingly confident and technically innovative. The oddities and awkwardness that can be seen in some of his work from the 1860s had disappeared almost entirely. Argenteuil provided constant stimulation; he did not need to search for places to paint. However, all this would have been irrelevant without his dealer Durand-Ruel.

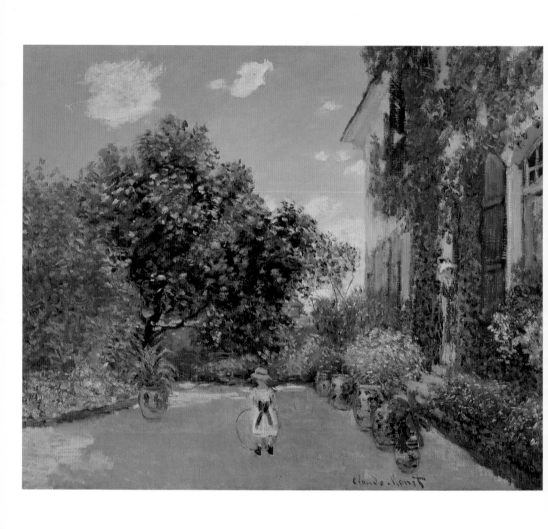

Throughout the 1860s Monet had devoted an inordinate effort to the pictures he hoped to hang at the Salon. These works, large and elaborate figure-scenes for the most part, were uncharacteristic of his output. Private buyers, and hence dealers, preferred smaller, less formal paintings; and since Durand-Ruel was prepared to buy in bulk, the artist was relieved of the necessity of looking for buyers. He could concentrate on smaller pictures, painting more of them, and experimenting more freely. While individual works may seem less bold than the extraordinary set pieces of 1865–70, collectively they amount to a reworking of the idea of landscape painting.

72
The Artist's House at Argenteuil, 1873.
Oil on canvas; 60·2×73·3 cm, 23³⁄₄× 28⁷⁄₈ in. The Art Institute of Chicago

Throughout the 1870s Durand-Ruel bought far more than he sold, amassing pictures for stock. Effectively, he was advancing considerable sums to Monet without realizing very much in the short term. It was a gamble which paid off eventually, but it required faith and courage on the dealer's part. Monet's relations with his patrons and dealers were typical of the fragmentation of the market with the demise of the Salon monopoly. This opened the way to men like Durand-Ruel, professional picture sellers, who supplanted the old colour-merchants who had stocked a few paintings for sale at low prices. The new breed of dealers had high overheads, as they needed sumptuous premises in fashionable districts, and had to carry enough stock to cater for sudden fluctuations in taste. The importance of the dealer as middleman was typical of the 'get rich quick' atmosphere of postwar Paris. The need to raise capital for rebuilding had resulted in a fever of speculation, and pictures profited from the rise in conspicuous consumption. Durand-Ruel and his rivals sold luxury goods, greatly in demand in the boom climate of the immediate postwar period. They functioned on borrowed money, and, like the stockbrokers and bankers who were among their clients and backers, they frequently underwent booms and bankruptcies.

73
A Greiner, Claude and Camille Monet, 1871

In 1873 Durand-Ruel's business crashed – temporarily, as it turned out – but the sudden end to his buying forced Monet to explore alternative markets. Although he had some steady private patrons in the mid-1870s – the opera singer Jean-Baptiste Faure and the homoeopathic physician Georges de Bellio were among the enthusiasts who

acquired considerable numbers of his pictures – Monet's work was difficult to sell directly. He needed more public exposure, and the idea of an independent exhibition arose once again.

Monet and his associates had first considered a group show in 1867, after they had all been rejected by the Salon. The idea simmered over the next couple of years; in 1869 Bazille wrote to his parents describing his plans to set up a group show with 'a few talented people'. 'We will invite any painter who wishes to send us work. Courbet, Corot, Diaz, Daubigny and many others … have promised to send us paintings and highly approve of our idea. With these people, and Monet, the best of all of them, we are certain of success.' Before the war it had proved impossible to raise the money, but by the early 1870s many of the young artists were doing better, and in the changed climate of the Third Republic an independent exhibition stood more chance of success. While the government was precarious and terrified, after the Commune, by anything that smacked of dissent, the demise of the old order encouraged a much more open attitude among the public. Paradoxically, while the Salons were more restrictive than ever before, the split between Academic doctrines and contemporary taste was openly acknowledged. Jane Mayo Roos has studied the relationship between the Impressionists and the Salon in great detail, demonstrating that even the postwar Director of Fine Arts, Charles Blanc, recognized the need to distinguish between the 'shop' and 'museum' aspects of the Salon. In 1872 he officially invited artists to organize an alternative show in order to sell their paintings, writing 'As for an exhibition designed to attract buyers, that is a matter which could fittingly be left up to the initiative of the artists, privately or collectively.' He even suggested that the government could assist by lending them a space in which to set up such a commercial venture. As the Salon itself became narrower, losing the catch-all quality of the 1860s, so the rationale for independent exhibitions became increasingly clear to artists and the public.

Indeed, independence from the discredited old order could work in the artist's favour, helping to transform the rebels of the 1860s into the fashionable darlings of the 1870s. To have been rejected from

the imperial Salon was almost an advantage for artists like Monet, who were seen as untainted. The novelty of their style and their interest in contemporary life – the middle-class world of factories, commuter trains and Sundays on the river – could attract the rising class of financiers, industrialists and liberal politicians who were rebuilding France.

The move to set up an independent forum for artists was perceived in many quarters as a blow for freedom, fresh air and pluralism. First mooted in the spring of 1873, the 'Anonymous Society of Artist–painters, Sculptors, Engravers, etc.' was founded in December that year. The core group of artists and organizers comprised Monet, Pissarro, Renoir, Sisley, Degas and Berthe Morisot (1841–95). Even within this small group there were personal tensions and strong disagreements about the intentions of the Society, but the collective advantages outweighed the problems. The aims of the Society had been published in the columns of an art-world newspaper, the *Chronique des Arts*:

A co-operative public company, with variable personnel and capital, has been formed by artist–painters, sculptors, engravers and lithographers, for a period of ten years, beginning on the said 27 December, and having for its object: (1) the organization of free exhibitions, without jury or honorary awards, where each one of the associates can show their works; (2) the sale of the said works; (3) the publication, as soon as possible, of a magazine exclusively related to the arts.

There was little in this to frighten the establishment. Pissarro had strongly left-wing views and he had tried to give the declaration a more overtly political slant, but he was voted down. The blandness of both the declaration and the name of the group were deliberate; the painters wished to avoid a collective pigeon-hole. Other artists were invited to participate, and the total number of exhibitors rose to thirty.

When the First Exhibition of the Society of Painters, Sculptors and Engravers (now usually referred to as the first Impressionist exhibition) opened on 15 April 1874 it was met with interest. It had been

publicized in advance and timed to open two weeks before the Salon to ensure plenty of press coverage. Housed in the borrowed studio of the photographer Nadar (Gaspard Félix Tournachon, 1820–1910) on the fashionable boulevard des Capucines, the exhibition was designed to make a splash in the new Paris (74). Its contemporaneity was underlined by one of the exhibits, Monet's *Boulevard des Capucines* (76). Probably painted on the premises shortly before the show opened, it shows the boulevard, complete with top-hatted dandy leaning from a balcony window to observe the passing crowds. The audience must have felt that they could scarcely be more up-to-date (75) – a point made by the critic Ernest Chesneau, who wrote of this picture that Monet had captured, for the first time,

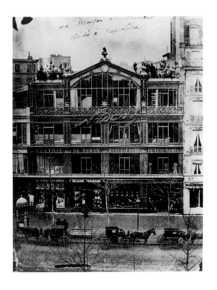

74
Nadar,
35 boulevard
des Capucines,
c.1861

the extraordinary animation of the public highway, the milling of the crowd on the pavement and of vehicles on the road, the trees lining the boulevard swaying in the light and the dust … [never before] has the ungraspable, the fleeting, the instant of movement, been seized and fixed in its astonishing fluidity, as it is in this extraordinary, this marvellous sketch.

Chesneau used the word *ébauche*, translated here as 'sketch'. The precise English term is 'lay-in', the technical name for the first stage of a traditionally painted canvas, and the state of the picture's finish

was raised by other critics. Because of the rather inclusive approach of the committee in charge, however, there were also enough works by conventional painters to ensure that most visitors could find something to their taste. In addition to the works of Monet, Renoir, Pissarro, Sisley, Degas, Morisot, Paul Cézanne (1839–1906) and Boudin, pictures by more conservative artists softened the impact of the new painting. This was deliberate; Degas had been especially eager to show a variety of work to avoid the appearance of a narrow faction. There were over two hundred items in all, including sculptures and, the number of visitors reached 3,500 – a respectable total, though tiny when compared to the size of the Salon audiences.

The two exhibitions charged the same entrance fee – one franc – but there the resemblance ended. The 1874 Salon was exceptionally conservative. Restricted to narrowly patriotic subjects in the grand manner, it contained no genre painting and few landscapes or portraits. It was overcrowded, chaotic and old-fashioned. By contrast, the show at Nadar's was carefully hung, with a generous amount of space allotted to each artist and works placed together in complementary groups.

The history of Impressionism has often been described as a titanic struggle of talented artists against a blindly conventional art world, and accounts of this first exhibition of 1874 have tended to sound as if the reaction of the press and public was unremittingly hostile. In fact this was not the case; the concept of an independent show organized by artists was widely welcomed and, although it made a small loss financially, it was moderately successful in terms of attendance. The general tenor of the reviews was positive if mistrustful, and even reviewers who disliked many of the pictures seem to have shared the feelings of Léon de Lora, writing in *Le Gaulois*: 'Their efforts deserve to be encouraged.' Some public criticism was more pointed, and the association between artistic daring and political radicalism was hinted at in several reviews. The founders of the group were called 'rebels', 'insurgents' and 'intransigents' – all terms which were loaded with meaning in a frail Third Republic, not long after the conclusion of a vicious civil war. The style of the pictures, and the manner of

their exhibition, without jury or medals, did constitute a challenge to tradition, authority and the status quo.

Although the Society had a deficit after the exhibition and was consequently wound up, the interest aroused by the first show encouraged the artists to organize independent group exhibitions seven times in the next twelve years. Monet did well out of the press coverage; he was generally recognized as the quintessential representative of the new movement. It was fitting, therefore, that one of his pictures, *Impression, Sunrise* (62 and 77), should provide the label which was gradually accepted by the majority of the painters in the group.

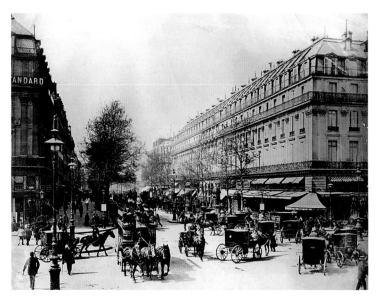

75
Boulevard des
Capucines,
Paris, 1880s

76
*Boulevard des
Capucines*,
1873.
Oil on canvas;
61×80 cm,
24×31¹⁄₂ in.
Pushkin
Museum of
Fine Arts,
Moscow

This painting of the port of Le Havre was probably given its title in a moment of exasperation: Renoir's brother Edmond was editing the catalogue, and when he drew Monet's attention to the monotony of his titles – *View of a Village*, with variations – Monet is said to have replied, 'Why don't you just call them "impression"?' The word was widely used by the artists and their defenders, and it was not a random choice; many reviewers, such as Castagnary, the advocate of Realism, saw it as central to the intentions of the group.

If one wants to characterize them with a single word that defines their efforts, then one would have to create the new term of *Impressionist*.

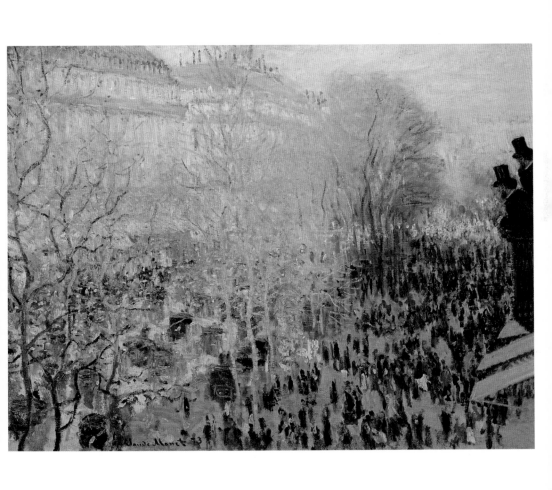

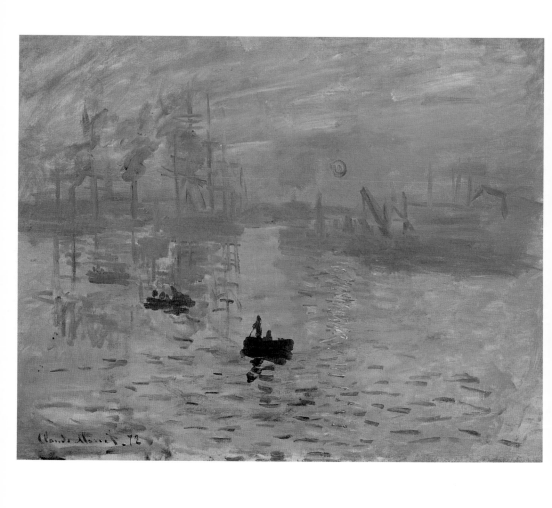

They are impressionists in the sense that they render not a landscape but the sensation produced by a landscape.

These artists were painting what they saw, not what they knew was there; perception, not appearance.

This notion of truth to personal experience, and the associated belief in the freshness of this new look at nature, were central both to the idea of 'Impressionism' and the work of Monet. Monet commented of *Impression, Sunrise*, 'It really can't pass as a view of Le Havre'; in this, as John House has shown, he was distinguishing it from other paintings of his, such as *Fishing Boats Leaving the Port of Le Havre* (78), shown in the same exhibition. While the clear grey light of the fishing scene illuminates every part of this canvas, *Impression, Sunrise* does not really reveal anything; major landmarks are obscured by mist, and the picture is dominated by the scarlet disc of the sun against the cool, damp veils of grey. The artist is interested in the colour of the air, not the topography of the harbour. Of course this is also true of *Le Havre*, in which the brilliant puddles of water on the quayside are captured in striking detail and contrasted with the reflections of the masts on the choppy sea and the smoke rising into the sky. All three areas – water, reflections and smoke – remain distinct, whereas in *Impression, Sunrise* they blend together, the horizon vanishing into coloured mist. The ability to capture changing effects of light was to become increasingly important to Monet over the next fifty years, and this particular work has become a symbol of the Impressionist movement, not only because of its title but also because of the way in which Monet's later work seems to be hatching within it.

The idea of the 'impression' as a distinct type of scene was made explicit in Monet's use of the word in titles. All the pictures called 'Impression' share the same hazy light, a light in which form dissolves and melts away. The 'Impression' was therefore a specific category of subject, essentially internal and individual, representing not a place but an experience of a place. The word has also come to be used by extension as a label for a style which rejected the prevailing notion of 'finish'. By exhibiting pictures which had been started (rarely completed) out-of-doors, Monet and his colleagues were

77
Impression, Sunrise, 1872.
Oil on canvas; 48×63 cm, 18^7⁄$_8$×24^7⁄$_8$ in.
Musée Marmottan, Paris

blurring the distinction between a sketch, an essentially preparatory work, and a 'picture' – something thought out, planned and produced in a studio. This did not mean, however, that Monet saw the distinction as unimportant – on the contrary, he was careful to emphasize that certain exhibited works were to be seen as sketches.

There had always been a connoisseur's market for sketches, but exhibiting and selling 'Impressions' was a new move. The bourgeois patrons who bought his work through Durand-Ruel preferred pictures which were comparatively clear and detailed; the art world insiders who bought directly from the painter preferred sketches, which were usually cheaper. In periods when Durand-Ruel was not buying, Monet sold more sketches and 'impressions', often for very

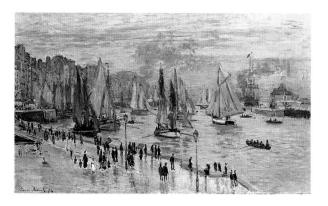

78
*Fishing Boats
Leaving the
Port of Le
Havre,*
1874.
Oil on canvas;
60×101 cm,
23^5⁄$_8$×39^3⁄$_4$ in.
Los Angeles
County
Museum of Art

79
*The Studio
Boat,*
1876.
Oil on canvas;
54×65 cm,
21^1⁄$_4$×25^5⁄$_8$ in.
Musée d'Art et
d'Histoire,
Neuchâtel

low prices. The pressure to produce saleable work at a rapid pace affected the quality of his output and led to criticism even from supporters as well disposed as Zola. From Monet's point of view, therefore, 'Impressions' can be seen as a neat solution to a practical problem, but their appeal to the audience cannot be accounted for so simply. There was also something in the notion of a 'seized instant' that intrigued the public of the 1870s, a period in which rapid change and instability were felt to be omnipresent.

France in the 1870s was a society in the process of rebuilding itself, and the excitement generated by that feeling of newness and change, the thrill of the transient moment seized even as it vanishes, is integral to Monet's work during this critical decade. The 'Impressions'

capture the essence of an era of exceptionally fast development. Monet's pictures of Argenteuil celebrate evanescent effects and the process of change, both natural and man-made. He painted the fields in frost and sunshine and the new housing estates at their edge with the same pleasure and excitement.

During the 1860s and 1870s Argenteuil was both an industrial zone and the centre of the new Sunday pastime – boating. Ideally situated in a deep basin of the Seine close to Paris, it was the site of regular regattas. Monet painted the factories, railways and commercial

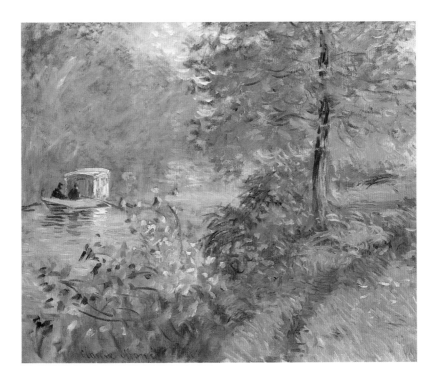

traffic on the river, but he seems to have been most attracted by water and boating for pleasure. As a native of Le Havre, the town which had introduced yachting to France, he clearly felt an affinity with life on the river, and as soon as possible he bought and converted a small boat which became a floating studio (79). Bobbing about on the river, enveloped in the light reflected off the water, he was able to observe the scene with great precision and with the eye of a participant, not an onlooker.

Open-air observation had long been practised by painters, both in France and abroad. The English artist J M W Turner (1775–1851), whose works Monet had studied at the National Gallery in London, once claimed to have been lashed to the mast while painting a ship in a storm. This famous story is a fabrication, but it was eagerly seized upon by people who felt that the artist's direct experience of the storm guaranteed the truth of his depiction – as if it were necessary to suffer physically in order to produce 'real' art. The Impressionist emphasis on direct work in front of the motif was one of the elements that encouraged early critics to describe their work as 'Realist'. *Plein-air* landscape painting offered many opportunities for heroic discomfort, and numbers of stories are told about Monet painting snow-scenes while icicles formed in his beard or risking death by painting the incoming tide on a beach cut off by cliffs. Many of these anecdotes originated with the artist himself; a canny self-publicist, he realized that the idea of the direct and unmediated 'impression' was reinforced by the image of the artist as a part of nature, reacting instinctively to the scene before him. However, the same kind of stories are told about artists whose style could scarcely be less like that of the Impressionists. The Pre-Raphaelites, working in England during the mid-nineteenth century, used the same type of anecdote to validate the 'truth to nature' of their microscopic, hyper-realist paintings. Outdoor work, therefore, did not dictate the visible brushstrokes and broad treatment of the Impressionist landscape, but the combination came to be seen as evidence of the artist's immediate and genuine response to the scene before him.

While Monet often claimed to work entirely out-of-doors, and most images of him painting emphasize the *plein-air* element of his work, nearly all of his pictures were finished in the studio. There is nothing surprising in this – after all, they were not intended to hang outside and at the very least they would need to be checked in the dimmer light of a room. The notion of fixing an 'impression' is thus paradoxi-cal; a good analogy is that of a butterfly-hunter, who takes his catch indoors to preserve it at its moment of greatest beauty. Monet was always keen to emphasize the idea of the intrepid stalker of new beauties, but less eager to admit to the process of preservation.

80
The Railway Bridge, Argenteuil,
1874.
Oil on canvas;
55·2×73·3 cm,
21³⁄₄× 28⁷⁄₈ in.
Philadelphia Museum of Art

Monet's work developed during the years at Argenteuil. By the end of the decade the characteristics of this 'new painting' had been established: a stress on outdoor work, modern-life subjects and a broad style implying a rapidity of execution that seemed in tune with the rapid changes observed in the subject, whether it was glancing effects of light on a snow-covered field or the constant flow and flux of strollers passing along a busy boulevard. It was during this period that Monet became the acknowledged leader of the Impressionist movement. In 1878 Théodore Duret, a critic friendly to the Impressionists, wrote in his pamphlet *The Impressionist Painters*:

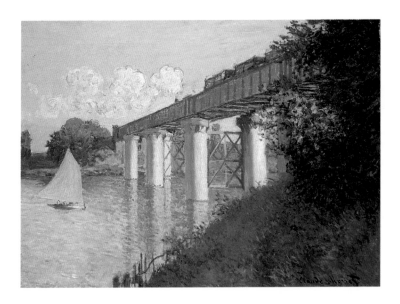

If the word Impressionist was … accepted to designate a group of painters, it is certainly the peculiar quality of Claude Monet's painting which first suggested it. Monet is the Impressionist artist *par excellence* … No longer painting merely the immobile and permanent aspect of a landscape, but also the fleeting appearances which the accidents of atmosphere present to him, Monet transmits a singularly lively and striking sensation of the observed scene. His canvases really do communicate impressions.

The initial move to Argenteuil produced a rush of work, and from 1872 to 1876 Monet was exceptionally prolific, painting on average a picture a week. The dual theme of train and river, modernity and

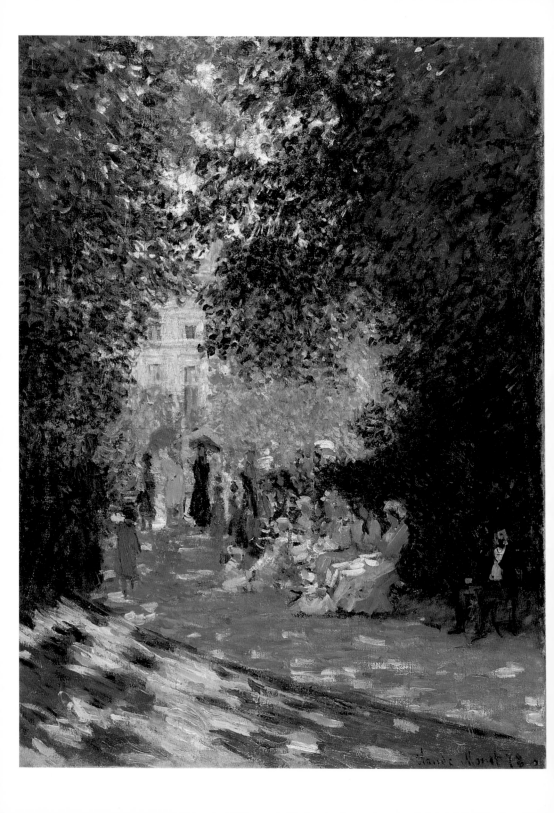

tradition, is represented in many paintings; among them *The Railway Bridge, Argenteuil* (80), in which the train rushes past the sailing-boat in a manner reminiscent of Turner's *Rain, Steam, and Speed*. The rebuilt railway bridge especially fascinated Monet; he painted it repeatedly, always with a train passing over it – a nicely evident contradiction of the idea of instantaneity, since after all the service did not run in a continuous loop.

After an immensely productive four years, by 1876 Monet's attention was starting to wander. That year he began to paint Paris again, producing a series of images strikingly different from those of the pre-war years. Instead of the busy boulevards and Seine bridges at the heart of the city, Monet turned to the parks, especially the recently completed Parc Monceau in the 8th arrondissement (81). This park was often described as 'English' in character, and it is still less formal than the open spaces of central Paris. Monet stressed the secluded atmosphere of the tree-fringed walks and the lawns with clumps of flowering bushes. The balance between figures and setting is clearly tilting back towards landscape; the figures are simply 'staffage', put in to adorn the blossoming alleys that are the real focus of the picture.

81
The Parc Monceau,
1878.
Oil on canvas;
72·7×54·5 cm,
28⁵⁸× 21³⁸ in.
Metropolitan
Museum of
Art, New York

At the same time, his Argenteuil subjects shifted from the public spaces of the river and the town to his own garden or the surrounding fields. Monet's paintings became increasingly enclosed and detached, showing scenes of women and children in sun-dappled gardens. These sold to private collectors, but the prices fetched were low, and an auction of work in March 1875 produced disappointing results. It was partly in the hope of widening his market that Monet prepared his entry for the second Impressionist exhibition in April 1876.

Held at Durand-Ruel's premises in the rue Le Peletier, this show was more selective than that of 1874. There was more serious critical discussion, with the writer Edmond Duranty publishing an essay entitled 'The New Painting', and both Zola and the poet Stéphane Mallarmé (1842–98) writing lengthy reviews. The association with subversive politics that had affected reception of the exhibition in

1874 continued, and Mallarmé made it explicit in his essay *The Impressionists and Édouard Manet*, which was published in England – possibly to avoid censorship. Mallarmé summed up the relationship between 'class struggle' and recent developments in art:

The participation of a hitherto ignored people in the political life of France is a social fact that will honour the whole of the close of the nineteenth century. A parallel is found in artistic matters, the way being prepared by an evolution which the public with rare prescience dubbed from its first appearance, Intransigent, which in political language means radical and democratic.

Only nineteen artists participated in the second group exhibition, and their works were hung in separate sections like a series of small-scale one-man shows. This encouraged them to demonstrate their range, and Monet selected his pictures very carefully. He chose a mixture of size and subjects, including small landscapes and one large single figure, which attracted a great deal of attention. *La Japonaise* (82), posed by Camille, is a perplexing picture; in some ways it is a deliberate return to the kind of Salon slickness he had practised with an earlier full-length, the 1866 *Camille* (see 33). It seems probable that he was trying to attract a more conventional (and free-spending) type of patron. *La Japonaise* did not sell at the exhibition, but the same month it was successfully auctioned for 2,010 francs. As before, the exhibition created public interest which took some time to bear fruit.

By 1876 Monet's situation at Argenteuil was less idyllic than it had been in the early days. He had burdened himself with debts, Camille was seriously ill and the town itself was losing its charm as the pace of development hastened. In 1877 he returned to Paris to paint his most resolutely contemporary subjects. The twelve paintings of the Gare Saint-Lazare, completed between January and April, depict a location which was virtually synonymous with modernity. Not only was the train itself the great image of contemporary technical achievement, but the station he chose was also new – it had been one of the last of the imperial improvements. Monet passed through it regularly as it was the Paris terminal of the Argenteuil line, and for

82
*La Japonaise
(Camille
Monet in
Japanese
Costume)*,
1876.
Oil on canvas;
231·6×142·3 cm,
91¹⁄₄×56 in.
Museum of
Fine Arts,
Boston

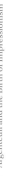

most of the decade he had had a base nearby. Until 1874 he worked in

a studio a stone's throw away in rue d'Isly, and in 1877–8 Caillebotte

paid for him to use an apartment slightly further away in rue

Moncey. Saint-Lazare would thus have been as familiar a subject,

in its way, as the bridges at Argenteuil, and the manner in which he

painted the station shows the same increasing interest in effects of

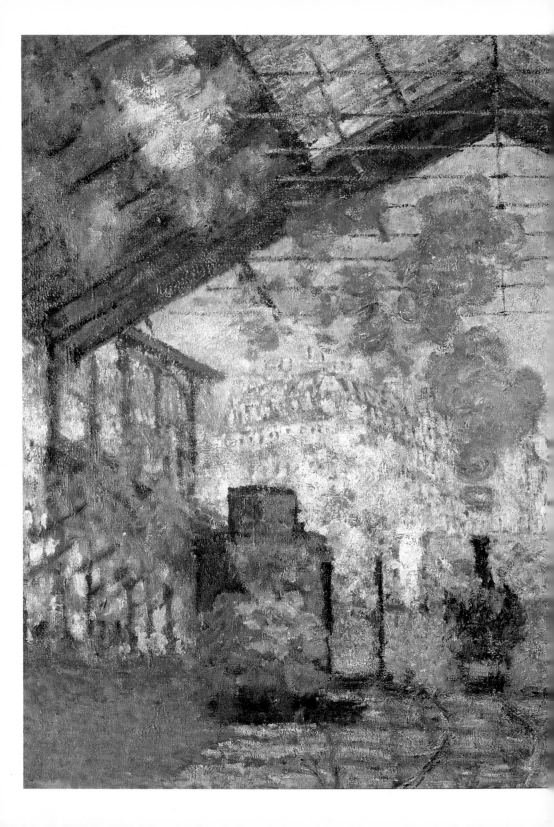

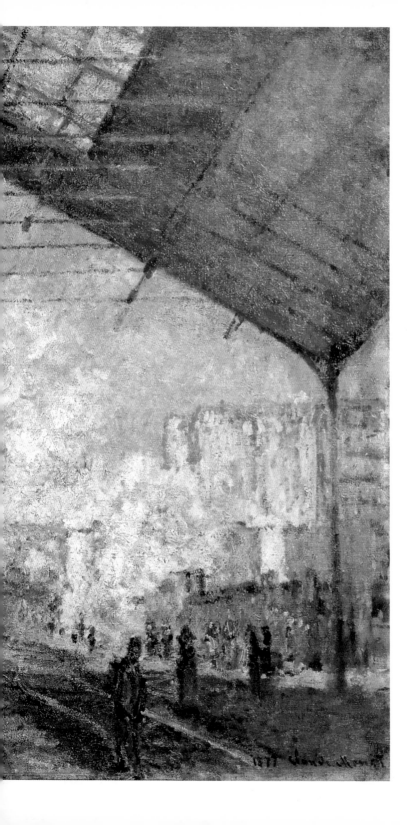

83
*The Gare
Saint-Lazare*,
1877.
Oil on canvas;
75×100 cm,
29$\frac{1}{2}$×39$\frac{3}{8}$ in.
Musée
d'Orsay, Paris

light and atmosphere rather than visual information (83).

Much of the painting was actually done in the station precincts. Many years later Renoir recounted Monet's lordly appearance in the stationmaster's office:

He put on his best clothes, ruffled the lace at his wrists, and twirling his gold-headed cane went off to the office of the Western Railway, where he sent in his card to the director … He announced the purpose of his visit. 'I have decided to paint your station. For some time I've been hesitating between your station and the Gare du Nord, but I think yours has more character.' He was given permission to do what he wanted. The trains were all halted; the platforms were cleared; the engines were crammed with coal so as to give out all the smoke Monet desired. Monet established himself in the station as a tyrant and painted amid respectful awe. He finally departed with a half-dozen or so pictures, while the entire personnel, the Director of the Company at their head, bowed him out.

This account is highly embellished and not very reliable – apart from anything else the number of paintings produced has been halved – but it does give some indication of Monet's demeanour and of his unquestioned position as the leader of the Impressionists. Even Renoir, the only artist with whom he used the familiar '*tu*', was staggered by his audacity and concluded 'I wouldn't have even dared to paint in the front window of the corner grocer!'

The paintings are a tour of the station. Sometimes described as the first of Monet's series, they are really more like a set of tourist views of the kind he was to paint in the 1880s – appropriately opening with a good look at the point of departure itself. The twelve Saint-Lazare paintings differ in size, style and viewpoint, in contrast to the series pictures which typically present a single motif under different atmospheric conditions. Like the series paintings, however, these images of a busy station are short on human presence and long on coloured mists. Monet concentrated on what interested him, and here it was emphatically the diaphanous clouds of steam emerging from the funnels of the locomotives and drifting upwards in cold air

of the glass-roofed station. The English writer and artist George Moore vividly described them as 'piercingly personal … rapid sensations of steel and vapour'. The figures seem ghostly and schematic, not unlike the view from the window of a train as it rushes past the platform. This could plausibly be considered the quintessentially modern viewpoint. Reviewing the eight Saint-Lazare scenes shown at the third Impressionist exhibition in April 1877, Zola declared:

Monsieur Claude Monet is the most marked personality of the group. This year he is exhibiting some superb station interiors. One can hear the rumble of the trains surging forward, see the torrents of smoke winding through vast engine sheds. This is the painting of today; modern scenes beautiful in their scope. Our artists must find the poetry of railway stations, as our fathers found the poetry of forests and rivers.

Ironically this was to be Monet's last substantial set of urban scenes; after the Gare Saint-Lazare he largely rejected modern France as a subject, returning to 'forests and rivers' for inspiration.

The third Impressionist exhibition was the first to bear that name officially. The original unwieldy group had slimmed down to eighteen artists and, with fewer of the more traditional painters who had contributed works in 1874, their show seemed more unified. Monet's contribution of thirty paintings was very different from the previous year's showing; there were fewer river scenes and over half the pictures showed subjects which were decidedly modern. The Saint-Lazare paintings were the centrepiece. They were the first set of Monet's works conceived and executed to have a cumulative effect, and this seems to have been understood by some of those who were already in sympathy with the artist; two recent patrons bought three each.

As always, Monet planned the exhibition carefully and with an eye to displaying his versatility. He presented a number of works intended to contrast with the urban feel of the station paintings, including the large picture of *Turkeys* (84). Subtitled 'unfinished decorative panel', this picture was one of four that had been commissioned by Ernest

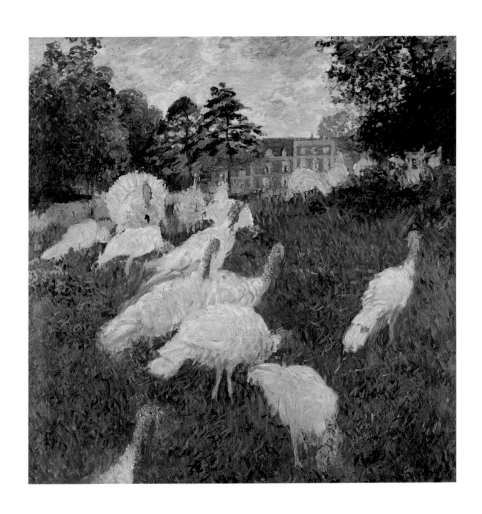

Hoschedé, who also purchased three of the Saint-Lazare paintings. The idea of decorative paintings, which was to become an important element of Monet's work in the next decade, can be seen in both the Saint-Lazare pictures and these works for Hoschedé.

The idea of fashionable art as interior decoration was fostered by both independent exhibitions and dealers' premises. Dealers could offer clients a range of works and they could also encourage patrons to buy the work of new artists or to experiment with different styles. Pictures could be borrowed for a few days, or they could be rented and exchanged on a regular basis. Changing your pictures with your wallpaper implied that paintings were no longer seen as important symbolic statements of political allegiance or dynastic loyalties, but primarily as beautiful objects – 'decorative panels'.

84
Turkeys,
1876.
Oil on canvas;
172×175 cm,
67³⁄₄×69 in.
Musée
d'Orsay, Paris

Monet's work for Hoschedé was the continuation of the eighteenth-century tradition of decorative painting for châteaux, but it marked a new departure for him in both artistic and personal terms. During 1876–7 Monet had spent extended periods in Paris and also at the Château de Rottembourg in Montgeron on the outskirts of Paris, the home of this important new acquaintance. Ernest Hoschedé was immensely rich; he was the owner of one of the great new department stores which were currently transforming the experience of shopping in Paris. Setting an example to his customers, he bought avidly and constantly. Art was his great passion, and the eventual collapse of his enterprise was at least partially due to the fact that his interest in Impressionist painting was greater than his interest in the business. He collected pictures by all the members of the group, changing them often; a sale of works weeded out of his holdings in early 1873 fetched record prices for several artists and encouraged the Impressionists to pursue their plans for an independent show. A man of the new order, a cultivated businessman with a taste for amassing art in large quantities, Hoschedé was in many ways typical of those buyers who preferred to avoid the Salon. The new social fluidity of the Third Republic is suggested by the manner in which this wealthy entrepreneur associated with the relatively impecunious painter. Monet was invited to the family château and treated as

a friend rather than a hired craftsman. After acquiring numerous Monets off the peg, including *Impression, Sunrise*, for which he had paid 800 francs in 1874, in the autumn of 1876 Hoschedé asked him to produce four panels specifically for a room in the château; *Turkeys* was one. These pictures show different aspects of the estate – traditional themes for such works, here treated with startling newness. *Turkeys* places the viewer low down on the grass, among the flock of life-size birds. At the bottom left the picture is daringly cropped as the scrawny neck of another bird intrudes, strolling across the lawn like a rather pompous garden-party guest. The asymmetrical composition gives the picture an odd informality which contrasts strongly with the scale of the canvas – 175 cm (69 in) wide. These pictures required regular visits to Montgeron, and Monet

85
Ernest and Alice Hoschedé, 1872

86
The four eldest Hoschedé children, *c.*1873. l to r: Suzanne, Blanche, Jacques and Marthe

seems to have become an intimate friend of both Ernest and his wife, Alice Hoschedé (85, 86).

Throughout the 1870s Monet had been on the move – London, Zaandam, Paris – and now Argenteuil no longer interested him. After completing the Saint-Lazare pictures he returned to Argenteuil, but he painted only four pictures there in nine months. The time had come to move on.

For Monet the last years of the 1870s and the early 1880s were a stark contrast to the financial and domestic stability of the first half of the 1870s. His personal life was marked by the lingering illness and painful death of Camille, while his growing attachment to Alice Hoschedé made his household both more complicated and more expensive. A general economic downturn brought with it the collapse of the art market, and his income shrank dramatically. The five years between leaving Argenteuil and settling at Giverny were hard, isolated and insecure, but by the end of the 1880s Monet's fortunes had begun to rise and his work had become both more assured and more widely accepted.

87
Frost
(detail of 95)

Monet had spent over six years in Argenteuil; it had been his first real home, a place which he and Camille had made their own. Many of the loveliest of the Argenteuil pictures depict their garden or the fields immediately surrounding their house, and most of them are animated by the presence of Camille and young Jean (88). As Zola had perceptively remarked in 1866, Monet's landscapes were essentially those seen by the urban visitor, the day-tripper:

Like a true Parisian, he brings Paris to the countryside. He cannot paint a landscape without including well-dressed men and women. Nature seems to lose its interest for him as soon as it does not bear the stamp of our customs … Claude Monet loves with a particular affection nature that man makes modern.

By the end of the 1870s Monet's interests had begun to change, and it was in Nature, rather than 'Nature stamped by our customs', that he began to look for his subjects. Between 1871 and 1877 the pace of change in Argenteuil happened with such rapidity that Nature seemed to be on the verge of disappearing beneath the Modern, in the shape of factories, boulevards and new housing estates. The countryside was spoilt and suburbanized. Monet's last images of

Argenteuil retreat further and further from the town, which appears only as a distant view along the dirty river (89). Between 1876 and 1878 he had painted truly urban scenes of the Gare Saint-Lazare and the flag-decked streets of Paris. These remarkable pictures seem to have exhausted the artist's interest in the capital and its suburban dependencies.

After leaving their house in Argenteuil in February 1878 the family lived in temporary accommodation in Paris until August, when they moved further down the Seine to the sleepy hamlet of Vétheuil. Leaving the suburban world of Argenteuil for this untouched area of countryside, Monet found new excitement in the rural landscape of

88
Poppies at Argenteuil,
1873.
Oil on canvas;
50×65 cm,
19³₄×25⁵₈ in.
Musée
d'Orsay, Paris

89
Argenteuil, the Bank in Flower,
1877.
Oil on canvas;
54×65 cm,
21¹₄×25⁵₈ in.
Private
collection

the Seine valley. Studying the village, the river and the surrounding fields, he began to simplify his compositions and concentrate on the precise delineation of light effects. This was not a break with his previous pictures – the fascination with shifting patterns of light had been very apparent in the paintings of Saint-Lazare – but it did make the focus of his interest clearer. The modern-life subjects, which could have been seen as distracting, were replaced by less complicated motifs, leaving the artist free to concentrate on the natural world.

The move from Argenteuil was not only the abandonment of a particular kind of subject – the modern suburban scene – it also

marked the end of the comparatively bourgeois life he had shared with Camille. Moreover, in Paris and at Montgeron he had spent a great deal of time in the company of the Hoschedés, and when the Monets moved to Vétheuil they were no longer a nuclear family. Ernest Hoschedé had suffered disastrous losses in the first wave of financial collapses that occurred as the boom of the early 1870s turned to bust. He does not seem to have been much engaged by the running of the enterprise he had inherited – trouble had been brewing since 1874, but he ignored the signs of imminent collapse, continuing to buy pictures. When bankruptcy occurred in 1877, he appears to have been unable to take any measures to protect what remained of the family's assets. Complete ruin followed.

Ernest's response was an ineffective attempt at suicide followed by solitary flight to Belgium. Alone with five young children and heavily pregnant, Alice sought refuge with her sister at Biarritz. Alice's family had never been keen on the marriage, and her reception on the coast was not so warm as to make her wish to stay. As soon as she could she returned to Paris with her children, now totalling half a dozen after the train journey south had been enlivened by the premature birth of a second son. Living in a rented apartment near the Parc Monceau, since the château, which actually belonged to Alice, had to be sold, she renewed her acquaintance with Monet and his family. When the move to Vétheuil was mooted, the decision to set up a joint household was made.

Vétheuil was a place Monet had discovered while roaming along the river looking for interesting spots to paint; it was close to Bennecourt, where he had painted Camille on the riverbank in 1868 (see 51). The small village, huddled around a magnificent thirteenth-century church, had not yet been affected by the tide of modernization that had swept over Argenteuil. There was no train service; people travelled by horse and cart, and virtually everyone but Monet, the local doctor, the priest and the tobacconist gained their living from agriculture. Remote from the industrialization that had transformed the areas around Paris, Vétheuil was still a primitive backwater (90). It was certainly much poorer than Argenteuil,

and therefore much cheaper to live in. The low cost of renting a substantial house must have been a major attraction, for the joint household consisted of four adults and eight children, including a delicate newborn. Ernest, now returned to France, appears to have been at Vétheuil initially, where he taught the now tutorless children.

Although there has been much speculation over the exact nature of Monet's relationship with Alice Hoschedé, and it has been claimed that he was the father of her last child, Jean-Pierre, the story adhered to by both families was that the move was prompted by simple economy. Hoschedé's ruin had been financially calamitous for the Monets as well. In the palmy days of 1874 the inital 'weeding-out' sale of pictures from his collection had brought welcome publicity and good results for all the Impressionists, but a second auction in June 1878 had flooded the market and prices tumbled. It was known to be a forced sale where any offer would be accepted; Monet's pictures had gone as low as thirty-eight francs a canvas, and one painting by Pissarro had fetched only seven francs. The new speculators of the so-called 'Republic of Opportunists' were feeling the pinch and there were few buyers around.

Even buried deep in the countryside, it was difficult to make ends meet. Alice had an allowance from her family and Ernest, who began to scrape a small living in Paris, was supposed to send her money. It seldom arrived, and with eight children to feed and clothe and an unfashionable artist as the breadwinner the collective family was in acute straits. At one point the joint household owed over 3,000 francs in grocery bills. A fourth group show held in the spring of

1879, under the title Exhibition of Independent Artists, actually made a modest profit of 439 francs for each exhibitor, but Monet had little energy to spare and Caillebotte organized his contribution of twenty-nine pictures.

That May, Monet wrote miserably to the absent Ernest, 'I am utterly discouraged and can no longer see or hope for a way ahead … I am only too aware … of the impossibility of coping with our share of expenses if we continue to live together.' In the same letter the artist described himself as 'increasingly bitter' and his wife as 'ill most of the time'. Camille had been unwell since before her second pregnancy, and soon after the birth of Michel in March 1878 she was permanently bedridden and in great pain. The nature of her malady is unclear, but it appears to have been some kind of cancer of the womb; she declined, through lingering stages, until September 1879. After her death, the ambiguity of Alice and Monet's relationship became a subject of scandal; it was hinted at unpleasantly in the Parisian press when Monet's work was reviewed, and the little village became less welcoming. After a series of acrimonious letters and visits from Ernest, Alice decided to throw in her lot with Monet – not an easy choice for a woman who had been used to security and luxury.

It is tempting to seek for connections between these turbulent events in the artist's life and his painting. For example, *Pheasants and Plovers* (91), painted after Camille's death, has been interpreted as an image of the destruction of his family of two adults and two children. Monet was a professional painter, however, and his works were almost all intended for sale; he did not use his work as a vehicle for therapeutic self-expression, and one can only speculate about the personal meaning of such images. This was neither the first nor the last time that he painted dead birds, and it seems forced to look for a biographical link in this case. 'Game-pieces' of this kind were a well-established category of still life, and such small pictures were more likely to find a buyer than larger, more complex works – Courbet and Renoir both painted similar subjects. When there was a personal significance to a picture it was usually quite explicit;

91
Pheasants and Plovers
1879.
Oil on canvas;
67·9×90·2 cm,
26³⁄₄×35¹⁄₂ in.
Minneapolis Institute of Arts

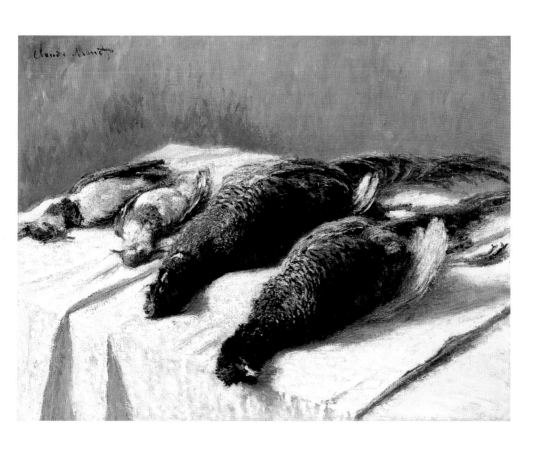

for example, Monet's painting showing Camille on her deathbed (92), was never offered for sale.

Monet later described to Clemenceau how he felt compelled to record his dead wife's appearance:

I caught myself watching her tragic forehead, almost mechanically observing the sequence of changing colours which death was imposing on her rigid face. Blue, yellow, grey, and so on … But even before the idea had occurred to me to record those features, my organism was already reacting to the sensation of colour and my reflexes compelled me to take unconscious action in spite of myself.

This is the artist's most intimate reference to Camille; the sadness of her death is made more poignant by the fact that he was forced to write to de Bellio, a regular and generous patron, beseeching him to redeem his wife's gold locket from a pawnshop in Paris – 'I should like to tie it around her neck before she leaves forever.'

Alice had nursed Camille and made sure that she was given the last rites; her lengthy illness and her death, which occurred at home, must have affected the entire household. Since Monet always relied on his family for models, their absence from the paintings of this period in Vétheuil may reflect the fact that posing, or group outings, were hard to manage. While the village and its immediate surroundings clearly fascinated the artist – he painted over 178 pictures within a two-km (roughly 1-mile) radius of the church – he tended to paint them from a distance, with little foreground detail and no figures.

92
Camille on her Deathbed, 1879.
Oil on canvas; 90×68 cm, 35$\frac{1}{2}$×26$\frac{3}{4}$ in.
Musée d'Orsay, Paris

Indeed, in contrast to the Argenteuil landscapes, those produced in this new location are almost entirely uninhabited. Monet chose not to depict the labourers who must have been a common sight and the meadows in his earlier paintings never contain peasants or cattle, only Camille and Jean, strolling or dreaming among the poppies and the long grass (see 88). After leaving Argenteuil Camille reappears in only one picture, that chilling deathbed portrait. The move to Vétheuil determined the new direction of his work, through a combination of fresh motifs and personal circumstances.

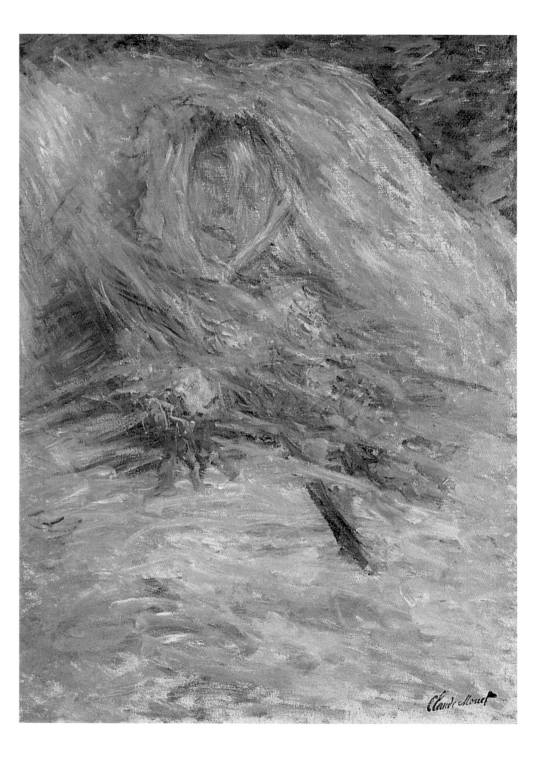

Vétheuil in the Mist (93) is typical of Monet's early Vétheuil pictures in its subject – the village, dominated by its church – and its viewpoint, from mid-river. The towering medieval church appears in no fewer than forty-five of his paintings – an early example of the interest in repeating studies of a single motif which was to become

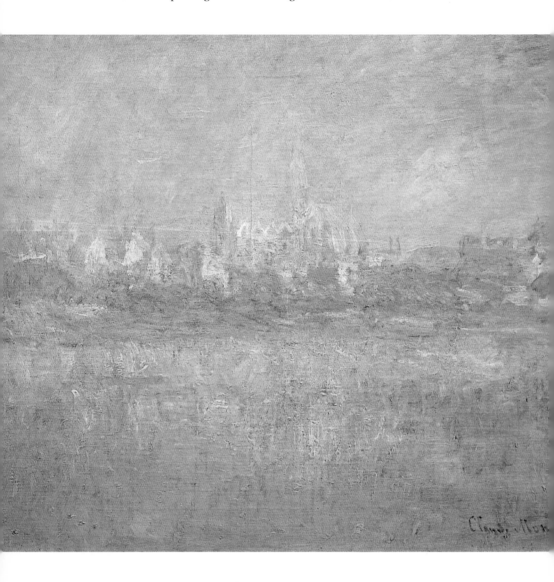

so marked a feature of the second half of his life. Monumental architecture seems to have fascinated Monet: the station at Saint-Lazare, the church at Vétheuil and later the Gothic cathedral at Rouen all provided fruitful subjects for his increasingly fine percep-

tion of atmospheric effects, offering a kind of solid, blank surface on which to project changing light. Although at Vétheuil he was painting a building rich in social and symbolic meaning, Monet gave little sense of its human significance. The church appears rather like a rock formation, a natural cluster of shapes. This is partly the effect of the distant viewpoint and the swirling mist, but it is also the result of the extraordinary freedom with which the surface of the picture is treated; clotted in some places, gossamer-like in others, the richness of the texture distracts attention from the subject of

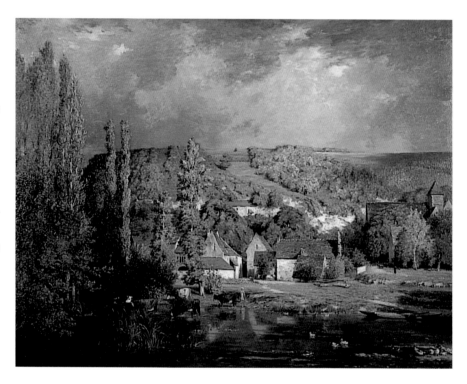

93
Vétheuil in the Mist,
1879.
Oil on canvas;
60×71 cm,
23⁵⁄₈×28 in.
Musée
Marmottan,
Paris

94
Charles Busson,
The Village of Lavardin,
1877.
Oil on canvas;
175×220 cm,
67⁷⁄₈×86⁵⁄₈ in.
Musée des
Beaux-Arts,
Angers

the painting to the materiality of the canvas. The overwhelming impression is one of light.

Vétheuil in the Mist shares the simple composition of *Impression, Sunrise* (see 77), which Monet often used during this period, with the horizon approximately half-way down the canvas, a watery reflection of the main motif and a boat off-centre. Like the earlier painting it too was to become a talismanic work. It can be compared with the near-contemporary *The Village of Lavardin* (94) by Charles Busson

(1822–1908), which was bought by the state two years earlier. Large and striking, this gives an exact rendering of the storm-light falling through gun-metal clouds on to brilliant green grass. The houses cluster in the centre, with the clump of trees to the left forming a wedge which helps to direct the viewer's attention. The scene is brightly lit and everything is in sharp focus. In contrast, *Vétheuil in the Mist* demonstrates how far Monet had moved away from the conventions of pictorial description. Its looming forms are unstructured and without apparent meaning; they are essentially uninformative, although they do convey the exhilarating sensation of watching the clouds melt in the shimmering sunlight of a cold winter's day.

The move from recording a subject to evoking an atmosphere, first apparent in the early 1870s, became the major feature of Monet's work in the next decade; his subjects were increasingly immaterial. This may have discouraged buyers. The slump of 1873 had brought in six years of hard times, but in 1879 a new left-wing government came to power under Jules Grévy and the Third Republic began to seem secure for the first time. The economy improved, but it took some time for confidence to return to the market for avant-garde painting. Works like Busson's picture were reassuring, not only because of their traditional style but also because of the image of France they presented – tranquil, stable and modestly prosperous. Bourgeois patrons had been shaken by the economic depression, and in retreating to the rural hinterland Monet was very much in tune with the anti-urban mood of other self-employed middle-class entrepreneurs. However, if his subjects were appealing, his style was not. Most of his pictures were far too introverted and sketchy to find buyers in what remained of the market for modern painting. When *Vétheuil in the Mist* was offered to a regular patron of Monet's, the opera singer Faure, it was rejected; the canvas had 'not enough paint on it', and what it did have was 'too white'. The price asked by the artist was fifty francs.

Desperate for cash, Monet took to selling his works for ever lower prices, sometimes disposing of them in job lots for twenty-five francs each. The hasty execution complained of by critics during this period

was not just a misinterpretation, based on comparison with the academic style. He genuinely was rushing his work in order to support the two families. The winters of 1878 and 1879 were exceptionally cold. The temperature dropped to –25°C and the village was cut off for weeks at a time. The price of food and firewood rose. In angry letters to her husband, Alice complained that their children were not only ill but shoeless. Muffled in coats and scarves, Monet spent the short days painting the snow-covered village and the frozen waters around it, and in the months after Camille's death he produced a series of haunting images of the ice-filled river.

Freeze and thaw have long been metaphors for emotional states, and these pictures have understandably been interpreted as symbolizing the artist's desolation. However, the paintings are astonishingly varied in mood, and their immediate visual impact often seems at odds with conventional expectations. Some, such as *Frost* (95), are serene and delicate, with the ice sparkling in the sun; others, such as *The Church at Vétheuil, Snow* (96) convey gloom and heaviness, with a muddy sky and sticky slush clogging the ground. We have no direct record of Monet's feelings during this period; his letters are terse and discreet. Although he was a prolific correspondent, with the exception of his later letters to Alice the majority of his writing seems to deal with business – mainly money and mainly asking for it. Manipulative and rhetorical, their tone sometimes verges on self-parody. For example, in the spring of 1879, when Camille was gravely ill, he lamented to a generous patron, Eugène Murer, 'Life is sometimes hard, and that is what is driving me to ask you to send me a small cask of 20 or 30 litres of good brandy.' There is little evidence to link these pictures to his feelings about anything other than the scenes themselves, and his quicksilver responses to it. Perhaps that in itself was his way of coping.

Snow-scenes had long been a favourite theme of the Impressionists; they allowed for adventurous treatment of light and colour and minimized the importance of form. Works such as Sisley's *Snow at Louveciennes* (97) display the iridescent qualities of reflection and the dramatic enhancement of shadows that made such subjects

95
Frost,
1880.
Oil on canvas;
61×100 cm,
24×39³⁄₈ in.
Musée
d'Orsay, Paris

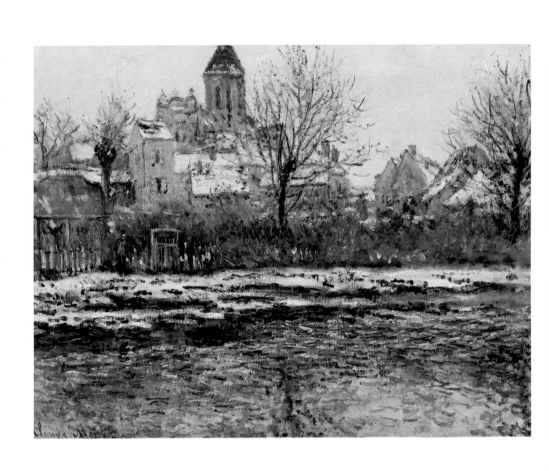

alluring. Monet's works of 1878 and 1879 are quite different, however; the absence of figures lends them a curious emptiness, initially disconcerting but also thrilling in the manner in which they draw the viewer in to experience the artist's sensation.

Monet urgently needed to find new clients and, determined to try to improve his fortunes in any way possible, he broke the habit of a decade and reapplied to the Salon in the spring of 1880. His decision to try the official channels once again was partly at the urging of a new dealer, Georges Petit, and partly prompted by the example of Renoir, who had shown a portrait of Madame Charpentier and her children to great acclaim the previous year. The rules of the

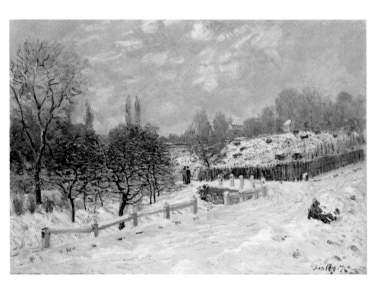

96
The Church at Vétheuil, Snow,
1879.
Oil on canvas;
53×71 cm,
20⁷⁸×28 in.
Musée
d'Orsay, Paris

97
Alfred Sisley,
Snow at Louveciennes,
1874.
Oil on canvas;
65×92 cm,
25⁵⁸×36¹₄ in.
Private
collection

Impressionist association forbade any member to show at the Salon, and Monet was well aware that his decision would be treated as a betrayal. His Vétheuil move and his involvement with the Hoschedé ménage were symptoms of a wider withdrawal from his old circle. He no longer lived close enough to Paris to participate in the group's dinners or café discussions, and the idea of Impressionism as a collective enterprise, a group challenge to the establishment, was losing its original appeal. The establishment no longer existed as a single, powerful opposition, and the art world and the Salon were both becoming more diverse. In 1880 a new government under Jules

Grévy demonstrated its liberality by allowing the largest Salon ever. It was the last to be held under the old system; after 1880 control was relinquished by the state and handed over to the Society of French Artists, comprising all those who had exhibited in previous years.

As the composition of the picture-buying public altered, splintering into a number of sub-groups with specialized tastes, so the apparatus of criticism, art dealing and exhibiting changed to meet the needs of this more varied market. When the Impressionists had held their first show in 1874 they had appeared aggressive, eccentric and even revolutionary. By the 1880s independent exhibitions had become

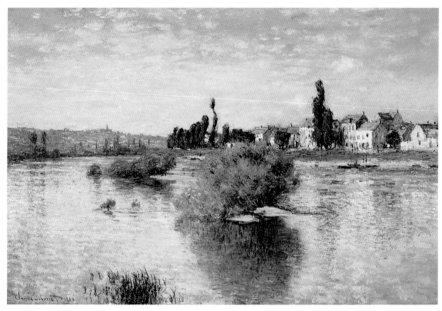

98
The Seine at Lavacourt, 1880.
Oil on canvas; 100×150 cm, 39³⁄₈×59¹⁄₈ in.
Dallas Museum of Art

more common, and the mere act of setting up a show in unofficial premises no longer carried a stigma. The core group of Impressionist artists had always been powerful and distinct personalities, and after a decade of irregular group exhibitions they had become less alike. The artistic differences between Degas and Monet or Renoir and Pissarro meant that their works did not necessarily complement each other, and personal disagreements, especially over politics, threatened the unity of the group. The task of orchestrating the exhibitions became increasingly difficult, and only Pissarro, a Socialist

who believed in the importance of collective endeavours, displayed his work in all the eight shows. In choosing the Salon rather than the Impressionists, therefore, Monet was also attempting to display his independence from a group containing artists with whom he did not wish to be associated, such as Paul Gauguin (1848–1903). Monet produced the classic turncoat's justification in an interview with the journalist Émile Taboureux in April 1880 for *La Vie Moderne*. He claimed that far from having left the group, the group had left him, and staked out his position as Defender of the Faith: 'I am and always will be an Impressionist … but I now see my companions-in-arms, men and women, only rarely. Today the small band has become a banal school, opening its doors to the first dauber who comes along.'

Despite his stirring words Monet was prepared to compromise in order to have a picture accepted at the Salon. Perhaps recalling the fate of *Women in the Garden*, he was sure that *Sunset at Lavacourt*, an 'impressionistic' river-scene, would not make it past the jury; it was, he thought, 'too much to my own taste'. To replace it, he sent in *The Seine at Lavacourt* (98). This brightly lit and comparatively crisp picture he considered 'more judicious, more bourgeois'. *The Seine at Lavacourt* is an unadventurous picture – Daubigny had been producing very similar works twenty years earlier and Monet himself had used the composition several times before. As he had predicted, it was accepted for exhibition but hung so high up that it attracted little attention.

99 Overleaf
Floating Ice,
1880.
Oil on canvas;
97×150·5 cm,
38¼×59¼ in.
Shelburne
Museum,
Vermont

At the same time he submitted *Floating Ice* (99), which was rejected. However, it starred in a later exhibition that same year. In April Monet was invited to hold his first one-man show at the offices of the periodical *La Vie Moderne* – the same month in which the interview with Monet appeared in that publication. This unconventional method of displaying contemporary art had been initiated by one of the paper's journalists, Edmond Renoir, the artist's brother. The intention was to provide an unintimidating setting which could attract a new audience; as an explanatory article put it:

How often people interested in art have told us how much they should like to visit the studio of this or that artist if they did not hesitate to go

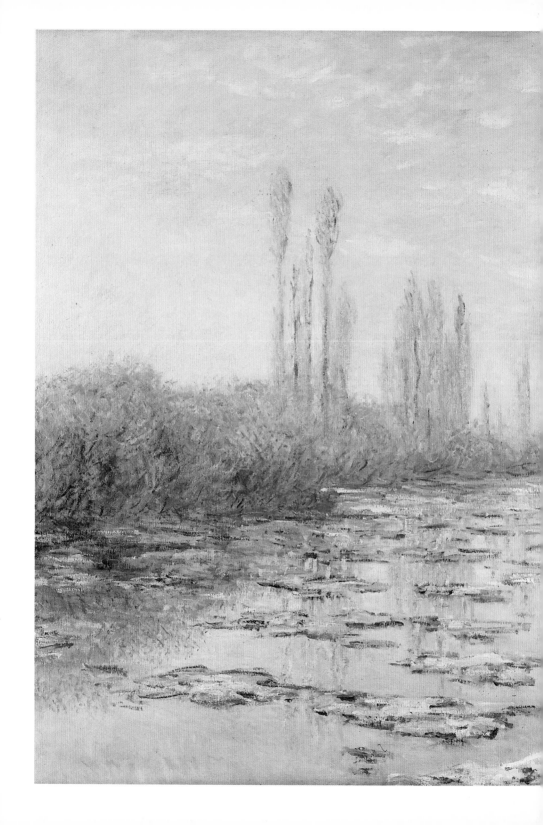

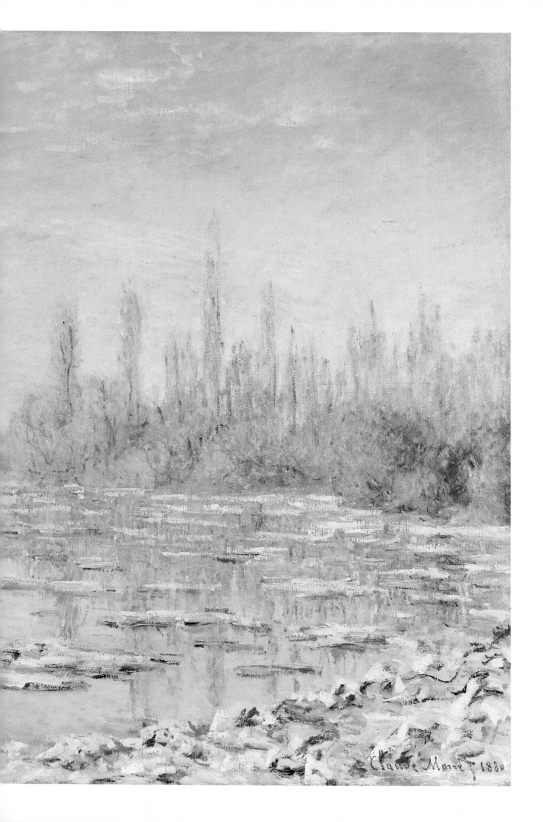

Claude Monet 1880

there on their own, which they can really only do on condition of having themselves announced as prospective buyers, especially if they have no occasion of being introduced by a mutual friend. Well then, our exhibitions will merely transfer momentarily the artist's studio to the boulevard, to a hall where it will be open to everyone, where the collector can come when he pleases, thus avoiding possible friction and having no fear of imposing.

Although the writer claims to be transferring 'the artist's studio to the boulevard', in fact the effect was to make exhibitions more private. The people who visited *La Vie Moderne* were a self-selecting group of educated, well-off liberals – much more likely to buy Impressionist art than the average boulevardier. Commercially, the move to small shows was a shrewd one, making picture-viewing pleasanter and less hectic. Indeed, one sympathetic reviewer wrote in his Salon notice that those interested in Monet's work would see it better displayed at *La Vie Moderne* than in the grand halls, where 'all Lavacourt's freshness evaporates on contact with the neigh-bouring canvases, painted in shoe-polish.' The 1880 Salon was in fact the last attempt at an annual event, and over the next couple of decades state sponsorship of the arts moved increasingly into the realm of industrial production, leaving the fine art market open to competing dealers and independent exhibitions.

La Vie Moderne provided more than just an exhibition space. Monet already knew the founder, Georges Charpentier – he had tried to borrow money from him. Charpentier was a major patron of Renoir – his pretty wife and children had been the subject of Renoir's Salon success the previous year – and the Charpentiers were part of the new Republican élite. They could make as well as follow fashions. Monet's first solo show was accompanied by a catalogue written by a member of their circle, Théodore Duret, a liberal journalist and long-standing supporter of Impressionism, who had already done a great deal to publicize Monet's work. It was followed by both an admiring review and Taboureux's interview, both in the same issue of *La Vie Moderne*. There were clear advantages to showing paintings in a newspaper office. The publicity provided by the Charpentier

100
Path in the Île Saint-Martin, 1880.
Oil on canvas; 80×60.3 cm, $31^{1}2 \times 23^{3}4$ in.
Metropolitan Museum of Art, New York

claque made Monet a more attractive proposition for commercial dealers, and overall the exhibition proved successful. Madame Charpentier bought the largest picture, *Floating Ice*, for 1,500 francs – a considerable sum and the amount Monet had asked for *Lavacourt* at the Salon from which *Floating Ice* had been rejected.

Reassured by the apparent upturn in his fortunes, Monet settled down to enjoy the summer at Vétheuil. He produced a number of sunny rural scenes such as *Path in the Île Saint-Martin* (100). The church in the middle distance is the same building as that in *Vétheuil in the Mist*, here given substance and surroundings, and the painting is not very different in subject and composition from such conventional works as Busson's *Village of Lavardin*. It fits squarely into the tradition of *paysage riant* (smiling countryside), a joyous and fertile landscape with man, and the Church, firmly anchored in the centre.

Despite its apparent informality, however, it is as carefully designed as the earlier views of Paris such as *The Garden of the Princess* (see 45). The intersecting spurs of the low hills lock together just behind the church, with the focal point of the spire emphasized by a bush and a clump of poppies lined up beneath it. To the right and left poplar trees echo it as vertical points of punctuation. What prevents this complex composition from seeming forced or artificial is the glorious colour, with its wedgwood and cerulean blue sky and the scarlet of the poppies zinging through the patchwork green of the meadow. Monet's brushwork is richly varied, with the short, straight horizontal strokes of the foreground vegetation contrasting with the swirling curves of the clouds. There is a sense of animation which has little to do with the character of the scene and depends mainly on the energy with which the artist confronts his motif.

The fascination with surface and what could be termed the evaporation of the subject can be traced back to Monet's work of the late 1860s, in such pictures as *On the Bank of the Seine at Bennecourt* or *La Grenouillère* (see 51 and 56). It was to become increasingly dominant in his work during the 1880s, and by this date was also beginning to attract the buying public. Part of the pleasure of paintings such as these is their immediacy. The physical involvement of the

artist, made conspicuous in the mass of marks on the surface of the image, gives the viewer a feeling of vicarious participation in the making of the picture. The idea that the artist sees differently from, and better than, the rest of us is one which had always been part of the Romantic image of the artist, and by the 1880s it was beginning to replace the idea that the artist should be judged by the technical skill with which the evidence of the making of the picture is concealed. The Charpentiers' circle of cultivated and wealthy people were prepared to look for new values in Monet's work, and discussion of his painting was increasingly full of admiration for the difference and freshness of his way of seeing.

In the autumn of 1880 Monet spent a few days in the Norman resort of Les Petites Dalles with his brother Léon. It was his first trip to the sea in almost a decade, and was immensely invigorated by revisiting his first subject, the Channel coast. He immediately made plans to return for a lengthy painting trip, initiating a period of several years in which marines were to be his main subject. This change of tack seemed to bring good fortune, and renewed contact with a re-financed Durand-Ruel led to the sale of fifteen canvases for decent prices in February 1881. Durand-Ruel continued to make purchases throughout the summer and seemed sure that he could sell Monet's recent work. That spring Monet enjoyed a productive month on the coast at Fécamp and Grainville, starting twenty pictures. Durand-Ruel was happy to take them, and in March Boudin mentioned that Monet's works were selling for 2,000 francs. Although this may have been inflated, optimism seemed justified, and Monet and Alice began to think of leaving Vétheuil and setting up a joint household somewhere more suitable. The idea of such a decisive and public declaration of their unconventional relationship was not welcomed by Ernest. That summer, as Alice exchanged letters with her irate husband, Monet painted a number of valedictory pictures of his garden – just as he had done at Argenteuil.

Unlike the relatively sedate paintings of the garden at Argenteuil, *The Artist's Garden at Vétheuil* (102) does not present an image of suburban contentment but of a world in which nature threatens to over-

whelm the human presence. The immense sunflowers tower over the children and obliterate the presence of the road which ran between their house (on the right) and the garden plot; it is the figures, not the plants, which seem out of scale. The sense of nature as an irrepressible force can be seen in early nineteenth-century Romantic works combining infants and flowers, such as *The Hulsenbeck Children* (101) by the German artist Philipp Otto Runge (1777–1810), but Monet's painting reverses the normal balance of power to show flora, not fauna, as the dominant force. His last twenty years were to be devoted to the creation of a world in which flowers swamp all other forms of life in the immense and all-absorbing Water-lilies.

The Artist's Garden at Vétheuil is one of three versions of this subject, unusual among Monet's works of this period in that they include

101
Philipp Otto
Runge,
*The Hulsenbeck
Children*,
1806.
Oil on canvas;
130·4×140·5 cm,
51³⁄8×55³⁄8 in.
Kunsthalle,
Hamburg

102
*The Artist's
Garden at
Vétheuil*,
1881.
Oil on canvas;
151·4×121 cm,
59⁵⁄8×47⁵⁄8 in.
National
Gallery of Art,
Washington,
DC

members of the household. The two children on the steps are Michel Monet and Jean-Pierre Hoschedé, while the woman in the background is probably a nurse or maid. It is unlikely to be Alice, for while she may have replaced Camille as mistress of the Monet household, she never replaced her as a model. A few pictures from this period, such as *Woman Seated under the Willows* (103), may have been based on Alice, but the forms are blurred and anonymous. Integrated into a continuous pattern of soft, curving brushstrokes, the figure blends into the background in a manner which is the visual equivalent of whispering.

The period in Vétheuil had confirmed Monet's move towards landscape rather than figure painting. He had produced some portraits of the children (104) – by this stage the young Hoschedés were address-

103
*Woman
Seated under
the Willows,*
1880.
Oil on canvas;
81·1×60 cm,
$31^7_8 × 23^5_8$ in.
National
Gallery of Art,
Washington,
DC

104
*Portrait of
Blanche
Hoschedé
aged 14,*
1880.
Oil on canvas;
46×38 cm,
$18^1_8 × 15$ in.
Musée des
Beaux-Arts
et de la
Céramique,
Rouen

ing him as 'papa Monet' – but he does not appear to have needed them to lend meaning to the landscape. Later in his life the relative eclipse of figures in his work was explained by Alice's aversion to posing and her resentment of models, but this reasoning seems inadequate. Monet's painting style, as well as his personal circumstances, had changed considerably since the years at Argenteuil and his interests were increasingly moving away from social scenes and towards the highly focused observation of the natural world.

In the autumn of 1881, after Monet had returned from a late summer session of work on his marine subjects, Monet and Alice decided to move from Vétheuil to Poissy. The distance was not great, but the new town was larger and offered proper schools for the children. Vétheuil had become less friendly since the death of Camille, and the setting up of a new household could be seen as a declaration of independence from the past. Monet never liked Poissy, however; he found little of interest to paint in the district, and once he had settled the family he began to look for subjects outside the area, mainly on the Normandy coast.

Early in 1882 Monet travelled to Pourville, near Dieppe. Pourville was a seaside resort, not unlike Trouville where, as a newly married couple, he and Camille had spent a couple of months in the summer the Franco-Prussian War began. This time Monet chose to visit in the winter, at low season. He was captivated by the beauty of the empty beaches and stayed until April, returning in June to install Alice and the children in a local hotel. Between his initial trip to Pourville in February and the return to Poissy in October he produced nearly a hundred seascapes. He seems to have enjoyed working with his new family around – one member was always delegated to help carry the equipment – but they rarely appear in the paintings and when they do it is to emphasize nature's grandeur, not to domesticate it.

The cliff-walks and the beaches in these Pourville paintings are quite different from the Trouville scenes painted more than a decade earlier. The glamour and excitement of works such as the joyous *Hôtel des Roches-Noires* (see 59) are replaced by empty water and sand; the artist's attention has shifted from people in an open-air

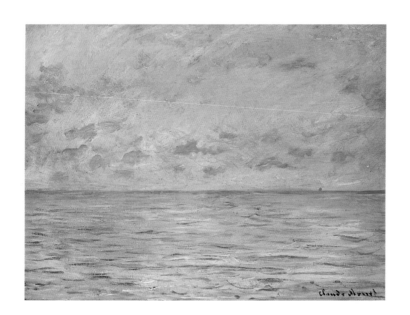

setting to the air and the sea alone. The simplicity and emptiness of *The Sea at Pourville* (105), with its stripes of sea, horizon-line and glowing sky, was not new in European painting. It is part of what Robert Rosenblum has characterized as a distinctively northern tradition of the artist as an individual experiencing the true force of nature in solitude. As a French artist with Norman roots, Monet had absorbed elements of both northern and southern European painting, and in this picture, looking across the Channel to England, he is orienting himself to the north in literal and artistic terms. In Argenteuil he had been fascinated by the way in which the landscape was being altered before his eyes by the active intervention of men.

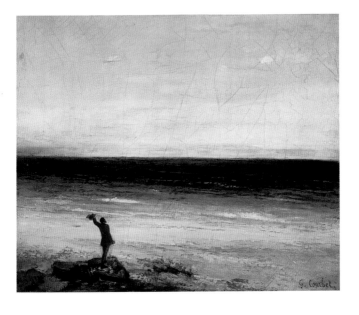

105
The Sea at Pourville,
1882.
Oil on canvas;
54×73 cm,
21¹₄×28³₄ in.
Philadelphia
Museum of
Art

106
**Gustave
Courbet**,
The Sea at Palavas,
1854.
Oil on canvas;
27×46 cm,
10⁵₈×18¹₈ in.
Musée Fabre,
Montpellier

Here on the coast, he ignored the evidence of human presence to concentrate on nature at its most pared-down.

By this stage the interest in modern-life subjects which had been so strong an element in the Impressionists' early work had definitively vanished from Monet's painting, and his work now treated the traditional themes of French landscape painting, emphasizing continuity rather than change. The pictures of the Norman coastal resorts, Pourville, Varengeville and Etretat, take the empty rural scenes of Vétheuil a stage further. Typically, they turn their backs on the land

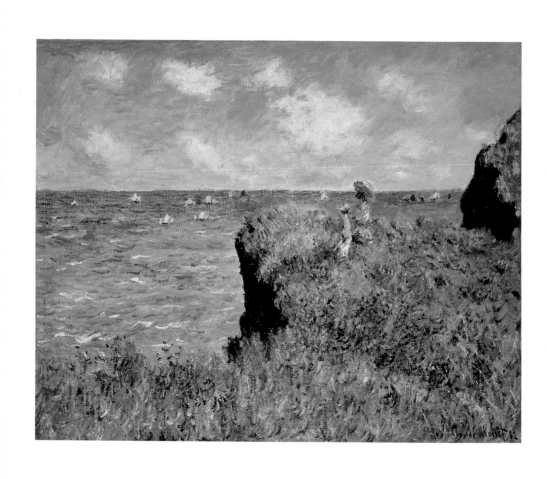

and its inhabitants to focus on the immensity of the sea and the sky. Many of these works use a highly simplified composition reminiscent of *Floating Ice*; the traditional curves and scenic bends used to shape a beach in such pictures as *The Pointe de la Hève at Low Tide* (see 26) have been jettisoned, and what is presented is a stark series of stripes, undefined and unbordered by anything but the picture-frame. Anecdote and information have vanished, leaving the viewer alone with nature. These pictures are not especially easy to look at; their lack of focus is unsettling. The appeal of their grand blankness, like that of the Vétheuil paintings, rests partly on the sense of peace and solitude – as if everyone else had left the beach and gone home. It's the tourist's ideal experience.

By the 1880s, however, it would have been rare to have the beach to yourself in a resort such as Pourville. The areas Monet chose to paint were far from remote; in such works as *The Cliff Walk at Pourville* (107) he must have deliberately positioned himself to block out the casino, the hotels, the beach establishments and the bathing-huts that had been fixtures for many years. He might also have been turning his back on other easels: this stretch of the Normandy coast was well known to many artists.

107
The Cliff Walk at Pourville,
1882.
Oil on canvas;
66·5×82·3 cm,
26¹⁴×32¹² in.
The Art
Institute of
Chicago

In January 1883 he decided to work in a notable beauty spot, Etretat (108). It could scarcely be described as undiscovered; for nearly fifty years it had boasted a hotel called Au Rendez-vous des Artistes. Monet had painted there before, in 1868–9, and was well aware of the competition from both the dead and the living: Delacroix had worked at Etretat, and so had Courbet. Courbet's self-aggrandizing *The Sea at Palavas* (106) – a Mediterranean scene – shows a rather different manner of relating to the sea – a nice contrast to *The Sea at Pourville*. Monet's concern was to display the grandeur of nature, not to proclaim the magnificence of the artist, and when he came to paint one of the most famous features of the rugged cliffs near the town, the needles and the gateway known as the Manneporte, he hesitated over issuing a challenge to the dead master. In one of his regular letters to Alice, he described the project as 'terribly daring'. In the event he painted several different views, of which *Etretat, Rough*

Sea (109) is most directly related to Courbet's work in the same area (110). It uses a virtually identical viewpoint, but Monet increases the proportion of the picture occupied by cliff and sea and diminishes the area of sky. The viewer is brought closer to the sea, and its choppy surface takes up more than half of the space in the painting.

In other views of the same motif this 'close-up' effect is increased. In *The Manneporte* (111) the spectator is placed helplessly bobbing around in the water deprived of any solid footing. Monet once said that he would like to be buried in a buoy, and this painting transmits a sense of disembodiment, becoming one with the water. The elements at their most fundamental hold sway; nowhere is there any suggestion that this was a popular holiday spot, much frequented by English and Parisian tourists. By using a telescopic viewpoint, Monet has shut out the busy environs of the surrounding town, and the artist's experience becomes our own. This type of picture became increasingly popular, prized for offering a kind of privileged access to the inner workings of a creative mind. Monet's temperament and the individuality of his vision were becoming marketable commodities, and marketing strategies were becoming more important than ever before.

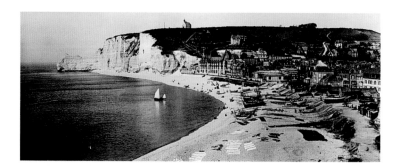

Having staged an independent one-man show, become newly contracted to Durand-Ruel and continuing to sell directly to his old patrons, Monet was manipulating the market in a highly profitable manner. Picture dealing was becoming an important business, and the most fashionable Parisian gallery was now Georges Petit's newly opened Exposition Internationale. Faced with this new competitor,

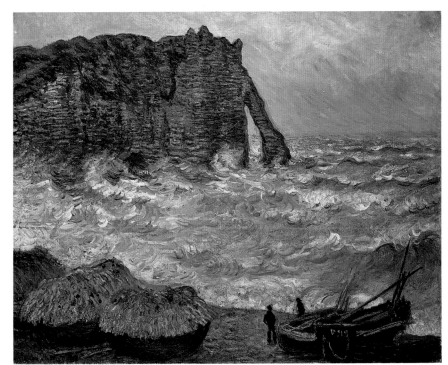

108
Etretat, late
19th century

109
*Etretat, Rough
Sea,*
1883.
Oil on canvas;
81×100 cm,
$31^7_8×39^3_8$ in.
Musée des
Beaux-Arts,
Lyon

110
**Gustave
Courbet**,
*The Cliffs at
Etretat after
the Storm,*
1870.
Oil on canvas;
133×162 cm,
$52^3_8×63^7_8$ in.
Musée
d'Orsay, Paris

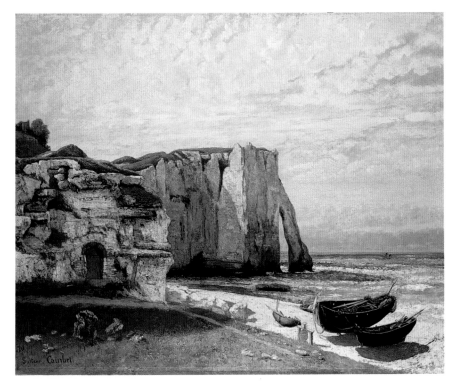

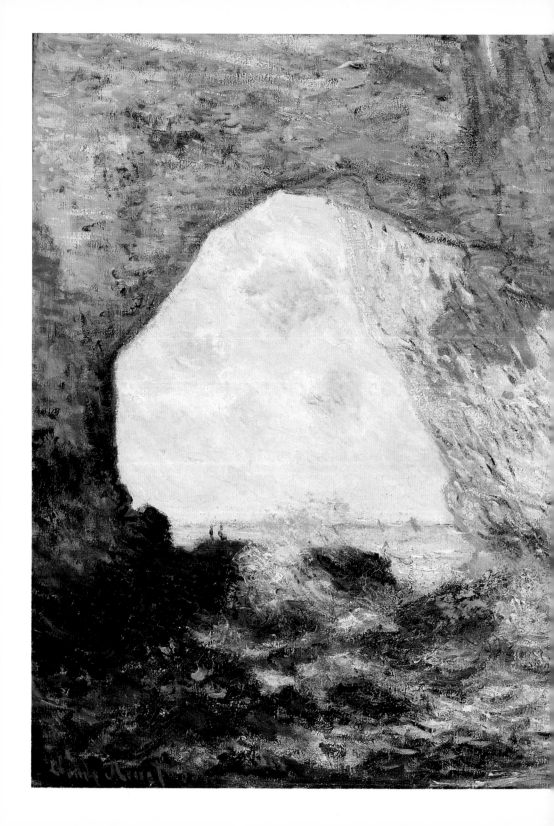

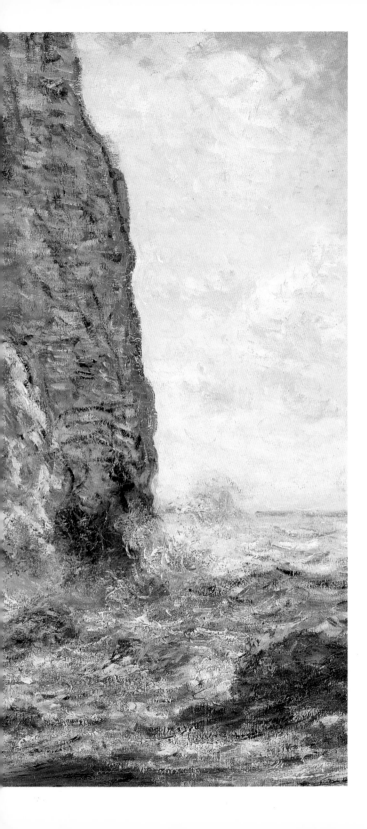

111
The
Manneporte
(Etretat),
1883.
Oil on canvas;
65·4×81·3 cm,
25³⁄4×32 in.
Metropolitan
Museum of
Art, New York

Durand-Ruel must have been aghast when early in 1882 a sudden dip in the financial markets led to the collapse of his main backer, the Catholic banker Jules Feder. Encumbered by debt and under the threat of bankruptcy once again, Durand-Ruel set about cajoling the unwilling Impressionists into another group appearance. It was not easy, but in the end most of them came round – even Monet and Renoir, who had realized that their personal fortunes were better served by individual exhibitions. All the members of the original group recognized how much they had been helped by Durand-Ruel.

Unlike the 1879 exhibition, when he had left the choice and organization of his works up to Caillebotte, Monet collaborated closely with the dealer, deliberating carefully over the right paintings to send in. Eventually they selected thirty-five pictures, mainly recent. Madame Charpentier's *Floating Ice* was shown once again, together with the picture Monet had described as 'too personal' for the Salon. Evidently he expected a more discerning public to attend this exhibition.

In the event, the Seventh Exhibition of Independent Artists lacked only Cézanne and Degas and proved the most representative of the eight 'Impressionist' shows. Most of the pictures came from Durand-Ruel's holdings, and their warm critical reception must have been a great relief to him. The show was successful in reviving his fortunes; new buyers appeared, and Monet's work was especially well received. That same summer Durand-Ruel held a group exhibition in London, and set up further shows in Holland, Germany and the USA. At Monet's suggestion he took up the idea of the one-man show, and early in 1883 he opened a series of month-long exhibitions at his Paris premises. The first was devoted to Boudin, and in March Monet himself had fifty-six pictures on view. These provided a mini-retrospective, starting with the early Salon work *The Pointe de la Hève at Low Tide* of 1864 (see 26) and ending with recent Pourville scenes. Critics were still unsure how to treat a one-man show, and sales were not good. Thus, despite his strong ties with the man who had supported him through so many difficulties, Monet was quite prepared to look elsewhere for an income; as he pointed out in a letter to Durand-Ruel, 'One must see things from a commercial point of view.'

During the 1880s both Monet's artistic reputation and his commercial success were finally firmly established. Settled with Madame Hoschedé, he found domestic harmony; at the same time his artistic reputation and his fortune were definitively established. Paris, the suburbs and self-consciously modern subjects were left behind, and instead he began to explore new regions of France, together with a deeper study of the familar countryside of the Seine valley. He developed a new way of working, producing the two contrasting kinds of landscape and showing them in one-man exhibitions designed to display his range and virtuosity. Moving away from the group shows of the Impressionists, he linked himself with a number of new galleries, forcing the dealers to compete for his work. Year by year his prices rose, and canny manoeuvring gained him a decent share of the profits.

112
*The Petite
Creuse River*
(detail of 133)

This was the only time in Monet's life in which he travelled extensively. He took lengthy painting trips, up to three months at a time, and his journeys usually led to the coast. There were personal reasons for this – Monet remained deeply attached to the landscape of his early youth. He had begun as a painter of the Normandy beaches, and after more than a decade devoted mainly to inland scenes he may well have felt the need to refresh himself by going down to the sea again. Indeed, his work of the 1880s has been seen as a series of reprises, taking up old themes as if recapitulating his entire artistic development. The Channel coast was the first of these renewed meditations. He may also have been motivated by practical considerations. His marines sold well; buyers appeared to prefer them to rural scenes. Sea subjects also allowed him to experiment in a way which became increasingly important by the mid-1880s, when Impressionism was no longer as new as it had been – even conservative critics were beginning to review Monet's work in tones of restrained approval.

Brighter colouring, the use of *plein-air* painting, broad brushstrokes and modern-life subjects were all becoming common even in the work of mainstream artists. These elements of Impressionism no longer enraged either public or critics. The most radical new work seemed to be coming from a younger group of painters, the Divisionists or Neo-Impressionists, led by Georges Seurat (1859–91) and Paul Signac (1863–1935). Although Monet had never concealed his desire to sell, and to sell well, the summit of his artistic ambition was not simply a loyal clientele and a comfortable living. He also wanted to be admired by other artists. Thus, although he was happy to mix socially with fashionable conservative artists such as Henri Gervex (1852–1929), Jean Béraud (1850–1936) and Paul Helleu

113
Georges
Seurat,
*Bathers at
Asnières*,
1884.
Oil on canvas;
201×300 cm,
79¹⁄₈×118¹⁄₄ in.
National
Gallery,
London

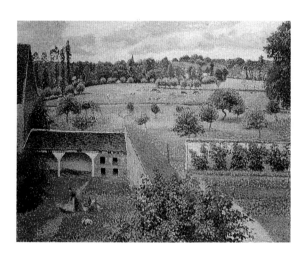

114–115
Camille
Pissarro,
*View from My
Window,
Eragny*,
1886.
Oil on canvas;
65×81 cm,
25⁵⁄₈×31⁷⁄₈ in.
Ashmolean
Museum,
Oxford.
Above right
Detail

(1859–1927), he also needed to compete with the new generation. Travel gave him the opportunity to broaden both the scope of his subjects and the range of his style.

Impressionism had so far been associated with the area around Paris and the Channel coast; it was essentially the art of northern, metropolitan France. The Neo-Impressionists tended to paint in the same area. Seurat's work was mainly produced in the dormitory suburbs and on the fringes of Paris; *Bathers at Asnières* (1884; 113) depicts a scene not far from Argenteuil. Although this grubby, sunny landscape with its plebeian bathers can clearly be related to such suburban idylls as *La Grenouillère* (see 56), it is radically different in style

and feeling. Seurat's method of painting replaced the blending of paint on the palette with tiny strokes of colour placed directly on to the canvas, a technique intended to replace the notions of individual expression and emotion with scientific impartiality. In 1885–6 Seurat and Signac developed a method of painting with minute dots of unmixed pigment, which became known as 'Pointillism'. Among the older Impressionists, Pissarro took to using the technique in a number of paintings, such as *View from My Window* (114, 115). Monet and Renoir, however, reacted very differently.

In December 1883 the two artists travelled to the south coast together. Renoir had recently made trips to Provence, Italy and Algeria, and was already familiar with the bright light and new motifs of the Mediterranean landscape, but for Monet they were a revelation. On his return he wrote to Durand-Ruel of his eagerness to go back alone as soon as possible: 'I have always worked better on my own … following my own impressions.' The old days of setting up the easels side by side had gone forever. As commercial success came into view, so competition and diversification became more important than the protection of colleagues – 'friends and allies in the struggle'. The idea of an 'impression' as unique, the possession of a single gifted individual, was an increasingly important element in Monet's market appeal. Early criticism of the Impressionists had often attacked their painting on the grounds that it was the product of distorted vision, physical or psychological; for example, in 1876 Louis Enault had described the work at the second group show as 'Lines drawn by the blind … and colour which is nothing but the debauch of all the colours of the rainbow'. Gradually this desire for pictures that asserted a uniform and universal way of seeing was replaced by the essentially relativist concept of sight which granted the artist a special role as one who saw differently, and therefore better than other people. In an 1883 review of his work even the comparatively conservative Alfred de Lostalot was prepared to acknowledge that 'Monet is a man of exceptional vision; he sees things differently from most of mankind, and as he is sincere he makes an effort to reproduce what he sees.' Although this was often 'shocking', Lostalot concluded that it was worth making an effort:

'One has to go beyond the first impression … soon the eye grows accustomed and the magic does its work.'

The Impressionists had always been a very varied group, divided among themselves. Although their exhibitions are usually called the 'Impressionist' shows, in fact most of them had other titles; 'Independent' was the most common. They had began in 1874 as an event announced by an Anonymous Society, and ended in 1886 simply as the 'Eighth exhibition'. Their collective enterprise had been conceived in opposition to the Salon, and as the official institution weakened, the notion of independent group shows became less useful. In the fragmented and competitive art scene of the mid- and late 1880s, it was the solo show that attracted the most attention. The period of the 1880s has sometimes been described as 'The crisis of Impressionism', but many recent scholars consider that Impressionism was, in fact, never more than a convenient label for uniting very disparate artists. Certainly after the eighth and last 'Impressionist' exhibition in 1886, the term had run its course. The artists were growing older; in middle age they all had a substantial body of work to look back on and perhaps they felt the need to move away from a manner of painting that had begun to seem predictable. Each of these strong personalities went their own way, developing an individual response to changing circumstances.

After the turmoil of the 1870s in the 1880s France underwent a number of smaller crises. A series of weak governments and the rapid pace of industrialization encouraged speculation, and scandals and corruption helped to create a mood of insecurity. Small sects flourished – anarchist, communist, spiritualist, monarchist – and extremists proliferated on both left and right. Monet's new patrons came from the wealthy élite, who in a different political climate might have attempted to exert a direct influence on national events. In the late 1880s, however, they tended rather to withdraw into their exquisite homes, closing the doors on the vulgarity and turmoil outside, and concentrating their energies and wealth on the cultivation of their souls. The new emphasis on pictures as beautiful objects, visible in both Monet and Renoir's work during the 1880s,

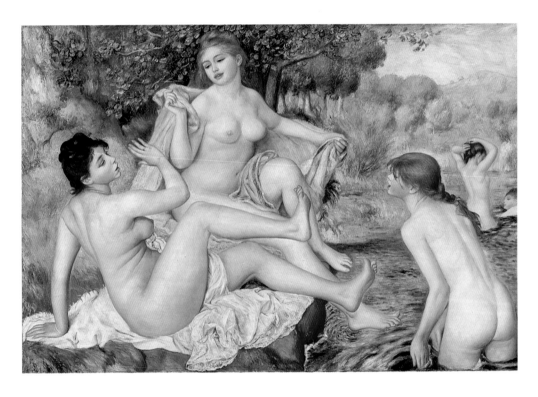

117
Pierre-
Auguste
Renoir,
*Nude in the
Sun*,
1875–6.
Oil on canvas;
80×64·1 cm,
31^12×25^14 in.
Musée
d'Orsay, Paris

needs to be seen in the context of a widespread retreat from politics and public life.

As early as 1880 Renoir had been dissatisfied with what he considered the ephemeral nature of his work, and his voyage to Italy had inspired him with a new veneration for the Renaissance and Neoclassicism. The large *Bathers* (116) which he worked on from 1880 to 1883, is strikingly different from pictures of similar subjects in an 'Impressionist' style (*eg Nude in the Sun*; 117); a hard, crisp outline and a traditional prettiness have replaced the blurry brushstrokes and blotchy, unglamorous flesh of his earlier works. Monet's pictures, however, moved in the opposite direction; the facture, the actual laying-on of the paint, became increasingly broad and exuberant, and the subjects became less dramatic. *Cap Martin, near Menton* (118) was painted in early 1884, when he returned to the Mediterranean. It is simply composed, dividing into quarters; a strong diagonal dives from the top of the trees on the left-hand side to the bottom right corner of the canvas, slicing the view into foreground and middle ground, while a second triangle of intensely blue water fills the gap between shore and mountains. The sizzling colours, which the painter memorably described as 'brandy-flame' and 'breast of pigeon', impart a sensation of energy which is enhanced by the excited flurry of brushstrokes that cuts between orange path and ultramarine sea. The landscapes Monet painted on this trip are thrilling pictures, demonstrating the energy and contin-uing creativity of the artist, now in his mid-forties. His early experi-ments with surface texture, from La Grenouillère to Vétheuil, had laid the foundation for the freedom with which he now responded to the brilliance of the Mediterranean, using thick, block-like strokes that do not blend together. Colour is used to define shape, rather than breaking it up in the Pointillist style, in a manner which is assertively physical and unlike the work of any other painter of the period except, perhaps, Monet's old friend Paul Cézanne.

Monet treated these southern scenes very differently from the Seine valley, which he knew so well. Getting to grips with a new area was never easy for him; painting an unfamiliar landscape required

116
Pierre-
Auguste
Renoir,
The Bathers,
1887.
Oil on canvas;
117·8×170·8 cm,
46³⁄8×67¹⁄4 in.
Philadelphia
Museum
of Art

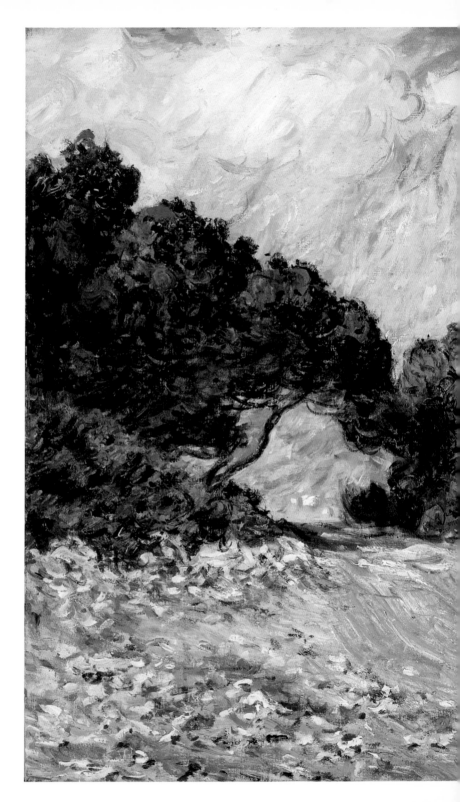

118
*Cap Martin,
near Menton,*
1884.
Oil on canvas;
67·2×81·6 cm,
26^12×32^18 in.
Museum of
Fine Arts,
Boston

119
Georges Petit's New Premises in the rue de Sèze. La Vie Parisienne, 25 February 1882

120
The drawing-room of Durand-Ruel's apartment, 35 rue de Rome, Paris, showing the doors painted by Monet

intense concentration, and finding the right motif was difficult. There were usually some botched attempts before he could settle down properly. At Bordighera, just over the border in Italy, he had trouble finding the right place to stay – his hotel proved to be full of Germans, which upset him so much that he moved to one frequented by English visitors. He took long walks around the area, becoming accustomed to the brilliant sun, so different from the 'white light' of the Île de France region, and adjusting to the startling colours. In one of his frequent letters to Durand-Ruel, he wrote of the South: 'Now that I have a real feel for the landscape, I dare to put in all the pink and blue tones; it's like fairyland, it's delicious.'

Having arrived in January Monet did not return home until April. When he finally reappeared it was with more than thirty paintings – paintings that proved immensely saleable. Durand-Ruel took twenty-one; the others were mainly snapped up by Petit and another new dealer, Auguste Portier.

In the spring of 1885 some of these southern scenes were exhibited by Petit. They were well received, even by critics who had dismissed Monet's earlier work; this certainly had something to do with the increasing familiarity of the Impressionist technique, but it was also the result of their grandiose presentation in the rue de Sèze (119). Monet had said that the Mediterranean landscape required 'a palette of diamonds and jewels', and these lushly beautiful pictures accorded well with the atmosphere in Petit's gallery.

The idea of paintings as decorative accessories for luxurious rooms is not something that we now tend to associate with Impressionism, when our experience of the pictures themselves is likely to be in the relatively austere setting of a public museum. It was not a strange idea for Monet, however; he had already created large 'decorative panels' for the ill-fated Hoschedé château, as well as thirty-six small still lifes of fruit and flowers for the doors of Durand-Ruel's drawing-room (120). The latter were produced in fits and starts between 1882 and 1885. Charming but undemanding works, which could be dashed off during an afternoon of poor weather and put aside when there was something more urgent to attend to, they gave Monet the

opportunity to think about decorating a room as a whole – an idea was to which was to resurface much later in the huge water-lily scheme for the Orangerie in Paris. They also domesticated his painting in a way that may have helped it become acceptable, giving it a social setting that could be seen as part of the package. Presentation was not everything, but it was certainly a major part of selling these pictures. It would not have been sufficient, however, had the pictures not underlined the increasing separation of Monet's work from contemporary life subjects and his shift of emphasis towards decoration and surface.

In his painting campaigns of the 1880s and early 1890s Monet crisscrossed the country, painting on the Atlantic, Mediterranean and Channel coasts while also continuing to work in the area around his home at Giverny (see Chapter 6), where the family had finally settled in 1883 after Vétheuil and Poissy. As a group, the landscapes of this decade add up to a kind of 'tour de France'. Concentrating on the beauties of the coast and ignoring the cities and industry in favour of a tourist's eye view, they promote the old-fashioned idea of rural France as essentially stable and unchanging. Lacking the disturbing elements of the Argenteuil or Paris subjects and without any overt reference to modernity in their subject matter, these images of Normandy, Brittany and the Riviera offer a vision of France as a series of exquisite and varied landscapes, virtually uninhabited.

Monet's choice of locations on his painting trips was very different from his attitude to the landscape around his home. In the Seine valley he was constantly looking for motifs which were 'not too conventionally picturesque'. When travelling, he often used well-known illustrated guidebooks to help him select suitable sites. This was partly the result of commercial pressures; Monet could not afford to waste too many days trekking around the cliff-tops with crates of equipment and a porter. It also seems to have been required by his market, and thus he tended to favour areas made familiar by the work of other painters.

Even the coastal scenes he knew best, the Normandy cliffs, can be clearly related to the work of other artists. Mountains and

magnificent, awe-inspiring views had long been established as staple elements of the Romantic sublime, but by the time that Monet was working on his cliff-top scenes, these too had become well established as 'breathtaking' scenery (121) – the traveller in search of sublime emotions in the high season would have had to join a queue to experience vertigo. As Robert Herbert has shown, it might have been easier to experience a sense of communion with nature in the calm surroundings of Petit's or Durand-Ruel's gallery than on the cliff-tops, jostled by fellow seekers after solitude.

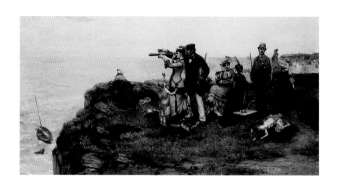

121
Pierre Outin,
The Look-Out Point,
1878.
Oil on canvas;
59×98·5 cm,
23¹₄×38³₄ in.
Location unknown

Not only Normandy but virtually the whole of the French coastline was becoming colonized by the new holiday industry. Fuelled by general prosperity and facilitated by improved road and rail links, tourism was moving to more distant areas of the country by the 1880s. As Monet's experiences with hotels in Bordighera suggest, the Mediterranean coast of France and Italy had been successfully promoted as a place for wealthy northerners to spend the winter, and was spawning its own flood of guidebooks and recommended itineraries. The seasonal visitors were wealthy and cosmopolitan – potential picture-buyers. Monet was a tourist himself, and his work seemed to capture the essence of the southern idyll. He encountered several Impressionist collectors during his stay; the southern coast, like Monet's painting, was just embarking on an apparently limitless growth in popularity.

After spending the summer of 1885 at Giverny, Monet returned to the coast in September, establishing his family in a hotel in Etretat. Having already painted the area in 1868 and 1883, he knew what

interested him there and was able to concentrate on developing new working methods rather than striding around the cliffs in search of suitable vistas. Monet was determined to follow up the success of the southern marines, and he plunged into an intensive bout of painting; by the end of the autumn he had begun fifty-one canvases. This flurry of production was made possible by a change in his method of painting; instead of working on one canvas at a time, he started several versions of the same motif in different weather conditions. On one day he worked at six different sites. Lugging numerous half-finished pictures around the beaches and cliff-tops was strenuous work, but it was a practical and profitable way of getting the most out of each day's expedition. According to a contemporary account by a famous resident of Etretat, the novelist Guy de Maupassant (1850–93), the younger members of the family were called in to assist:

[Monet] walked along, followed by the children who carried his paintings, five or six canvases showing the same subject at different times of day and with different effects. He took them up or abandoned them as the changing sky dictated.

He even had some half-finished works from earlier visits sent down to the coast so that he could continue to work on them in the open air. However, his pictures were ultimately completed in the studio, despite his repeated claims to work entirely *en plein air* – claims that were elevated into gospel truth by the increasing number of writers and critics who came to record his ethos and his working practice.

Painting repeated versions of the same spot was nothing new for Monet; back in Le Havre he had painted sunlit and overcast views of the same street, and the twelve Saint-Lazare paintings date from 1877. However, the marines of the 1880s bring a new intensity to the process. The pictures of Etretat allow comparison across two decades: a picture such as the early *Rough Sea at Etretat* (122) contrasts strikingly with two images of the same subject from the 1880s – *Etretat, Rough Sea* (see 109) and *Etretat in the Rain* (123). Human activity is reduced and finally disappears altogther, and the colours become progressively brighter. *Etretat in the Rain* was painted after the trip to the south, and while there had presumably

122
Rough Sea at Etretat,
1868.
Oil on canvas;
66×131 cm,
26×51⅛ in.
Musée
d'Orsay, Paris

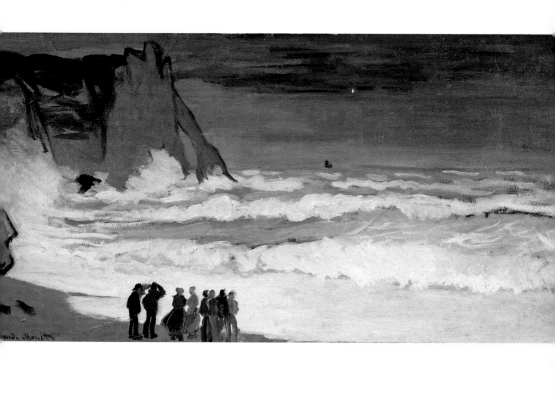

Claude Monet 1886

123
Etretat in the Rain,
1886.
Oil on canvas;
60·5×73·5 cm,
$23^7{}_8 \times 29$ in.
Nasjonal-
galleriet, Oslo

124
*The Needle
and the Porte
d'Aval,*
1885.
Oil on canvas;
64·9×81·1 cm,
25^5⁄$_8$×32 in.
Sterling and
Francine
Clark Art
Institute,
Williamstown

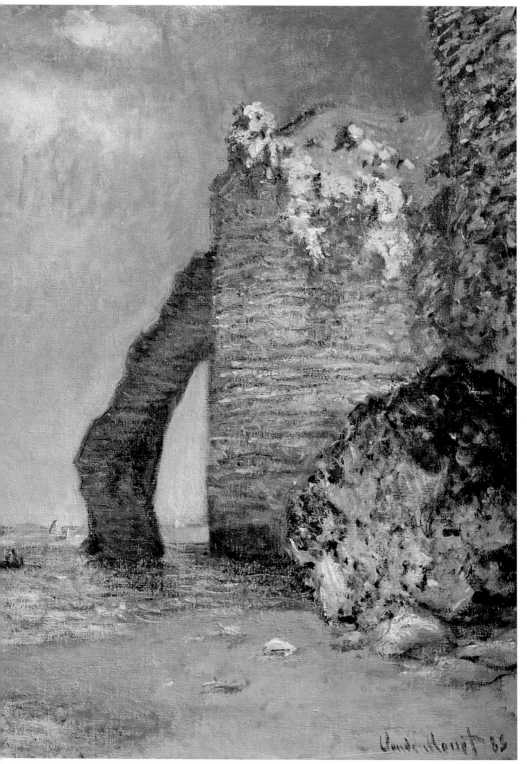

Claude Monet '85

always been moments when the Channel coast glowed in this way, it has been suggested that the brilliant clarity of the blues and greens transposes the hues of the Mediterranean to the chilly northern waters, showing that Monet's perceptions were subject to change and that he was constantly learning to see afresh.

A contemporary sunlit scene painted in the same region, *The Needle and the Porte d'Aval* (124), shows the same process at work even more clearly; the pinks and turquoises of the Riviera are mingled in the scintillating reflections and gossamer clouds. Pictures painted two years earlier seem muddy in comparison, while the works of the 1860s appear sullen and moody. This is partly the result of the shift towards lighter, sweeter colours, but it is enhanced by a major change in Monet's technique. Rather than painting with contrasts of light and dark, he is using contrasts of colour. In *The Needle and the Porte d'Aval* the reflection of the Needle is made up of flecks of contrasting paint, flesh-pink, lilac, ochre, all of the same brightness. This is very different from the sharp jumps between white foam, dark-grey sky and viridian water in *Rough Sea at Etretat*, where the breakers move back to a distant horizon in regular steps, giving the viewer a sense of receding into the immensity of the sea. *Rough Sea at Etretat* uses the traditional method of producing volume and depth in two dimensions; *The Needle and the Porte d'Aval* appears much flatter, as the use of small touches of colour draws attention to the surface of the canvas. Monet's brushstrokes become livelier as the subjects of the pictures become sparer and more simplified.

The brushwork and colouring of these mid-1880s pictures is far more abrupt and daring than that of Monet's earlier seascapes but it did not put off potential purchasers. By this time a certain section of the picture-buying public had actually come to value innovation more highly than tradition, and constant variation was necessary if an artist wished to stay ahead of the pack; the concept of 'progress' replaced 'deviation'. Novelty had become fashionable, and the proliferation of 'isms' which became so marked a feature of the art world towards the end of the nineteenth century produced a situation in which a distinct style was saleable in its own right.

The wrong kind of subjects could still offend, but Monet's shift from explicitly modern to 'timeless' scenes and the virtual disappearance of figures helped to make his pictures acceptable to a wide audience. Shorn of the association with political radicalism that had been fastened to it in previous decades, his painterly daring became palatable. Well received by critics and buyers alike, the decorative element of these new pictures was a positive asset; their apparent lack of subject was seen as offering an opportunity for enjoyable reverie on the part of the spectator.

As always, Monet was fully aware of these changes and of the potential threat posed by the Neo-Impressionists whose work was creating a considerable stir in Paris during the second half of the 1880s. The pictures of Seurat and Signac shared the sites and subject matter of Monet's work of the 1860s and 1870s, but they were sharply different in terms of technique. The luscious, glittering surfaces of Monet's 'tourist pictures', their singing colours and dramatic viewpoints set them at the opposite end of the spectrum from the hard, unvarying smoothness of the Neo-Impressionist 'dot'. The new young artists treated every scene with the same bright and unblinking gaze, imposing a form of visual banality on even the most animated and joyous subjects. In contrast, Monet made the familiar seem exotic. The dose of southern sun had transformed his painting, making it not only more richly patterned but more decorative – a change similar in kind, though very different visually, to the shift in Renoir's work of the same period.

Perhaps it was the confidence of middle age that allowed him to paint in a manner that could almost be seen as moving backwards, away from the 'Realism' of mid-century. His early models, Boudin and Jongkind, had tended towards the northern tradition of small-scale works based on the observation of everyday life and explicitly directed at a middle-class market. Monet's new pictures, with their combination of delicacy and opulence, could plausibly be linked to the traditions of the Renaissance and the 1600s, when Italy and the Italianate style had dominated French art. Luxurious and refined, they were immensely successful.

The year 1886 was highly important for Monet. A second show at Petit's in June sold well: his canvases went for around 1,500 francs each. More important for the long-term future of his reputation and his fortune, Durand-Ruel took a gamble and sent some forty or fifty paintings to the United States, very much against the artist's wishes. 'The Impressionists of Paris' opened in New York that April. Despite the difficulties he had encountered in his native land, or perhaps because of them, Monet's ambitions continued to be centred on France. In the summer of 1885, when the plan was first mooted, he had complained tetchily: 'I do not wish my pictures to disappear to the land of the Yankees ... I would prefer to reserve a choice for Paris, because it is above all there, and only there, that a little taste still exists.' In fact the show went extremely well, and an enthusiastic new market opened up.

Durand-Ruel had been amassing Impressionist pictures for so long that he needed to enlarge the pool of buyers in order finally to recoup on his decades of hair-raising investments. The 'tasteless Yankees' of Monet's grumblings turned out to be both receptive and free-spending, and a second American exhibition, in 1887, confirmed the trend. Declaring 'The Americans are not savages ... on the contrary, they are less ignorant, less bound by routine than our French collectors', Durand-Ruel opened a New York branch the following year, and by the end of the decade Monet was to become friendlier to his American buyers. Although the initial show brought about a breach between the artist and his dealer, in the twentieth century the Monet boom was to be fuelled mainly from Durand Ruel's New York gallery.

The last Impressionist group show was also held in 1886. Monet did not participate, and the exhibition was dominated by Seurat's monumental *Sunday Afternoon on the Island of La Grande Jatte* (125). Hung in the last room of the exhibition, together with works by Pissarro and Signac, it provided a fitting coda for Impressionism as a group effort. The critic Félix Fénéon, a great champion of Seurat's style, reviewed the show in the pamphlet *Impressionism*. He summarized the history of the movement, tracing its ancestry through Manet, Monet, Renoir, Degas and Pissarro, concluding with

125
Georges
Seurat,
*Sunday
Afternoon on
the Island of
La Grande
Jatte*,
1884–6.
Oil on canvas;
207·5×308 cm,
81^34×121^38 in.
The Art
Institute of
Chicago

the development of Neo-Impressionism as a distinct phenomenon which had supplanted the older style. Fénéon was not a particularly well-established or influential critic; however, his clearly expressed conviction that the heyday of Impressionism was past represented exactly the kind of judgement that Monet was determined to disprove with his 'tourist-paintings'.

The Mediterranean paintings had been a success. For his next series, Monet decided to experiment with a very different scene – the wild coast of Brittany. Although it was closer to Paris than Bordighera or Menton, Brittany had a reputation for exoticism and primitiveness which promised a striking contrast with the sensual pleasures of the

126
Storm off the Belle-Isle Coast,
1886.
Oil on canvas;
65×81·5 cm,
25⁵⁸×32¹⁸ in.
Musée d'Orsay, Paris

127
Théodore Gudin,
Storm on the Coast at Belle-Isle,
1851.
Oil on canvas;
131·5×202·5 cm,
51⁷⁸×79⁷⁸ in.
Musée des Beaux-Arts, Quimper

south. In September 1886 he installed himself on the island of Belle-Isle, 'the beautiful island'. It was one of the most remote points of the province and notoriously windswept. In October the season of storms began, and Monet was in his element. He found the rugged scenery and tempestuous weather so exciting that he extended his trip from two weeks to three months, placating the irritated Alice with daily letters complaining of rats under the bed, a strong smell of pig in the bedroom, and an unvarying diet – 'mainly eggs and lobster'. Despite these privations, he found the area thrilling to paint – 'sinister, diabolical, but superb' was his summary. Dark and emotional, the Breton pictures are very different from those

produced on the south coast (126). This was quite deliberate. Monet was well aware of the need to sing more than one tune, commenting to Durand-Ruel, 'It's all very well to be a man of the sun ... but one must not specialize in a single note ... I'm inspired by this sinister landscape, precisely because it is unlike what I'm used to doing.'

The terrain of Belle-Isle, with its bleak and treeless fields and plunging, jagged coastline, was the antithesis of the Riviera. The season, too, was different – early winter in a harsh climate, as opposed to the arrival of spring in the south. The contrast between the two groups of paintings was more than a matter of recording physical dissimilarity, however. Like Provence, Brittany had its own language, distinct racial composition and peculiar local customs. Since the 1850s, it had attracted painters who found its landscape exciting (127), its costumes picturesque and its religious rituals appealing – popular subjects for sale to a sophisticated metropolitan audience, which increasingly preferred its sacred scenes to show an ironic distancing from the subject (129).

By the time that Monet was painting, the region had also become associated with Neo-Impressionism – not the Divisionism of Seurat and Signac but the *cloisonné* or 'enamelled' technique practised by Gauguin, Émile Bernard (1868–1941) and Paul Sérusier (1863–1927). Gauguin's *The Vision after the Sermon* (128) is a stylistically innovative version of a sacred image painted in the same year as Monet's Brittany scenes; despite the very different subject, it demonstrates the same desire to convey a sense of the archaic qualities of the place. Like Seurat, Gauguin had been on the edge of the Impressionist group for several years; he was friendly with Pissarro, Cézanne and Degas and had exhibited in the group shows since 1880. Monet had a strong dislike of both the man and his work, and his Belle-Isle pictures, like the Etretat scenes of the previous summer, may be partly a response to the challenges of the younger artists.

At Belle-Isle Monet was accosted by John Russell, an Australian artist who owned a house there. Russell saw him painting and humbly asked if he were 'the Prince of the Impressionists'. Monet mistakenly identified his admirer as an American, but his fame had clearly

128
Paul Gauguin,
*The Vision
after the
Sermon; Jacob
Wrestling with
the Angel*,
1888.
Oil on canvas;
73× 92 cm,
28³⁄₄ ×36¹⁄₄ in.
National
Gallery of
Scotland,
Edinburgh

129
Pascal-
Adolphe-Jean
Dagnan-
Bouveret,
*Breton
Women at a
Pardon*,
1857.
Oil on canvas;
125·1×69·2 cm,
49¹⁄₄× 27¹⁄₄ in.
Museu
Calouste
Gulbenkian,
Lisbon

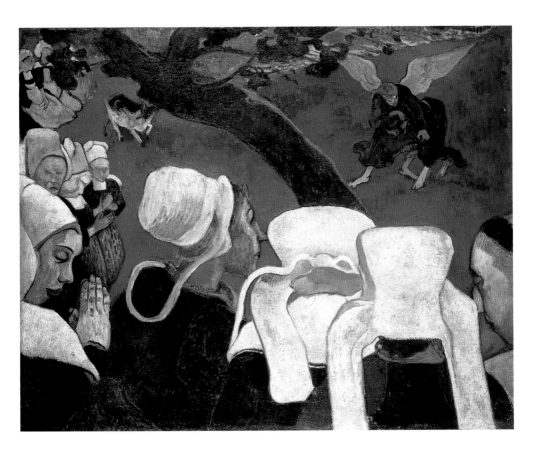

spread even beyond the transatlantic audience. As the presence of Russell suggests, by the 1880s Brittany was certainly not untouched by modernity and tourism, although it was still considered wild. The words 'savage' and 'sinister', which recur approvingly in Monet's written descriptions of the landscape, are the clichés of the cultured tourist in search of the exotic. Gauguin's desire for the 'primitive' was eventually to lead him to Polynesia, but at Pont-Aven, not far from Belle-Isle, he, too, could comment happily: 'I love Brittany; there I find the savage and the primitive.'

The general popularity of such received ideas can be gauged from the fact that both painters' Breton works were taken up by an ambitious new arrival on the gallery scene, the firm of Boussod and Valadon. Their Paris buyer was a young Dutchman, Theo van Gogh. While Monet's pictures were reasonably safe purchases, since a market for his work seemed well established, Gauguin's pictures were a different matter. Just as Durand-Ruel had gone out on a limb in supporting the Impressionists, so Theo van Gogh, encouraged by his brother, the painter Vincent van Gogh (1853–90), was to help do the same for Neo-Impressionism. For the next few years he also bought many Monets.

130
Pyramids of Port-Coton, 1886.
Oil on canvas; 65·5×65·5 cm, 25³⁄₄ × 25³⁄₄ in.
Fondation Rau pour le Tiers-Monde, Zurich

While Monet was painting at Belle-Isle, Fénéon had written another article announcing the demise of Impressionism. He contrasted its prettiness and romanticism unfavourably with the 'scientific rigour' of Seurat and his followers. Monet was fully aware of the importance of press coverage; he subscribed to two newspaper clipping services, and the article may have been forwarded to him in Brittany. Although we cannot be sure whether Monet read the review, his Belle-Isle paintings seem to tackle the accusations head on. Sombre in mood and colour, they examine the landscape in a new and rigorous manner. The constraints of working on a small island may have helped to concentrate the artist's attention; more than any previous set of 'tourist' pictures, the Belle-Isle canvases focus tightly on a limited number of motifs. One group of paintings depicts the same subject six times; the tall, wave-eroded rocks known as the 'pyramids' are studied from the same viewpoint, under different

weather conditions (130). Another five show a storm at sea. After reworking them in the studio, Monet exhibited ten together at Petit's in the spring of 1887, a contribution to the '6th Exposition Internationale' that provided a kind of substitute for the defunct Impressionist group show. He wanted his Brittany pictures to be seen as an ensemble, not only for the decorative effect but also in order to make clear the process of observation and perception which had produced them.

Heavily worked in strong colours, the Romanticism of these exotic paintings displayed the personal quality of the artist's vision. Their encrusted surfaces are as different as possible from the smooth, semi-mechanical style of Neo-Impressionist 'dot painting' or Gauguin's areas of flat colour. Far more dramatic and less obviously appealing than the Mediterranean scenes, they were equally success-ful with the public. A laudatory article by the writer Gustave Geffroy (1855–1926), critic of the radical paper *La Justice*, appeared during the exhibition. Geffroy had reviewed Monet's work favourably in the past, and he was to become his first biographer. He and Monet had happened to be staying in the same hotel on Belle-Isle, and Geffroy had been able to watch Monet at work. He was therefore able to pad out his review with a lengthy and romanticized description of Monet's working methods – a process which he described as 'alchemy'. This emphasis on the artist as a magician was part of the new critical approach to Monet's work in which the process of perception, the distilling of visual experience into a physical object, was seen as fascinating in itself. Monet was apparently able to trans-form pigment into gold. It really appeared that he could do no wrong, and his stock with the dealers rose accordingly.

Early in 1888 Monet returned to the Mediterranean coast, this time to Antibes, a flourishing town with a spectacular coastline. Once again the new location meant a change of tack; he wrote to Alice, 'After terrible Belle-Isle, this is going to be tender, here there's nothing but blue, rose and gold.' Prolonged exposure to the scarred and powerful Breton scenery, however, had altered the artist's view of his own inclinations; having been hailed by Durand-Ruel as 'the painter of

sunlight', he now found the even luminosity of the southern spring almost impossible to handle. In a letter to Berthe Morisot, he complained 'It's so difficult, so delicate, so tender … particularly for someone like me, who is inclined towards tougher subjects.'

Despite his misgivings, he managed to work productively, and the new paintings were on exhibition on 4 June, in record time. Less than a month after the artist returned from the coast, Theo van Gogh presented 'Ten Marines from Antibes' at Boussod and Valadon (131). Fresh from the artist's easel and announced by the title as a limited number of precious and rare objects, Monet's first show devoted to a single spot was sensationally successful, initiating an astonishing spiral of speculation in which pictures were sold and resold several times in a single year. Monet had ensured that his contract with this particular gallery gave him a half share in the profit of all resales; since the price of one painting rose from 1,300 to 3,000 francs in eight days, the sub-clause was worth including.

While the pictures are certainly covetable, with their dazzling light and jewel-like colours, this sudden rise in their financial value cannot be explained purely in terms of visual appeal. 'Monet' had become a brand-name, and his pictures were now investments; much of the reselling was done between professional dealers who were well aware of the manner in which they were manipulating the market to increase prices. While Monet may have been one of the most spectacular beneficiaries of the new art-market, he was not alone. All the Impressionists were starting to do much better.

There are of course reasons why it was Monet and not, for example, Cézanne who became so desirable in the late 1880s. His pictures were less difficult, and buyers did not need to believe in the artist as they did with Cézanne. Soothing and beautiful, Monet's landscapes were seen as truly French. They also appeared apolitical and unprob-lematic in a period of considerable unrest, when the government seemed to be lurching from crisis to crisis; indeed, Geffroy had recommended the Antibes exhibition to readers of *La Justice* as an antidote to the strain of current events.

131
Cap d'Antibes,
Mistral,
1888.
Oil on canvas;
66×81·3 cm,
26×32 in.
Museum of
Fine Arts,
Boston

In February 1889 Monet travelled with Geffroy to the Massif Central, in the heart of France. The journey had been planned as a social visit, with a friend of Geffroy, the poet Maurice Rollinat, putting them up at his home in Fresselines. Rollinat was a local, and he took both his visitors on long walks around the valley of the River Creuse. After the sweetness of Antibes, Monet was ready for another tough subject – a pattern seemed to be emerging of pretty southern scenes alternated with harsher, more monumental subjects. He noted approvingly the 'real savagery' of the Creuse and, pausing only to collect his materials from Giverny, he embarked on a three-month campaign. It was his last major trip for five years. The Massif Central was a fitting final point to his decade of charting the French landscape; having worked on the northern, southern and western coasts, he had now travelled from the margins of the country to its heart.

132
The Creuse at Sunset,
1889.
Oil on canvas;
73×70 cm,
28³⁄₄×27⁵⁄₈ in.
Musée
d'Unterlinden,
Colmar

133
The Petite Creuse River,
1889.
Oil on canvas;
65·9×93·1 cm,
26×36⁵⁄₈ in.
The Art
Institute of
Chicago

Between March and May he painted twenty-four canvases, his last important works of the 1880s. Although very different in its forms, the mood of the landscape, sombre and almost threatening, reminded Monet of Belle-Isle; like the Belle-Isle paintings, the Creuse pictures are enormously concentrated. Simple motifs are repeated: the riverbed and the rocks around it appear in no fewer than ten works, all made from the same point. The unvarying nature of these elemental organic forms is set off by the extraordinary range of colours used (112 and 132, 133). With their strident, acidic tones, Monet considered the finished works 'lugubrious'; however, they were even more popular than the Antibes paintings.

The Creuse pictures are the product of a specially intense engage-ment with the subject and an anxious process of reworking which left Monet cursing the forces of nature when the slow pace of his painting was overtaken by the change of seasons. These are serious pictures; their bulk and monumentality could be seen as a riposte to the equally monumental works of Seurat, while the surging brush-work is a self-conscious display of individual physicality quite unlike the precision of Pointillism. The energy that Monet found in the torrents and wind-tossed vegetation of the Creuse, however, could be an enemy to the artist as well as a source of inspiration. The tree

in *The Petite Creuse River* (133) had begun to sprout leaves while the artist was still painting its bare branches. Appalled by a sight that threatened the balance of this composition and four others using the same motif, Monet negotiated with the tree's owner, paid fifty francs in compensation, and had most of the buds stripped away by two labourers. Having thus erased this irritating manifestation of the untidiness of the natural world, he was able to complete the paintings. While this incident obviously demonstrates the inaccuracy of the numerous descriptions of Monet's fidelity to the random features of the scene before him, it also proves how essential it was for him to have the motif before his eyes; repainting it from memory in the studio sessions would have been impossible. The balance between the moments of observation and reflection was a very delicate one.

Exhausted by this particularly taxing campaign, Monet was ready to consolidate his success. The centennial of the French Revolution was marked in 1889 by another Universal Exposition, including a pair of government-sponsored art shows. Three Monets were on display at the centennial exhibition, and the artist was offered an official decoration – which he refused. Having made his fortune outside the state system, he was not inclined to be grateful for favours bestowed too late to be of use. Far more important in practical terms was a joint show with the sculptor Auguste Rodin (1840–1917), held at Petit's between June and September – an unusually lengthy run for a private exhibition. Timed to run concurrently with the Universal Exposition which was attracting large numbers of foreign visitors to the city, the show provided a virtual retrospective of Monet's work since the early 1860s, with almost 150 works and a 90-page catalogue. Many of the works were on loan, but others, especially the more recent pictures, were for sale. Over half had been painted within the last ten years. The exhibition displayed both the artist's long struggle and his continuing creativity. A commercial and artistic success, it provided a resounding finale to this critical decade.

Monet's peregrinations of the 1880s had been balanced by a new stability in his domestic life, a stability rooted not only in his relationship with Alice Hoschedé and her children but also in a specific place – Giverny. In the spring of 1883 Monet found the house in which he would spend the second half of his life. It was called Le Pressoir – the house of the cider-press – and the gardens that he created there in the fertile Seine valley gradually became more and more important for him, both as a sanctuary and as a subject. From the 1870s onwards he had been retreating from the city and from public life, and in the last years of his life he seldom left Giverny.

Monet had never really liked Poissy, and early in 1883 he began the search for somewhere better. In Giverny he discovered the perfect spot (135). The village was small, but it was relatively prosperous and fairly accessible by train, road or boat. The surrounding countryside was fertile. Giverny lay beside the Epte, a Seine tributary, and a small stream, the Ru. The east–west alignment of the valley meant that there was a constant, gentle light which appealed to Monet. During the rest of the decade the stability of Giverny counterbalanced the exotic subjects of his travel paintings, and the range of new sights refreshed and sharpened his perceptions of familiar places.

In the late 1860s, while living with Camille and Jean in a house at Etretat, Monet had written to Bazille:

I am very happy … I am like a pig in clover, surrounded here by everything I love. I spend my time in the open air [and] then, in the evening, my dear friend, I find in my little house a good fire and a good little family … I am enjoying the most perfect tranquillity … I wish I could stay just like this forever, in a quiet corner of nature like this one.

At Giverny he and Alice created the ideal domestic environment, a simple but beautiful house in a glorious garden surrounded by

peaceful rural landscape next to a river. The move made public a relationship which seems to have evolved rather haphazardly; although they did not marry until after Ernest's death in 1891, Alice Hoschedé's decision to set up home with Monet and his two sons made her shift of alliance unequivocal and she was often prematurely referred to as 'Madame Monet'.

Giverny was her domain as much as Monet's; in the early years her allowance largely funded its upkeep (the initial move had been funded, once again, by a loan from Durand-Ruel), and during the first decade at Giverny Monet was often absent for long periods. Of course Alice was not left alone with eight children; there were

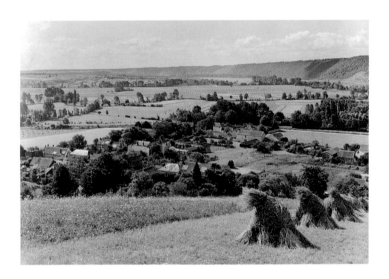

135
The village of
Giverny.
Country Life,
1933

maids, cooks and gardeners to help keep things in order, but without her constant presence it would have been impossible for Monet to have worked in the way that he did during the 1880s. The security provided by Giverny allowed him to become completely absorbed in the tourist paintings, and the entire household revolved around his needs and moods while he was in residence.

Alice's second son Jean-Pierre later recalled the clockwork organiza-tion of mealtimes (lunch at 11.30, dinner at 7), and the fearful sulks which resulted if the Master was kept waiting after the bell had rung twice (134). The black pall which fell over the house when Monet was

angry affected all its residents, whose lives were regulated by the rhythms and demands of his work. Poor weather or unsuccessful painting could result in days when he would refuse to get out of bed and everyone would tiptoe around the house as if a death had occurred. His relationship with Alice was passionate and occasionally dramatic; sometimes he would storm out of the house, spending the night at the hotel in nearby Vernon. Whatever its defects, however, the household at Giverny exerted a strong pull on all members of the joint family as they grew up, producing an incestuous tangle of relationships (138). Perhaps partly because of the irregular status of their own union and Monet's unconventional career as a painter, he and Alice exerted authoritarian control over their adult children, refusing to allow the daughters to marry men who seemed insufficiently solid and stressing the importance of proper professional careers for the sons.

The oldest, Monet's son Jean, studied chemistry in Switzerland and was then apprenticed to his uncle Léon, who was a pharmacist. In 1897 he returned to the family home to marry his stepsister Blanche, the third of the Hoschedé girls. They moved into a house nearby, and after her mother's demise and Jean's early death the childless Blanche returned to spend the rest of her life at Giverny. Jacques Hoschedé became a shipbuilder and went to Norway, where he married a local widow and acquired a stepdaughter, Anna Bergman (136). He had inherited Ernest's lack of business acumen and constantly needed to be bailed out by his elders. Like Jean, he also spent long periods of his married life at Giverny, where Monet had built special apartments for the two young couples over one of his studios. Jean-Pierre Hoschedé was sent to stay with friends of his mother to study agriculture in Périgord; he married their daughter, Geneviève Costadeau, and managed to create a relatively independent life for himself. As an old man he published a memoir of the artist, *Claude Monet, ce mal connu* (1961), which is the source for much of what we know about life at Giverny.

Michel Monet, Camille's younger son, was keen on combustion-engines; together with Jean-Pierre he seems to have spent much

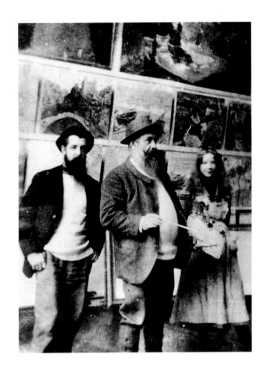

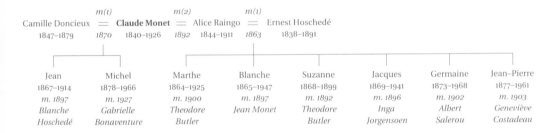

| Camille Doncieux | m(1) | **Claude Monet** | m(2) | Alice Raingo | m(1) | Ernest Hoschedé |
| 1847–1879 | 1870 | 1840–1926 | 1892 | 1844–1911 | 1863 | 1838–1891 |

Jean	Michel	Marthe	Blanche	Suzanne	Jacques	Germaine	Jean–Pierre
1867–1914	1878–1966	1864–1925	1865–1947	1868–1899	1869–1941	1873–1968	1877–1961
m. 1897	m. 1927	m. 1900	m. 1897	m. 1892	m. 1896	m. 1902	m. 1903
Blanche	Gabrielle	Theodore	Jean Monet	Theodore	Inga	Albert	Geneviève
Hoschedé	Bonaventure	Butler		Butler	Jorgensoen	Salerou	Costadeau

of his early years inventing such machines as a petrol-powered bicycle. The boys encouraged their parents to buy cars and in their old age both Claude and Alice, rather improbably, became motor-racing enthusiasts (137). As an adult, Michel Monet went on safaris in Africa; he also painted, always in secret. He married an artist's model, a woman his father disapproved of, but only in late middle age, after Claude's death. The last survivor of the original Giverny tribe, he allowed the place to fall into ruin and, although he left it to the state when he died in 1966 (as a result of a driving accident), it was in such poor condition that the paintings there were all transferred to the Musée Marmottan in Paris.

136
Monet
(centre) in the
second studio
with Jacques
Hoschedé and
Anna
Bergman

137
Monet in his
Panhard-
Levassor,
c.1901

138
The Monet-
Hoschedé
family tree

During the 1970s and 1980s the house and gardens were restored at immense expense by a committee of Monet enthusiasts, mainly American; although it contains only reproductions of his paintings, Giverny has become one of the most visited sites in France – a rival to Versailles. This is not as uniquely modern a phenomenon as might at first appear. Giverny had become a popular destination for artists within a few years of Monet's move. The first group arrived in the 1880s; many were American students, abandoning their Paris studios to spend the summer in this charming and affordable spot. Towards the end of the century Giverny was already well on the way to attaining the status of pilgrim-shrine that it enjoys today.

The unspoilt charm which had attracted the artists soon began to disappear. In 1887 the local café became a hotel, and the little grocery shop started to stock exotica such as English tea, marshmallows and maple-syrup, as well as frames, canvases and brushes. Within ten years tennis-courts had been constructed in the centre of the village and French visitors complained that the English language was essential for anyone wishing to participate in social life at Giverny. Art tourism was supplementing agriculture as the main local industry; although some wealthy Francophile Americans took houses nearby for the summer and could have bought Monet's paintings fresh from the fields, others had come to learn how to manufacture them. The great and growing popularity of Monet's work in the USA, fuelled by the opening of Durand-Ruel's New York branch, meant that young

American artists were familiar with his work and well aware of its saleability. Many of their pictures can now be seen next door to the Maison du Pressoir, in the Museum of American Art which opened in 1992.

Monet did not brook disciples, and although he had been well-disposed towards the new arrivals at first, he came to find 'those damned Americans' more and more of a nuisance. Very few of the visitors had any real talent, and most of them produced irritating pastiches of his own work, endless soft-focus views of haystacks and sunlit fields. A constant stream of importunate would-be guests appeared at the house. At the height of the craze, Monet felt that he could no longer work out of doors: 'I could not make a study in

139
Ernest
Hareaux,
*Working in
the Open Air*,
1888–9

the countryside without seeing myself surrounded by curious [Americans]. Easels and sun-umbrellas sprouted around the garden like mushrooms, I was very annoyed, and seriously thought about packing my bags' (139). The younger members of the family probably enjoyed all the bustle, and more than one of the American men had his eye on the daughters of the house. Theodore Butler, a long-established resident, managed to scoop the pool by marrying two out of four. The first Madame Butler was Suzanne, Monet's favourite model.

Having been unwilling to cede his paintings to the 'Yankees', Monet was predictably aghast at the idea of exporting a member of the family. Despite a genuine liking for Butler, both Monet and Alice

were reluctant to allow the match. Eventually, however, their consent was sealed by a double marriage. Ernest Hoschedé had died in 1891, nursed by Alice and buried at Giverny where she – and later Monet – would eventually join him. His death permitted Claude and Alice to tuck their own wedding in discreetly, four days before that of the young people, in July 1892. This meant that Monet, as Suzanne's official stepfather, was able to give her away in traditional style. The wedding was a true Giverny affair; Alice was devout, but Monet was an atheist, whose friendship with the local priest, Abbé Toussaint, was based on horticulture rather than religion. Nevertheless, he led the veiled Suzanne from the town hall to the church, in a procession watched by all the painters of the village.

This marriage and those that followed did little to weaken Monet's position as patriarch; on the contrary, it simply increased the family circle as a new generation of children appeared. The two little Butlers, James (Jim) and Alice (Lily), were mainly brought up in the grandparental establishment rather than in their parent's house nearby, as Suzanne contracted a form of degenerative paralysis shortly after her daughter's birth. She died in 1899, and in October 1890 Theodore Butler married her older sister, Marthe, who had effectively been taking care of their children for many years (140). The Hoschedé women certainly had a powerful sense of family responsibility; both Blanche and Marthe felt it incumbent upon them partially to replace their mother in Monet's household after he had been widowed for the second time in 1911. Of all the daughters, only the youngest, Germaine, can be said to have really 'married out' of the clan. Her first love-affair had been with a childhood companion, the son of the painter Sisley. A penniless would-be inventor, Pierre Sisley was not considered an eligible match by Claude and Alice. Germaine was packed off to the south of France, where she duly married a lawyer, Alfred Salerou. They eventually established themselves in Paris; their two daughters, Nitia and Sisi, can be seen in many photographs from the Giverny family albums.

From the mid-1880s Alice and the children became more visible in Monet's pictures. Challenged and stimulated by the constantly vary-

1	Isabelle Pagny	14	Fernand Haunddorf
2	Joseph Pagny	15	Lucien Raingo-Pelouse
3	Anna Bergman	16	Achille Pagny
4	Claude Monet	17	Germaine Hoschedé
5	Alice Monet	18	Suzanne Raingo
6	Marthe Hoschedé-Butler	19	Alice Butler
7	Jean Monet	20	Abbé Toussaint,
8	Theodore Earl Butler		the curé of Giverny
9	Blanche Hoschedé-Monet	21	Inga Jorgensoen-
10	Jean-Pierre Hoschedé		Hoschedé
11	Madeleine Pagny	22	Germain Raingo-Pelouse
12	Jeanne Sisley	23	James Philippe Butler
13	Alice Raingo-Pelouse	24	Pierre Sisley

ing scenes of his painting campaigns in Brittany, Normandy and the south, however, Monet took some time to adjust to the different scale and feeling of the area around his house, and it was not really until the summer of 1884 that he began to treat it seriously. Although the broad outline of the local landscape was thoroughly familiar to him – after all, he had been painting the Seine valley most of his life – the minute particularities of Giverny demanded careful study and exploration. In 1883 he had written of its promise in a letter to Durand-Ruel asking for assistance with the move: 'Once settled, I hope to produce masterpieces, because I like the landscape very much.' Over the next forty years it was to become his main and then his only subject, but the necessary process of acclimatization was slow. The type of motif for which he was looking was in some ways the contrary of the spectacular and 'typical' subjects of the tourist paintings; at Giverny he searched out the hidden and the low-key, looking always for things which were 'not too picturesque'. Exploring on foot and by water, he built up an intimate knowledge of every hollow in the fields and every turn in the stream, believing that 'One must always take a certain time to familiarize oneself with a new landscape.'

Monet's tourist paintings of the 1880s were deliberately planned to widen his scope; once he had established himself as an artist who could tackle the whole of France, he was able to add scenes from Giverny to his exhibitions without running the danger of being pigeon-holed as a one-trick wonder. Their lack of glamour acted as an astringent contrast to the bejewelled and dramatic images of the coast.

From 1885 he painted the Giverny fields. In these intriguing pictures the artist seems to be feeling his way, exploring the local features which were to become virtual obsessions: indeed stacks of hay or wheat and screens of trees became the exclusive subject of a grand series of paintings during the next decade. While his subjects were the familiar rural motifs of a multitude of landscape painters, the intensity with which he began to deepen his understanding of the ordinary countryside around his house was entirely his own (141). It was an intensity based on profound knowledge of the place, with the

way in which the light changed at different hours of the day. From it grew a sense of the importance of those changeable and contingent aspects – weather, seasons and light – affecting scenery which was in itself unremarkable, a subject as worthy of record as the heroic Grand Themes of the history painters. Consciously or unconsciously, he was gradually moving to take their place.

During the next two years Monet painted numerous landscapes with figures, always using members of the family as models. He seldom painted the boys, however, perhaps because they were less available; the older two were often away and the little ones probably fidgeted. On the other hand, Marthe, Blanche, Suzanne and Germaine were mainly educated at home and much of their time was spent in such pursuits as sewing, rowing or reading in the garden. Suzanne was Monet's favourite model, and in 1886 he painted two pictures of her holding a parasol in a pose which was a deliberate reprise of an 1875 portrait of Camille, *Woman with a Parasol* (142). Once again a comparison between the two paintings shows how drastically his attitude to the model had altered; in the earlier picture Camille's expression is clearly rendered, while Suzanne's features are simply a blur (143). The two later paintings were named in a way that tells the viewer not to look for character or story. They are simply called 'Study of a figure outdoors, facing left' and 'facing right'. Exhibited with these titles, they directed the audience to the artist's increasing preoccupation with formal values, questions of composition, balance, harmony and colour.

The figures in these pictures are seldom recognizable and tend to anonymity as in *Sunlight Effect Under the Poplars* (144). While it is true that, even as adult women, the Hoschedé daughters often dressed alike, and the two little boys generally wore matching costumes, Monet's reasons for painting them as etiolated matchstick figures with undifferentiated features probably had more to do with a general shift in his attitude to the relationship between landscape and the human presence. During the 1860s and 1870s the figures in his pictures were often blank and unreadable, but there was usually a greater distance between them and the viewer, and Camille, at

141
Poppy Field,
1890.
Oil on canvas;
60×100 cm,
$23^5\!/\!8 \times 39^3\!/\!8$ in.
Smith College,
Northampton,
Massachusetts

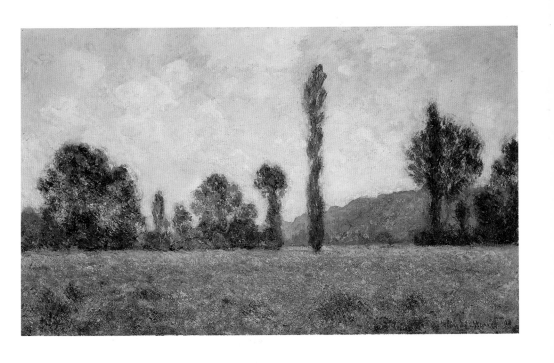

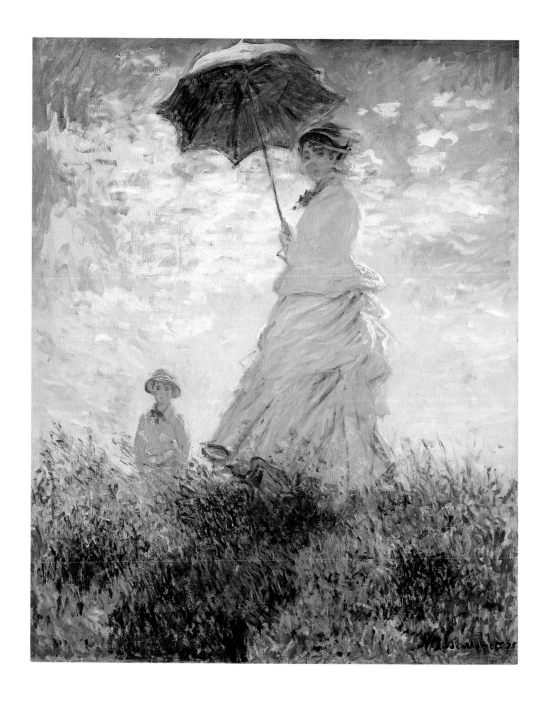

least, tended to be sharply characterized. By 1887, however, Monet
was writing to Duret of his desire to paint figures 'in the open air, as
I understand them, treated like landscape', in a manner that would
bring out their physical properties rather than involving any kind
of emotional or psychological contact. If a contemporary anecdote
is to be believed, Alice was unconvinced of the merits of such an
approach, and when Monet expressed an interest in working from
the nude with a professional model she vetoed the idea, declaring
'If a model comes into the house, I leave it.' Fortunately she and her
daughters provided five fully-clothed female figures on a more
or less permanent basis, and during the summer months they were
outside most of the time – especially on the river.

Money had been tight before the move, and the family did not come
to Giverny with a wealth of possessions; even at the end of Monet's
life, when he had been extremely rich for many years, the house
was furnished with simplicity. In 1883, however, their 'essentials'
included four boats – two mahogany sculls, the large rowing boat or
Norvégienne and the studio boat from which Monet painted many
of his river scenes. Towed by barge to a suitable site on the Seine,
Nettle Island (Île aux Orties), they became a focus of the family's
existence during the summer months. Manet had once referred to
Monet as 'the Raphael of water', and one of Giverny's major attrac-
tions must have been its proximity to two rivers. Between 1887 and
1890 Monet produced a number of pictures of the Hoschedé girls
floating, fishing, sculling or just drifting along in the family boats.

These lyrical pictures are more than romantic evocations of updated
water-nymphs; they also show Monet's increasing fascination with
the surface of water and its double properties, transparency and
reflectivity. One of his best-known paintings from this period,
The Rowing Boat (145) is the last of the series. Possibly unfinished,
it shows an empty vessel; there is no horizon and the disorientated
viewer is forced to focus on the clear, honey-dark water and the
plants swarming beneath it like elvers. The contrast with a similar
subject from the previous decade, *The Studio Boat* (see 79),
demonstrates the change in Monet's interests; he is looking into

142 Previous
page
*Woman with
a Parasol,*
1875.
Oil on canvas;
100×81 cm,
$39^3\!/_8×31^7\!/_8$ in.
National
Gallery of Art,
Washington,
DC
143
*Study of a
Figure
Outdoors,
Facing Left,*
1886.
Oil on canvas;
131×88 cm,
$51^5\!/_8×34^5\!/_8$ in.
Musée
d'Orsay, Paris

144
*Sunlight Effect
Under the
Poplars,*
1887.
Oil on canvas;
74·3×93 cm,
$29^1\!/_4×36^5\!/_8$ in.
Staatsgalerie,
Stuttgart

the water, not across it. While painting these Giverny boating subjects in 1890, he wrote to Geffroy: 'Once again, I have taken up things which are impossible to do; water with grasses moving in the depths … it's marvellous to see, but it's enough to drive one mad.' The attempt to capture ever more fugitive effects, especially changing patterns of light on water, was to preoccupy him for the last twenty years of his life.

Monet's first paintings of the area around Giverny concentrated on the river, reflecting the church and village of Vernon, a short distance upstream. His first pictures of Vernon recall similar subjects painted at Vétheuil, such as *View of the Church at Vernon* (146). These paintings are also similar in some ways to his coastal pictures of the 1880s; they, too, look directly at the motif, situating the viewer in the centre of the water rather than securely on land, and they typically have a high horizon or none at all. The river continued to fascinate Monet: works from the later 1880s, such as *A Bend in the Epte* (147), show a sealed, self-enclosed world, a river without fishermen, laundresses or traffic. The fields on the banks are equally empty of villagers; flower-filled and populated only by strolling Monet–Hoschedés, they seem to be simply an extension of the privacy of the house and its burgeoning garden.

Monet had always loved gardening – before he moved to Giverny roughly one eighth of his paintings had garden subjects. Living in rented houses, however, he had been unable to undertake any major horticultural schemes. At Giverny, especially after he bought the property in 1890, he was able to translate his pleasure in painting flowers into planning three-dimensional compositions, and the garden he created there, over many years and at vast expense, is rightly considered a masterpiece in its own way.

In 1883 Le Pressoir had a conventional Norman kitchen garden, an orchard and a great deal of box hedge which both Claude and Alice disliked intensely. The box hedge went quickly, but the garden continued to supply their table for many years until a second property, the nearby Blue House, was bought to fill this vital role and the area around Le Pressoir could be given over entirely to more

145
The Rowing Boat,
1890.
Oil on canvas;
146×133 cm,
57$\frac{1}{2}$×52$\frac{3}{8}$ in.
Musée Marmottan, Paris

ethereal pleasures. Monet combined local varieties and expensive foreign plants, and eventually had two greenhouses installed. Lilla Cabot Perry, an American writer and artist who was Monet's neighbour at Giverny for ten years, recalled that Monet, Alice and all the girls spent the night in a greenhouse to make sure that the temperature control was working properly. The entire family was involved; gardening was incorporated into the curriculum of those educated at home. With the aid of the Abbé Toussaint, their tutor, Michel and Jean-Pierre produced a guide to local flora and a new hybrid poppy, *Papavum x Monetii* – now, apparently, lost to gardeners. Some years later, when a team of six professionals had taken over the day-to-day operations, it was followed with a tribute to Alice, the iris *Madame Monet.*

Monet's withdrawal from city life into his private garden was typical of a wider Third Republic phenomenon. In a mood of general disenchantment with political life, inward-turning pursuits such as interior decoration, art collecting and gardening became increasingly popular. In 1887 the editor of a horticultural journal, *Le Jardin*, wrote in his opening number, 'In no other era have flowers and plants been so widely appreciated; they preside at all our ceremonies, take part in our festivities … and their mass cultivation has become a source of revenue for many regions formerly in dire straits.' Like many landscape painters, Monet sometimes turned to still lifes when the weather was unsuitable for outdoor work. Such pieces had always sold well, and his garden at Giverny was initially intended as a source of cut flowers for painting. Soon, however, it became a work of art in itself and he began to see it as the perfect subject for painting, malleable as the fields and hills could never be.

Riotous and sprawling, Giverny's gardens could scarcely have been more different from the traditional, formal grounds normally seen in France, while the 'water-garden' was intended to have a Japanese atmosphere. The gardens as much as the house and its inhabitants set Le Pressoir apart from the old-established Givernois, who regarded Monet's schemes with unmixed suspicion.

In 1893 he applied for permission to divert water from the Ru into the

146
View of the Church at Vernon,
1883.
Oil on canvas;
64·8×80 cm,
25¹₂×31¹₂ in.
Yamagata Museum
of Art

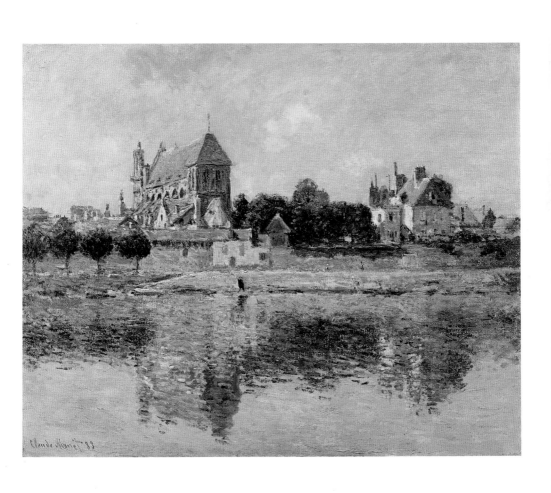

147
A Bend in the
Epte,
1888.
Oil on canvas;
73×92 cm,
28³⁄₄×36¹⁄₄ in.
Philadelphia
Museum
of Art

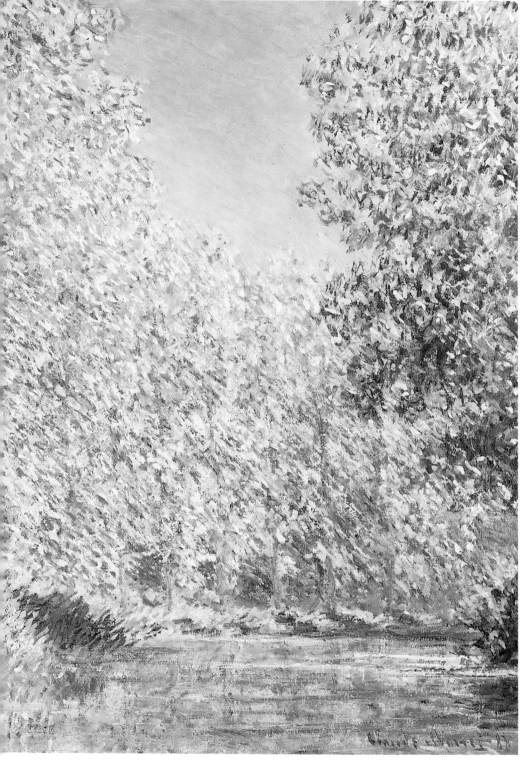

pond he had recently bought in a neighbouring field. He wanted to establish a lily pool, with a number of unusual plants that needed fresh water and careful handling. The villagers used the river for watering their cattle and washing their linen; and there were many objections. The resulting negotiations sent Monet into a rage; from Rouen he wrote to Alice that she should simply throw the plants into the river, but in the end the pond went ahead and was even expanded twice, in 1901 and in 1910 (148). In truth, it was too late for the villagers to fight the irreversible process of transformation that was already well under way, with the arrival of tennis-playing Americans, smart Parisians and the presence of the curiously relaxed establishment

148
Giverny. Plan of the gardens in their final form
A The 'Clos Normand'
1 The house
2 The second studio
3 The third studio
4 The greenhouses

B The Water Garden
1 Water-lily pond
2 Japanese footbridge

C Road to Vernon
D Railway

where the little boys wore pink felt hats and everyone, from Alice to the kitchen-maids, referred to the head of the household as 'Monet'. For the most part Monet's relations with the Giverny community were based firmly on cash. After he had bought up a row of trees he was painting in order to prevent them being felled before he had finished, it is perhaps not surprising that local farmers felt it was fair to demand payment for letting him paint in their fields. After all, he was clearly happy painting things he owned; as Cézanne commented bitterly, recalling a visit to Giverny in 1894, 'Monet is a great lord who treats himself to the haystacks that he likes. If he likes a little field, he buys it.'

The way in which Monet actually created his subject matter can be seen clearly in the development of the gardens. In 1890 he agreed to buy the house, paying 22,000 francs in four yearly instalments. The sum was less than a couple of his recent pictures and he could afford to invest lavishly in the grounds. Giverny's gardens are prized today not only because of their intrinsic beauty but also because of the fascination of comparing them with the artist's paintings. As the new schemes for the garden matured, so they began to attract him as motifs (150, 151), and the boundary between the garden as subject and as a work of art in its own right became increasingly blurred. After permission for the lily pond was finally granted, the

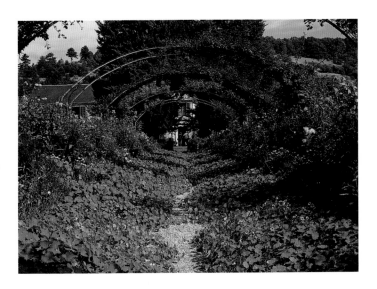

149
Giverny. The Grande Allée leading to the house

painter extended his personal domain even further, and the flamboy-ant flower-beds of the old garden were eventually complemented by the more restrained 'Japanese' feel of the water-garden on the other side of the road, with its hump-backed bridge. The garden became internationally famous in its own right, attracting visitors from as far as Japan (152). When the dust from their cars threatened to damage the aquatic plants, Monet paid to have the road tarred.

The garden today is a reconstruction (149), based on photographs, notes, written descriptions and the memories of those who knew it in its heyday. The story of its extraordinary renaissance has been

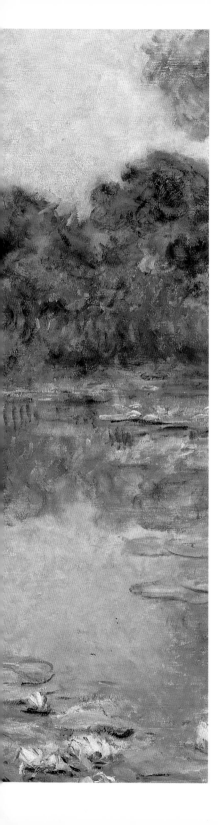

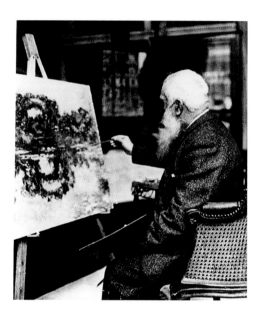

150
*The Rose
Portal*,
1913.
Oil on canvas;
81×92 cm,
31⁷⁄₈×36¹⁄₄ in.
Phoenix Art
Museum,
Arizona

151
Monet
painting the
rose portal –
in the studio,
1913

documented by Vivian Russell, making clear the manner in which the garden has been adapted for mass tourism. Monet's garden flowered only in the summer, for a few months; now visitors demand a show throughout the season, and a 'natural' look is achieved by incessant work all year round. What was once a family garden now accommodates half a million people a year, all eager for an intimate look at the artist's domestic life. An electric fence discreetly hedges the bamboo clump in the Japanese garden, while the little house has an endless stream of tourists up and down its narrow stairs. The home of the painter of tourist views has become a tourist attraction in its own right, a phenomenon which would have been altogether familiar to the artist.

As Monet's fame grew, so increasing numbers of admirers and critics came to Giverny. Monet was always aware of the commercial potential of good publicity, and the more important visitors were treated to a finely orchestrated performance in which the charm and intimacy of Giverny was complemented by an excellent lunch, after which they would believe whatever the artist chose to tell them, repeating obediently – and against all evidence – 'the open air is his only studio'. As his market stock soared through the 1880s and 1890s Monet continued to emphasize his position as a simple observer of the natural world. Repeatedly he insisted that he simply recorded what he saw, and that his style was just a matter of finely tuned sympathy to natural sensations. His way of looking was his own, however, and no amount of study or imitation could match it. In 1894 Theodore Robinson described a meeting between Monet and an eager young painter showing him yet another pastiched landscape. 'Monet asks "And do you really see nature like that?".' When the naive would-be disciple answered that he did, Monet put him down with a single riposte: 'Impossible, my dear friend; that is how *I* see it.'

Some of his old colleagues viewed the pictures of the 1880s with disapproval, considering them cynical, trivial and designed with commercial success in mind – as Degas said, 'the work of a skilful but not a profound decorator'. Monet was aware of these dangers, insisting to Durand-Ruel that he needed to contemplate his paintings in

groups before sending them for sale, lest he fall into the trap of unthinking production and become only 'a machine for painting'. This process of contemplation took place in the studio over a period of weeks or even months. It was not a formality. Some canvases were reworked, others rejected and a few destroyed outright. Monet's paintings increasingly represented a balance between direct observation and recollection, and as he became more involved with subjects close at hand, in Giverny or in the garden itself, so open-air work became less essential – although it continued to be an important part of the Monet myth. Even in 1897, when Maurice Guillemot was interviewing Monet for *La Revue Illustrée*, he felt compelled to

152
In the water garden, 1921.
l to r: Blanche Hoschedé-Monet, Michel Monet(?), Claude Monet, Mme Kuroki, Georges Clemenceau, Lily Butler

describe the room in which he was looking at the series of *Mornings on the Seine* not as a 'studio' but as a 'salon', 'since an artist painting from nature paints only out-of-doors'.

In 1899 a large purpose-built studio replaced the remodelled barn that Guillemot had seen, making it clear that, despite Monet's disclaimers more and more work was taking place indoors. While the size of the late Giverny canvases and the artist's increasing frailty made heroic *plein-air* exercises of the *Women in the Garden* type impossible, Monet's attitude to the motif had also changed in an important fashion. The true object of his art was no longer the visible

world but the world transformed through the artist's gaze, transformed through knowledge – knowledge not of the particular details of a plant shape or the curve of a river-bank but of its essential form. In a curious way, towards the end of his career Monet became an academic artist, one who painted according to an inner ideal, rather than a 'scientific naturalist' concerned with the representation of observable facts and physical phenomena. This move towards insubstantiality began in the 1890s, with the development of the 'series paintings'.

The year 1889 was marked not only by the Monet–Rodin retrospective, but also by the centennial of the French Revolution, representing a time of reassessment for the nation as a whole (154). The failure of an attempted coup led by General Boulanger in the spring finally brought an end to the monarchist threat to the Republic, and in the 1890s a fresh political consensus emerged under a young centre-left government bent on reconciliation and consolidation. The warring elements of the Third Republic were finally united under the slogan 'Neither revolution nor reaction'.

153
Grainstacks
(detail of 159)

In keeping with the republican tradition anti-clerical legislation was brought in and there was a new emphasis on the modern, secular state as the focus of national pride and aspiration. The arts were valued as an expression of French genius, and the comparative neglect of the 1880s in terms of state support was replaced by energetic intervention at all levels. The decoration of civic buildings replaced commissions for churches, and art and design were made part of the school curriculum. It was in the 1890s that Monet produced some of his most innovative paintings, pictures which were original not only in their subjects and appearance but also in the way that they were presented as series rather than as single works. This manner of working fitted in well with the new stress on the commercial potential of the arts and the notion of 'decoration' as a combination of fine and applied arts.

As Debora Silverman and Paul Tucker have demonstrated, the new government's preference for art that was decorative rather than didactic was based on economic considerations. It was part of a wide-ranging re-evaluation of France's future as a world power at a time when, despite the growth and prosperity of the later nineteenth century, she was slipping behind the economies of Germany, Britain and the USA. Comparative figures published in the early 1890s

showed a slow rate of growth and fuelled the widespread fear that
France was in danger of becoming a second-rate nation. Unable
to claim an empire as extensive as Britain's or an economy as vast
as that of the USA, France did have a unique asset in her artistic
tradition. French had long held a special position as the diplomatic
language of Europe and the tongue of the educated, even in
Germany and Russia: now the whole of French culture, and espe-
cially the visual arts, was presented as a national patrimony
of equal importance.

It became official policy to promote the development of a diverse
and lively art world in Paris – a policy which has been spectacularly
continued, for similar reasons, in the Paris of the 1980s and 1990s.
The city became the international capital of art, with students
flocking from all over the world to study in its studios and admire
its national treasures. This process was accompanied by a widening
of the market for French painting, promoted as the product of a
uniquely French talent for creating beauty. The new government
was starting to embrace the artistic rebels of the previous generation.
Three of Monet's tamer paintings were included in the centennial
display of French art accompanying the 1889 Universal Exposition.
This was something of an establishment accolade; having won
recognition as the major Impressionist in the 1880s, he was now well
placed to establish himself as France's leading landscape artist.

Landscape had won its battle for respectability, and paintings of the countryside were exceptionally popular. They sold, as always, to urban buyers. Republicanism had traditionally been associated with the cities and the world of industry, but by extending the franchise to all adult males, the new government attempted to reach out to the vast mass of Frenchmen who lived on the land. The urban bias of republican culture was reversed and the countryside became the focus of reform, with universal primary education extended to the villages and agricultural improvements. However, the 1890s were a

154
Charles Bivort
Poster
celebrating the
transformation
of the Corn
Market in Paris
into a Produce
Exchange in
the years
1789–1889

155
Oswaldo
Tofani,
*Modern
Agriculture.*
Lithograph in
*Supplément
Illustré du Petit
Journal,* April
1897

particularly desperate decade for country-dwellers whose livelihood depended on agriculture. During the second half of the nineteenth century wave after wave of peasants had left the land for the economic opportunities of the newly industrialized cities. From the 1870s onwards the terrible phylloxera epidemic had devastated the vineyards, and an influx of cheap wheat from the United States had knocked the bottom out of the market for French farmers. Their primitive agriculture was still labour-intensive, and mechanization offered a possible way forward for the impoverished peasants. Increasingly they looked to industry, in the form of harvesting-machines or factories, to provide an alternative to a life of rural poverty (155). The idyllic peace of Monet's pictures existed only for visitors and spectators.

Despite his long residence in Giverny, Monet remained essentially a visiting Parisian who viewed the fields around his house as a place for rest, recreation and painting. His poor relations with the local inhabitants must be seen in this light; for example, in 1895 the commune wanted to sell a piece of land to a starch-maker who planned to build a factory. This would have provided employment but it would also have polluted the river and spoilt the tranquillity of the place. Determined to keep industry away from 'his' village, Monet donated 5,500 francs to ensure that the land would remain untouched for fifteen years. By doing so he probably secured Giverny's long-term future as a centre of tourism; his house now receives half a million visitors a year and it has become the centre of a burgeoning Impressionist industry, appealing – now as then – to Anglo-Saxon visitors who see the French countryside exclusively as a holiday location.

Monet's work in the 1890s underwent a number of profound changes, but before embarking on the experiments with fugitive light which were to develop into the series pictures he actually spent almost a year without producing any pictures at all. From the summer of 1889 he devoted his time to organizing a public subscription to buy one of Manet's paintings and present it to the Louvre. This project had its roots in 1883; Manet had died on the very day that the joint family moved into Giverny. On hearing the news, Monet had immediately left for Paris, where he was a pall-bearer at the funeral. He was the obvious successor as leader of the avant-garde, and his strategy during the 1880s was calculated to build upon this role. By 1889, wealthy, successful and universally recognized as an artist of major importance, he was able to take a year off from painting to campaign for the state acquisition of Manet's famous *Olympia* (see 27).

Since his début as an artist in the 1860s Monet had painted more or less constantly, and this lengthy pause in his work was a serious affair. Clearly it was of great importance to him that Manet's picture should enter the national collection. The deceased artist's studio sale had not fetched high prices, and Madame Manet was left rather hard up, her only asset a considerable stock of paintings. *Olympia* was the

most important work left in her hands, and Monet's hard-fought battle to raise enough money to buy it at a decent price was partly motivated by a desire to help the widow of his old friend. However, Monet's personal ambition coincided with his apparent altruism. The older artist's scandalous pictures of the 1860s had been formative for the creation of 'the new painting' and the Impressionist movement in the 1870s. Recognition for Manet would be an important step towards official acceptance of the avant-garde movement as a whole. Even opponents of Manet's work recognized the symbolic importance of *Olympia* as an icon of anti-traditional art; its installation in the Louvre would be the thin end of the wedge. That was, of course, Monet's intention. As Berthe Morisot wrote to him, 'You, with your name and prestige, are the only one who can force the gate open.'

The campaign for *Olympia* revealed a new aspect of Monet; he was a deft politician. Decades of begging-letters had made him a master of epistolary coercion, and he was able to wheedle contributions out of a wide range of eminent members of the art world. Once a sum of nearly 20,000 francs had been collected, the next step was to persuade the hidebound state authorities to accept the picture. They resisted with considerable energy. The Ministry of Education was responsible for the fine arts; it was highly centralized, with the élite in Paris choosing works which were then despatched to every part of the country. When it had become too embarrassing to refuse the gift outright, the danger of an allocation to obscurity in some dusty provincial collection had to be outmanoeuvred. *Olympia* had to stay in Paris, and she had to be prominently hung. Eventually Monet's demands were met half-way. The picture went initially to the Luxembourg – the collection of contemporary artists – rather than to the Old Masters at the Louvre. The rules stated that a ten-year 'cooling off' period was required between an artist's death and the status of Old Master and, although as Monet pointed out this rule had been waived for Courbet, in the end he decided not to push his luck and the picture was hung in the Luxembourg, where it remained until finally transferred to the Louvre in 1907. A cartoon anticipated the scene in which the bedraggled Olympia, carrying her cat, was to become an incongruous but undeniable presence among the

nymphs and odalisques of the French School (156). Having made his mark as a public figure, Monet was free to return to painting.

Monet had abandoned plans for a second trip to the Creuse after becoming absorbed in the battle for *Olympia*. The long break gave him time to reassess his aims, and when he returned to his own work it was with a different set of subjects and a new approach. The glamorous, spectacular tourist paintings were replaced by close scrutiny of mundane motifs much nearer home. The paintings comprising this second wave of Giverny scenes are highly concentrated studies of individual motifs – fields, stacks, trees, a bend in the river, painted repeatedly from more or less the same viewpoint. Monet had reused motifs as far back as the 1860s, but the works of the 1890s are of

156
La Belle Olympia au Louvre.
Cartoon in *La Vie Parisienne*, 22 February 1889

a different order; for the first time numerous paintings of the same subject were to be shown together, as facets of perception rather than as a set of souvenir views. While Monet had shown 'sets' of pictures before – the ten Views of Antibes, the Saint-Lazare paintings – these had been essentially a development of a well-established way of exhibiting landscape painting, in which pictures were grouped together to form an 'album' of a specific well-known location. Monet's new paintings, by contrast, depicted the same subject repeatedly with only minor variations in composition. Between late summer and the spring of 1891 he painted twenty-five Grainstacks, followed by twenty-four Poplars and seventeen pictures of Morning on the Seine. This was an entirely new way of depicting landscape, feeding off repetition rather than variety and demanding a new kind

of attention from the audience. It took immense confidence to display virtually identical subjects, differing from each other only in colour, but by the 1890s buyers seemed eager to snap up anything Monet produced.

Monet's series paintings can be seen as the logical culmination of thirty years' work; they repeat subjects he had been attracted to since his student days, and they follow a path which in retrospect is very clear – the gradual transferral of interest from the subject to the style, from the motif to the envelope and from the contingent to the essential. This movement from the particular to the general and from a hard-edged to a soft style of painting is not exclusive to Monet; it can be seen in Titian or in Turner, and in the twentieth century it is virtually the expected route for a painter – a route established and sanctioned by the Impressionists. For Monet, while this shift was evidently the product of visual interests, the development of a kind of artistic shorthand and of an increased ability to convey complexity with apparently reduced means, the 'series' paintings were also a commercial success. The enormous popularity of these paintings is partly the result of their intrinsic qualities, but it also reflects the expectations of the audience – expectations which have changed over the past century. For many years they were celebrated as examples of 'pure' painting, proto-abstract works. Now their subject matter has been re-examined, and a political dimension has been suggested. While the pictures do contain some elements which can be seen as political in a direct sense, essentially it is the disappearance of the subject which is historically significant, revealing the new preferences of the public.

The Grainstacks series was the first, and in some ways it is still the most astonishing. Monet had treated the stacks around his house before, but it was not until the autumn of 1890 that he really became involved with the motif. It seems unlikely that he started with the intention of producing a series; the idea seems to have emerged from his intensified interest in what he called the 'envelope' of light that enclosed a motif. While this had always been an important aspect of Monet's work, in the 1890s it became his main concern. In October

1890 he recounted this new development in a letter to Geffroy:

I'm grinding away, struggling stubbornly with a series of different effects (stacks) but at this time of year the sun sinks so fast that I can't keep up with it. I'm beginning to work so slowly that I despair, but the longer I go on, the more I see that it is necessary to work a great deal in order to succeed in rendering what I seek – instantaneity, above all the 'envelope', the same light spreading everywhere – and more than ever I'm disgusted with things that come easily in one go. I am more and more obsessed by the need to render what I experience.

It is significant that Monet refers to the ostensible subject of the pictures only in parentheses (stacks) and that it is explicitly the 'effect' that interests him; he had moved from seeking a variety of motifs to a variety of effects. The fleeting nature of these light effects, the 'instantaneity' to which he refers, had been central to his work since the 1870s and can be seen as one of the cardinal elements of Impressionism. These pictures, however, look very different from even such refined images as *Impression, Sunrise* (see 77). The concept of a series of instants emphasizes the ephemeral nature of colour and light, freeing it from the necessity of description and allowing colour a new autonomy (157, 158). The claim that Monet simply captured nature with a fresh and uncorrupted eye cannot really be maintained in front of these hallucinatory pictures, with their astonishing variations of colour. The instant of perception was becoming more and more subjective, as noted by Signac, who in 1894 commented in his diary, 'Trees in nature are not blue, people are not violet … and [Monet's] great merit is precisely that [he] painted them like this, as [he] feels them, and not just as they are'.

Monet was not alone in experimenting with heightened colour and pattern; an interest in non-naturalistic representation had become fashionable among a group of younger artists, led by Gauguin (see 128). Partly in reaction to the deliberate dryness of the Neo-Impressionists, with their regular dots and everyday subjects, the 'Nabis' or Symbolists depicted a fantasy world of brilliant, abbreviated forms, flat and smoothly painted in exotic shades. Gauguin explained to an interviewer in 1895:

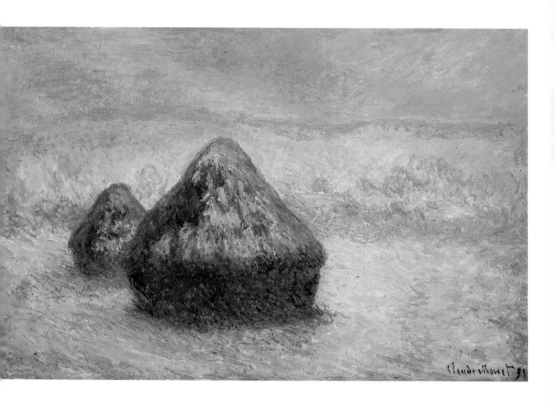

157
*Grainstacks
(Sunset, Snow
Effect),*
1891.
Oil on canvas;
65×100 cm,
25⁵⁄₈×39³⁄₈ in.
The Art
Institute of
Chicago

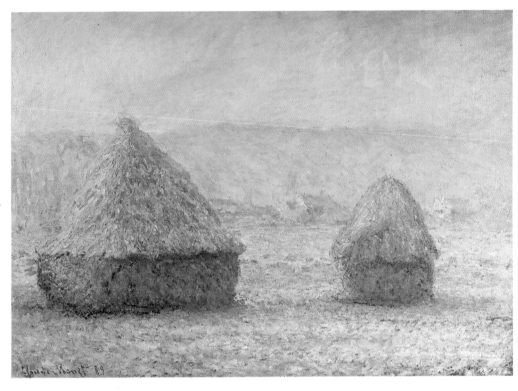

158
*Grainstacks,
White Frost
Effect,*
1889.
Oil on canvas;
65×92 cm,
25⅝×36¼ in.
Hill-Stead
Museum,
Farmington

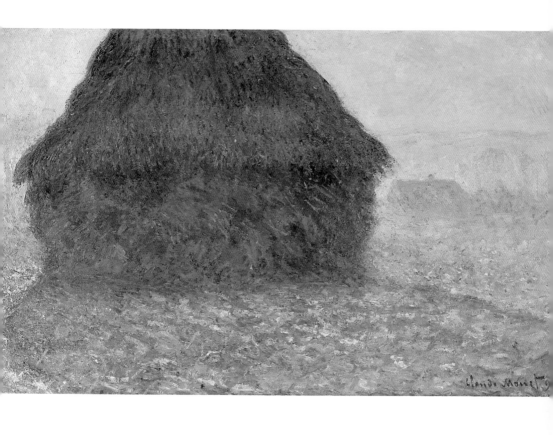

159
Grainstack in Sunshine,
1891.
60×100 cm,
$23^5\!/_8 \times 39^3\!/_8$ in.
Kunsthaus,
Zurich

It matters little whether there is any such thing as blue shadows or not. If tomorrow a painter should decide that he sees pink or violet shadows, he is free to do so without being answerable to anybody, provided that his work is harmonious and gives us food for thought.

Gauguin's work is intended to startle the viewer out of normal habits of seeing, and in this respect Monet's shift from depicting nature to creating an alternative realm of fantasy has led to him being described as the father of the Symbolist movement. However, the Symbolists added an element of mysticism and decadence which was foreign to Monet; their art still depicts recognizable forms – young women and woodlands are favourite subjects (160) – but the situations are always emotionally charged in a manner which makes a Monet grainstack seem baldly factual.

160
Emile Bernard, *Madeleine in the Bois de l'Amour*, 1888.
Oil on canvas; 137×164 cm, 54×64⁵⁄₈ in. Musée d'Orsay, Paris

The series paintings are mysterious, because they seem to add up to more than the sum of their parts; they are not mystic. Pissarro wrote to Gauguin in 1891:

The uneasy bourgeoisie, surprised by the great clamour of the disinherited masses, by the vast claims of the people, feels the need to lead people back to superstitious beliefs. Hence the hullabaloo about religious symbolists, about religious socialism, about an art based on ideas, about Occultism, Buddhism, etc. ... The Impressionists are on the right path, that is a healthy art based on *sensations*, and it is honest.

Monet was an atheist and, although his political beliefs were less explicit than Pissarro's, he is likely to have shared his distaste for

symbolism and his preference for 'a healthy art based on sensations'. The 'instantaneity' and the 'effect' which he sought did not depend on metaphysics for their significance. This did not, of course, prevent spectators and critics from discussing them in mystical language.

Opinions have varied over the most appropriate way to look at such pictures as *Grainstack in Sunshine* (153 and 159), which have been variously interpreted as other-worldly evocations of light, proto-abstract images of shape and colour, timeless images of rural France and, most recently, as political statements. Whatever the prevailing critical slant, they have always been seen as important, both in the context of Monet's work as a whole and as an element in the development of modern painting.

Monet himself claimed 'To me, the motif itself is an insignificant factor; what I want to reproduce is what lies between the motif and me.' This certainly suggests the approach which has been most favoured in the twentieth century, as Monet's work has been increasingly viewed in terms of its relationship to abstract painting. The Russian painter Wassily Kandinsky (1866–1944), later to be credited with the first truly 'abstract' work, ascribed his ability to make the leap away from subject-based art to the experience of seeing Monet's painting in Moscow in 1895:

Previously I knew only realistic art … Suddenly, for the first time, I saw a 'picture'. That it was a haystack, the catalogue informed me. I could not recognize it … what was absolutely clear to me was the unsuspected power, previously hidden from me, of the palette, which surpassed all my dreams. Painting took on a fabulous strength and splendour. And at the same time, unconsciously, the object was discredited as an indispensable element of the picture.

It was clearly possible, even in the 1890s, to see the Grainstacks in that light – although perhaps one had to be a painter to make the required leap of imagination. However, Monet was using a motif much favoured by other artists, and his first audience would have been familiar with the social and symbolic connotations of the subject (161).

For many years these pictures were known in English as 'haystacks'; to a modern, urban audience, the difference between grain and hay may not seem significant, but Monet's contemporaries would have been fully aware of the difference. Hay is dried grass, destined to be fed to animals during the winter months; grain makes bread, and it represents the wealth both of the farmer and by extension of the nation as a whole. For centuries paintings of rural life had included images of harvesting, threshing and sowing as an essential part of the imagery of the seasons. Pictures such as Poussin's *Summer* (see 11) and its nineteenth-century counterparts are explicit about the meaning of the grainstack and, while Monet was unlikely to intend *Grainstack in Sunshine* primarily as an image of rural prosperity, he would have been fully aware of the common currency of grainstack

imagery. Physically close to peasant life (162) yet socially and mentally distant from it, Monet was able to transform a prosaic everyday element into a kind of glowing, magical tumulus. He was making the familiar unfamiliar and allowing his audience to share his miraculous vision. In order to do so he had, incidentally, to pay the owner of the grainstacks to leave them in place, effectively transforming them in practical terms from food-source to artistic motif.

Monet's method of producing series obviously grew out of the repeated studies of adjacent motifs he had worked on during the 1880s, when he had often maximized the time available for paintings by working on several canvases of related subjects at once. Pictures which had been started out-of-doors would be finished in the studio at home, where he was more comfortable and working conditions

were better. This finishing process gradually increased in importance, and with the Grainstacks it became crucial. For the first time, Monet was painting works which were intended to be exhibited, if not sold, as a group and which took their meaning from each other as a series of linked perceptions of the passage of time and the fall of light. In the studio he looked at the group as a whole, harmonizing and balancing the pictures so that they would fit well together. Monet declared to W G C Bijvanck, a Dutch visitor at the first Grainstacks show in 1891, 'Their true worth only resides in relation to each other and as part of the entire series.' While this is true of many great European cycles of paintings, such as Giotto's frescos, in the Upper Church of San Francesco, Assisi, Monet's works do not lead towards a narrative or didactic climax; there is no message at the end of the series and the titles are deliberately vague – *Grainstack, Snow Effect* or *Grainstack, Sunset.* Essentially non-narrative, they force the viewer to look for purely visual differences. The paintings proceed without progressing; they refer only to each other in a kind of closed loop.

The notion of the series mimicks the artist's experience of the scene, introducing movement and change. Monet's attempts to capture instantaneity grew ever slower as he became familiar with the landscape from every angle and divided the instant of perception into smaller and smaller units. His method of working also changed, and he began to use several canvases for a single subject, using an unvarying viewpoint and studying the delicate differences of light and colour produced in the same spot under varying conditions. The children proved invaluable, helping to ferry the pictures to and from the house. In an interview with the Duc de Trévise, which was published in 1927, Monet gave a somewhat disingenuous account of a sudden moment of inspiration:

When I started [to paint] I was like the others; I believed that all one needed were two canvases, one for overcast weather and one for sunshine. I was painting the stacks which had struck me as they made a magnificent group … one day I saw that the light had altered and so I said to my stepdaughter, 'Please go and fetch me another canvas from the house.' She brought it, but a little later it had changed again;

161
Jean-François Millet,
Autumn, the Grainstacks,
1868–75.
Oil on canvas;
85·1×110·2 cm,
33¹₂×43³₈ in.
Metropolitan Museum of Art, New York

162
View of Giverny showing grainstacks,
c.1905

[I needed] another and then yet another. I worked on each one only as long as the effect held, and there you are. It's not very hard to follow.

While this anecdote is memorable, it is not altogether convincing; the artist did not undergo a sudden conversion to the notion of atmospheric purity, and he had been using multiple canvases well before the start of the Grainstacks. Indeed, another late recollection of Monet's suggested that the idea had originally dawned in 1879, as he was painting the talismanic 'white' picture of the church at Vétheuil (see 96):

I felt that it would not be trivial to study a single motif at different hours of the day and to note the effects of light which, from one hour to the next, modified so noticeably the appearance and the colouring of the building. For the moment I did not put the idea into effect but it germinated in my mind gradually.

However, when he returned to the grainstacks to begin a run of almost thirty pictures during 1890–1, his approach and his intentions appear to have been distinctly different. The group, rather than the individual piece, had become the focus of his work.

Fifteen grainstacks were shown at Durand-Ruel in May 1891. Monet was doing something entirely new; a one-man exhibition was still something of a novelty, and to reduce it to 'one man, one motif' was truly unheard of. The way in which the pictures were exhibited was crucial to their success; for the first time, works on the same subject were hung in a row in a single room, stressing rather than ignoring their repetitive nature. This forced the viewers to look at the nuances of light and colour, at the small alterations of stance and shading, to search for changes and to look for what the artist saw in the scene. Mimicking the painter's perception made viewing the works a deliberate act of collaboration, a collaboration which would be undertaken only by those sufficiently convinced of the value of the exercise. Paradoxically, this restriction of the audience to those already prepared to accept the painter's importance resulted in a boost for Monet's popularity; once the group of enthusiasts became a club, everyone wanted to join.

The paintings were sold individually, rather to Monet's regret; they are now dispersed (the largest collection is currently held by the Art Institute of Chicago, which has six pictures). The cumulative effect of the exhibition must have been overwhelming, and contemporary accounts make it clear that the repetitive nature of the pictures was felt to be aggressive and even disturbing, with the audience groping for a way to make sense of these brilliant, blinking images. Seven non-Grainstack subjects were also on view, but for most visitors the extraordinary series stole the show. Reviewers such as Geffroy went overboard, producing prose-poems to evoke the changing times of day and year on display:

[The grainstacks] first appear during the calm of a beautiful afternoon. Their edges are fringed with rosy indentations of sunlight ... they stand erect beneath the bright sun in a limpid atmosphere ... At the close of the warm days ... the stacks glow like heaps of gems ... Later still ... darkness envelopes the grainstacks which have begun to glow like hearth fires. Veils of tragedy – the red of blood, the violet of mourning – trail around them on the ground and above them in the atmosphere ... Monet unmasks changing portraits, the faces of the landscape, the manifestations of joy and despair, of mystery and fate.

Lauded in these terms by a wide range of critics, the exhibition was a huge success. Many of the buyers were speculators, selling the pictures on within a few months of the exhibition, and the final destination of most of the paintings was the United States. Enviously, Pissarro wrote to his son that Durand-Ruel would not take his own work and that the market had gone Monet-mad:

For the moment, people want nothing but Monets. Apparently he can't paint enough pictures to meet the demand. Worst of all, they all want *Grainstacks in the Setting Sun*! Always the same story, everything he does goes to America at prices of four, five, and six thousand francs.

Pissarro concluded that Monet was simply repeating himself – 'Such is the terrible consequence of success.'

By the time the Grainstacks show had opened, Monet was working on a second series of rural landscapes, depicting poplar trees on the

banks of the Seine. Contrasting in form and composition with the solid, heavy grainstacks, the delicate poplars were an entirely different kind of motif. Slender and elongated, they were subject to the change of the seasons and the movement of the wind. As he had done with the landscapes of the 1880s, Monet was setting up a rhythm of 'heavy' and 'light' subjects. The Poplars were followed by the solid, massy pictures of Rouen Cathedral and Mount Kolsaas, and then in 1896 by the exquisite modulations of the Morning on the Seine series.

Although they appear to be a natural rather than a man-made feature of the landscape, the poplar trees had actually been planted for timber. They were a cash-crop, just like the wheat in the Grainstack series. This particular group had attained their maximum height and were due to be felled, as Monet discovered some months after starting the paintings. Exactly as he had done with the grainstacks and the tree in bud in the Creuse, Monet intervened to preserve his subjects, paying a local timber-merchant to leave the trees standing until he had finished. Despite the fact that the pictures would be completed as a group in the studio, he still needed to work in front of the motif.

Unlike the Grainstacks, the Poplars were conceived from the first as a series. Monet had a clear idea of the variety of effects he wished to capture and the rhythmic relation between individual works. Poplars absorb water, so they were commonly grown along the borders of roads and fields with streams. They were an eyecatching feature of the flat Seine valley, and Monet had painted them many times. They feature in his first serious work to survive (see 17), and similar screens of trees appear in many of his early Giverny pictures. Being so familiar with the subject, Monet found it easy to launch directly into the series. Over the summer and autumn of 1891 he produced twenty-four pictures, using two different compositions. All but four were painted from the studio-boat, which allowed the artist to work on a number of canvases in a leisurely and comfortable fashion. Like the pictures of the Manneporte at Etretat (see 111) this produced a duck's eye view, as if the spectator is floating in the water and figuratively immersed in the subject. From this viewpoint the

poplars fill the entire canvas. One of the most characteristic compositions depicts two sets of trees with their tufty foliage writhing in an S-bend across the surface of the painting, as in *Poplars on the Banks of the River Epte* (see 18). The river itself appears in the lower third of the painting, reflecting the tree-trunks. In one of the pictures, *The Four Trees* (163), the distinction between trees in air and trees in water virtually disappears. This mirror effect flattens the entire picture, abolishing the illusionistic 'box-space' which had been central to European painting since the Renaissance.

Looking at these delicately coloured paintings, with their graceful curves and stylized repetition of natural forms, it is easy to see a kinship between Monet's pictures and the contemporary style in the applied arts (164) known as Art Nouveau. Using organic shapes and rejecting heavy ornamentation, Art Nouveau was designed on the principles of simplicity and fitness for purpose. It was intended to be modern and international, free of cultural baggage and speaking the universal language of 'pure form'.

Art Nouveau was initially an architectural style and it spread rapidly through the applied arts of furniture decoration, wallpaper, carpets, jewellery and so on. All of these art forms can be seen as essentially 'flat', and it was in the simplifications of commercial and graphic art that it was most successfully used in picture-making. The 'flatness' of Monet's poplars and their rhythmic nature appealed to a public which had already developed a taste for the pared-down style of Art Nouveau. They fitted nicely into rooms designed in the latest style, and one of the terms most often used by critics praising these pictures was 'decorative'.

In the 1860s and 1870s, calling a picture decorative would have implied that it was not a serious work of art. The aim of 'decoration' was not to teach or inform, but to provide pleasure. However, for the avant-garde and the fashionable picture-buying public of the 1890s 'decorative' had weightier implications – aesthetic purity and freedom from irrelevant concerns with politics, morality or subject matter generally. In a way this is simply an extension of the earlier Impressionist belief in the 'innocent eye'. Applied to painting the

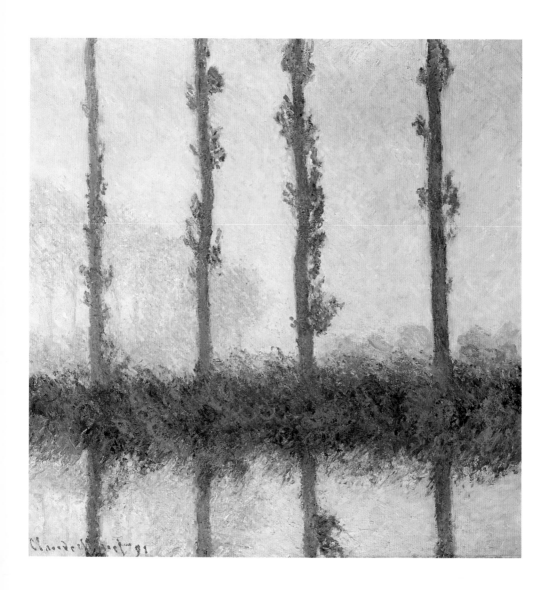

163
The Four Trees,
1891.
Oil on canvas;
81·9×81·6 cm,
32¹⁄₄×32¹⁄₈ in.
Metropolitan
Museum of
Art, New York

164
C F A Voysey,
Fabric
patterned
with
multicoloured
poplars,
*c.*1895–1900.
Victoria &
Albert
Museum,
London

natural world, as Monet was doing, 'decoration' meant concentrating on form and colour rather than naturalistic detail and avoiding anything that might 'date' the work – essentially, painting without social content. The slogan 'L'Art pour l'Art' ('art for art's sake') became a critical commonplace. It justified the gradual loss of interest in subject, and buttressed the general scepticism about the possibility that art could act as an agent for social change.

While decoration was prized by the 1890s avant-garde as a guarantee of unsullied artistic intentions, it had also taken on a new impor-tance for the state. The Universal Exposition of 1889 had rattled French industrialists by demonstrating the improved design of their competitors. Britain and Germany had always made goods that were cheaper and perhaps sounder than those produced in France, but French products had traditionally been more stylish. By the end of the century this no longer seemed to be the case. France's rivals had set out to improve their wares through careful study; educational programmes had been devised and national collections formed for the edification of the aspiring designer or entrepreneur. France, meanwhile, had been resting on her laurels, and the 1890s was devoted to catching up and then overtaking the competition.

As Debora Silverman has shown, between 1890 and 1900 a concerted attempt was made to raise the status of the decorative arts, making them as desirable as easel-paintings. Politicians and bureaucrats put their weight behind the Central Union of the Decorative Arts in its attempts to encourage the development of 'a modern style, based on reintegrating art and craft'. In 1894 the Louvre opened a department of 'art objects', according them the status of the traditional museum collections. The decorative arts were given a special section in the Salon, and the link between art and industry was emphasized. The old idea of state-sponsored 'high art' was replaced with a more practical approach; art could fill an important role in the national economy through influencing design. A protectionist parliamentary leader, Jules Méline, brought in trade barriers, and the economic emphasis was switched away from heavy industry towards agriculture and small artisans, in

keeping with his belief that 'French taste conflicted with mass production'.

The strategy was successful; France experienced a boom in the decorative arts. 'Frenchness' became the international flavour of the decade for luxury goods, unaffected by the existence of protectionism in major industries. The politician Georges Berger felt able to boast, 'The authentic French trademark is a passport that opens all borders and overturns all tariff barriers, when it is stamped on those thousands of products in which form and décor play the leading role.' Tourism, dress and the arts drew the wealthy to Paris in ever-growing numbers. The very countries which most threatened France in political and economic terms were the most avid consumers of its culture. Buyers came from the United States, Germany, Japan and even the rapidly industrializing Russia. Within this broader picture Monet was well placed to benefit. Like other astute businessmen, he kept a watchful eye on global developments. Although he had initially objected to Durand-Ruel's American operation, he rapidly realized that the American demand for his work raised his status in the eyes of his compatriots. It also raised his prices. Selling even-handedly to Durand-Ruel, Georges Petit and Theo van Gogh at Boussod and Valadon, he played one off against the other. By the mid-1890s he was asking 15,000 francs a picture and was well on the way to becoming a very rich man.

This inflationary spiral ultimately depended on foreign buyers. Americans such as Mrs Potter Palmer, the wife of a Chicago meat millionaire, James Sutton and Louisine Havemeyer bought Monet's pictures in bulk. They resold them quickly, always at a profit. American artists such as John Singer Sargent (1856–1925) and Mary Cassatt (1844–1926), both friends of Monet, also dealt in his paintings on an informal basis and helped to form the collections which now make it impossible to study his work without visiting the USA. Monet's pictures of the 1890s fitted well into these patterns of buying – serial paintings for serial purchasers. These works were also easily assimilated by an audience becoming accustomed to the idea of what we would now call multiples. Once the notion of the series had

been accepted – something that happened quickly with the exhibition of the Grainstacks – the pictures could be marketed in almost the same way as that season's latest look in women's clothing. The exhibition of Poplars in March 1892 was the first time a show had ever been devoted to a single motif. It was a triumphant success, and offers were coming in for the next series before the pictures had even been properly planned, let alone completed.

It is easy to see the trade in Monet futures as an inevitable consequence of the manner in which the art market was expanding. However, the production of his paintings was not a mechanical process. The continued success of his works depended on strict quality control and an acceptable degree of innovation. He had to maintain high standards, and selling works *in ovo* was a stressful way to proceed. Once the Poplars were finished, early in 1892 he started to tackle a very different subject – the great Gothic cathedral of the Norman town of Rouen. Although this was a return to an urban subject and to monumental architecture of the kind he had treated in Vétheuil, the paintings are in no way topographical. The Rouen pictures were also different from the previous two series, in that they took far longer to do, and they were interrupted several times by other projects. Between February 1892 and the spring of 1895 Monet worried over his canvases, unable to release them. The longer he held on to the pictures the harder it became for him to feel that they were good enough to meet the expectations of his audience, or himself – 'I am a proud person, with a devilish self-esteem. I want to do better and I want these cathedrals to be very good.' As he wrote in mitigation to an impatient Durand-Ruel, 'I have so much difficulty now in making anything and I take so long.'

The business of painting from the motif was over by April 1893; the really time-consuming work took place in the studio. *Plein-air* painting was relatively straightforward, even when – as at Rouen – it was a case of painting from a window. 'Finishing' was becoming increasingly important and complex. As the concept of a series as a harmonious whole grew in his mind, and the painted instant of his pictures became more and more precise, so the time needed to fix it

lengthened. Capturing repeated light effects relied essentially on the artist's memory, his ability to recognize a moment as identical to that which had instigated the stages of a picture. The combination of changeable weather and different times of day meant that there could be very long intervals between sessions of work on a single canvas. Indeed, some of the Rouen paintings were kept from one year to the next, awaiting a repetition of the initial effect. The representation of instantaneity was achieved more and more slowly. The original observation was repeated in the artist's memory, time after time, each new sighting marked by another layer of paint on the canvas. As the canvases grew more complex and encrusted, sedimented in layer after layer of richly coloured pigment, so that first moment became more evanescent and harder to grasp. The subject disappeared and the picture became an object, a beautiful artefact parallel to nature but less and less a representation of it (165). Declaring a picture finished, an instant of perception closed, became increasingly difficult for Monet. In 1893 he wrote to Geffroy from Rouen:

My stay here is getting on, but that doesn't mean that I am close to finishing my Cathedrals. Alas! I can only repeat that the further I get, the more trouble I have rendering what I feel; and I say to myself that anyone who says that he has finished a canvas is terribly arrogant.

Like the Saint-Lazare pictures of the 1870s, the paintings of Rouen Cathedral depict urban architecture, and it is interesting to compare the two sets of images. Monumental and elaborate, the great metropolitan railway stations were often referred to as 'the cathedrals of the nineteenth century'. Secular public buildings devoted to transport, trade and commerce, they represented the essence of the modern technological state. In France that state had long been at war with the Church, and Monet's choice of one of the great monuments of Catholicism was commented on. The critics who championed his work were mainly secularists, and they tended to interpret the pictures in essentially formal terms, discounting the subject matter as unimportant and treating the cathedral as a kind of 'found object' or natural form, 'as high and as beautiful as the rocks of the cape', in Geoffroy's words. As with the Grainstacks, there was a long

tradition of depicting the Gothic churches of northern France in a manner that emphasized their spiritual role, but Monet, who probably used a guide-book plate (166) as a compositional starting-point, stayed strictly on the outside. He was uninterested in entering the building, showing an indifference reminiscent of his attitude when painting from the Louvre as a student, and the close-up viewpoint of most of the paintings treats the cathedral simply as an enthralling surface, faceted stone rising before our eyes like a man-made cliff eroded by the years.

165
The Portal,
Harmony in
Brown,
1894.
Oil on canvas;
107×73 cm,
$42^1{}_8 × 28^3{}_4$ in.
Musée d'Orsay,
Paris

166
Rouen
Cathedral
c.1893

Wrestling with the problem of resolving the cathedral series and needing a change of scenery, at the end of 1894 Monet decided to refresh his eyes with the most adventurous of all his painting trips. On 27 January 1895 he set off for Norway on a trip that lasted a hundred days. Jacques Hoschedé had been living in Oslo for some time, and Monet wanted to see how he was getting on; but he also intended to paint. Norway offered a new kind of landscape – exotic and unknown. The winters at Giverny had been consistently mild, allowing the long spells of outdoor work that produced the frosted Grainstacks, but not providing any real opportunities for painting snow. Snow had always been a favourite Impressionist subject; its brilliance and reflectivity allowed strong colour contrasts and striking effects of light. Norway was bound to supply plenty of material for snow-scenes, and on his slow journey by train through Germany, Monet was excitedly anticipating the exoticism of this distant outpost, the 'ultima Thule' – a land of innocence, purity and harshness.

Settling down to paint seemed almost impossible at first. Having shared the fashionable western idealization of Scandinavia as a kind of frozen Tahiti, Monet was startled by the reality. The itineraries in guide-books all presumed that travelling would be done in the summer months, and the winter of 1894–5 was exceptionally cold, with heavy snowfalls obscuring rather than revealing the contours of the land. Touring was almost impossible. He cursed the 'immense whiteness' of the countryside, and despaired of finding a motif in the endless, brilliant expanse of unvarying snow and ice-covered, snow-topped sea. The emptiness and simplicity of the terrain which had attracted him initially proved unpaintable; he could not find a motif in the unfamiliar blankness. He had also failed to anticipate the incapacitating nature of the cold; with temperatures reaching a noontime high of –25°C, the weather really was too extreme for prolonged outdoor sessions.

Finally a compromise solution was found. On 19 February he settled into a guesthouse at Bjornegaard, about forty-five minutes from Oslo. This provided both a sympathetic place to stay and a sufficiently powerful local subject, Mount Kolsaas. Finally he could settle

down to work, free of the distractions of ski-jump competitions and sleighing – both of which he had enjoyed watching with Jacques. He painted thirteen versions of the mountain, totalling almost half of the pictures he brought home in the spring. Several were left unfinished, for the inevitable thaw came in April and, as he complained, 'just as I was learning how to paint it, it melted.'

Monet was attracted to Mount Kolsaas partly because of its situation – it was sufficiently large and isolated to provide a distinctive and dramatic subject (167). He also felt that it was a paintable motif, familiar in a way that the fiords and waterfalls were not. As always, Monet found it hard to paint a new landscape and Norway was so completely different from his homeland that he felt he would need to live there for a year before producing anything worthwhile. Kolsaas, however, seemed assimilable. He described it as similar to Mount Fuji, or rather, as similar to prints of Mount Fuji by the Japanese artists he admired (168). He also considered Sandviken, near Bjornegaard, to be 'like a Japanese village'. As far as Monet was concerned, they were all equally exotic and equally un-French; indeed the brilliant colouring of some of his Norwegian pictures is not far from the 'Fauvist' shades of Gauguin's Tahiti (169).

Despite its distance from France, Norway possessed a sophisticated Francophile élite who were highly receptive to contemporary painting. The National Gallery in Oslo, which had bought *Etretat in the Rain* (see 123) in 1890, was the first institution outside France to acquire Monet's work. His stay in the country excited considerable attention, which he did not enjoy. Although there was great local interest in his work, he refused to show his pictures before leaving Norway and reserved them to work on in the studio at Giverny.

Exhibited in May 1895 at Durand-Ruel's gallery in another substantial one-man show, the Norwegian paintings proved unpopular with buyers, who preferred the Cathedrals and the views of Vernon which were also included. Perhaps they were less attractive because they showed an unfamiliar and un-French landscape, perhaps because the Kolsaas series was dark and gloomy – more like the Creuse paintings than the scintillating images of Rouen Cathedral. They have

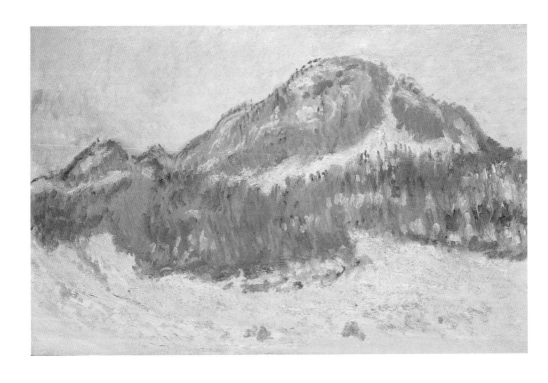

167
*Mount
Kolsaas (Rose
Reflects),*
1895.
Oil on canvas;
60·5×100 cm,
25³⁄₄×39³⁄₈ in.
Musée
d'Orsay, Paris

**168
Katsushika
Hokusai,**
*Mount Fuji,
Seen from the
Umezawa
Manor in the
Province of
Sagarui.*
Woodblock
print from
*Thirty-six
Views of
Mount Fuji*
1829–33.
23·9×34·3 cm,
9³8×13¹2 in.
British
Museum,
London

continued to be less popular; Monet's French pictures are still felt
to be more quintessentially Monet.

The trip to Norway, however, heralded a return to Monet's old orien-
tation northwards; the Mediterranean was abandoned and his next
trip was to be to London, in 1899. The years 1896–7 were largely dedi-
cated to a reprise of subjects treated in previous decades, with a
period of painting familiar spots at Pourville on the Normandy coast,

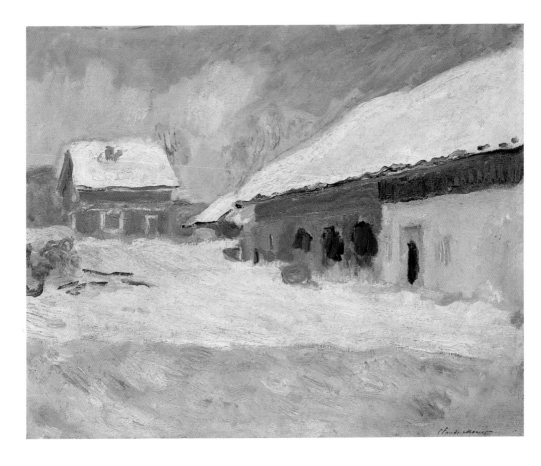

and a series of local river-scenes, the Mornings on the Seine. Painted
at dawn, using a very pale palette, these works reproduce extremely
poorly; the delicacy of the differences is lost and the paintings seem
washed out; encountering the real thing is a startling experience.
Far smoother than the Rouen pictures, they chart the gradual growth
of light at daybreak on a summer morning with astonishing purity.
They are probably the prettiest of Monet's paintings from the 1890s,

and they sold well in his triumphant one-man show at Petit's gallery in June 1898. This was held concurrently with a group exhibition at Durand-Ruel. That year Monet's work was also on show in Russia, Germany and the United States.

At this point Monet ceased to paint distinctively French scenes. The last two series initiated in the 1890s were the London pictures and over a dozen paintings of the Japanese bridge in the water-garden at Giverny. The 'Frenchness' of his work had been generally praised; he may have felt that he had proved his patriotic credentials, or he may simply have used up the Giverny motifs. It has also been suggested that the move to neutral or foreign subjects was the result of political events. By 1898 the nation had been divided for four years over the Dreyfus Affair. In 1894 Alfred Dreyfus, a Jewish captain in the French army, had been convicted of passing French military secrets to the Germans. Dreyfus was sent to a penal colony on Devil's Island in French Guyana, but much of the evidence was suspect and during his exile a campaign to release him gained momentum. Eventually a Major Esterhazy was discovered to have been the real culprit and the innocent Dreyfus was finally released. During this traumatic event the army and the Church closed ranks, and to be pro- or anti-Dreyfus became a litmus test of social and political allegiances. Families were split and the Impressionists divided – Degas and Renoir were convinced of the captain's guilt, while Monet and Pissarro believed that he had been framed.

Monet had not been on very friendly terms with his old companion Zola since a hostile review of his work in 1896, but when Zola took up the Dreyfusard cause in a series of scathing articles he was quick to congratulate him. Zola's writings on the affair were published in *L'Aurore*, a paper edited by Clemenceau, and it was there that the famous polemic 'J'Accuse' appeared on 13 January 1898. This article named those in the army and government responsible for covering up the conviction of an innocent man, and it blew the lid off the Dreyfus Affair as a whole. A few days later a petition, the 'Manifesto of the Intellectuals' appeared. Monet was among the signatories. Given Monet's apparent lack of interest in politics, this suggests that

169
Norway, the Red Houses at Bjornegaard, 1895.
Oil on canvas; 65×81 cm, 25⅝×31⅞ in.
Musée Marmottan, Paris

the Dreyfus Affair really meant something to him, and it is certainly possible that his abandonment of French subjects was the result of a distaste for the rhetoric of patriotism which had co-opted them.

The London series, started in 1899, can be seen as a double rejection of France in favour of its perpetual rival, England, followed by Monet's internal exile in the private space of his own garden. It might also have been that the artist had simply finished at last with the Île de France. By the late 1890s his age and eminence permitted him the great luxury of painting whatever he pleased; increasingly, his works were seen not as grainstacks or cathedrals or even landscapes but simply as 'Monets'.

The London pictures marked a return to truly urban scenes, something Monet had not tackled for more than twenty years. Although his main architectural subject was a nineteenth-century building, the Houses of Parliament, opened in 1852, the paintings of this period are unlike the Paris views of the 1860s and 1870s; there is no sense of the modernity of the city as a subject. Distant views, devoid of figures, these paintings of the Thames, its bridges and the Houses of Parliament show a kind of spectral London, luridly coloured and coated in fog (170). Monet made three separate trips to the city between 1899 and 1901, staying at the newly opened Savoy Hotel and painting mainly from the window of his room, as he had done at Rouen. The hotel's promotional booklet actually described the foggy river views as a major advantage of the establishment, lauding 'this soft London vapour which ... melts the colours, softens the harsh protrusions and gives to buildings an air simultaneously mysterious and stylish'. To transform polluted darkness into a tourist attraction is an impressive triumph of marketing. Monet was clearly not alone in his taste for fog.

In London Monet was a tourist once again, unfamiliar with the language and irritated rather than grateful when offered a cup of tea in mid-painting. He did not come to it unprepared, however; he knew that he wanted to study the light on the Thames, as he had done when he was a refugee there in 1870–1. He had visited the city at least twice since then, staying with the artist James McNeill Whistler

170
Houses of Parliament, Effect of Sunlight in the Fog, 1904.
Oil on canvas; 81×92 cm, 31^7⁄$_8$×36^1⁄$_4$ in. Musée d'Orsay, Paris

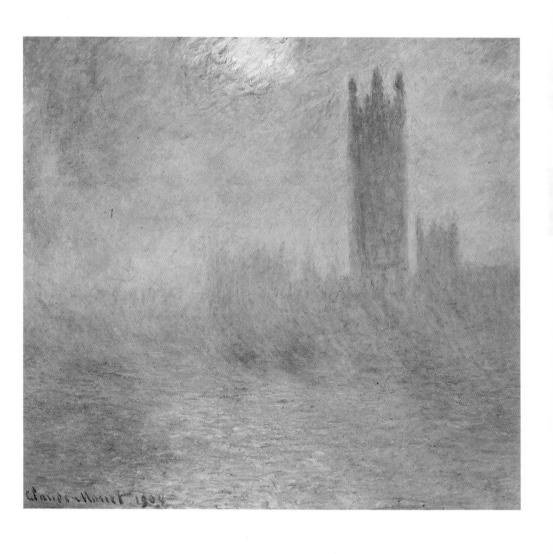

(1834–1903) in 1887 and with Sargent in 1888. By the turn of the
century he was clearly a sought-after celebrity. His letters to
Alice show that he dined out constantly. He even joined a select
group to watch the funeral of Queen Victoria in February 1901, where
Henry James – 'a well-known American writer who speaks excellent
French' – helped him to identify the various eminent mourners.
Monet exclaimed at the magnificence of the spectacle – 'It would
have been marvellous to have been able to sketch it' – but expressed
irritation at the crowds – 'Sargent and I could scarcely make our
way through to have lunch.'

Although he had admired the work of Turner in the National Gallery
with Pissarro on his first trip to the city, Monet is not known to have
had any contact with English artists. Turner had painted the river
and the old Houses of Parliament in flames, and Monet was certainly
aware of this precedent, but as usual he dismissed a potential rival,
declaring 'Once I admired Turner greatly, but now I like him less …
He didn't lay out his colour properly, and he used too much of it;
I've had a good look.'

John Constable (1776–1837), too, had painted Waterloo Bridge; but
while Pissarro, recalling that same period at the National Gallery in
1871, wrote to his son Lucien, 'The watercolours and paintings of
Turner and Constable … have certainly influenced us', Monet was,
as ever, less keen to admit artistic influence. He claimed that it was
the famous London fog that attracted him to the Thames and its
bridges: 'Without the fog, London would not be a beautiful city.
It is the fog which gives it its marvellous breadth. Its regular, massive
blocks become grandiose in this mysterious cloak.' As a painter of
atmosphere, if not of light, he could reasonably be expected to prize
the soot-filled mists of the winter months, with their purple and
green hues. Here was an 'envelope' that could be cut with a knife,
enclosing only the suggestion of buildings. As the architects of the
Houses of Parliament knew, the spiky mock medievalism of Victorian
Gothic looked at its best when wrapped in thick veils of cloud, with
pinnacles emerging from the mist like the masts of a ghost ship.
It is hard now to imagine the effect of the old 'pea-souper' fogs (171).

The abolition of coal fires in the 1950s and the consequent cleaning up of London's atmosphere has since transformed the winter air of the city, which now has seventy per cent more daylight in December than it did in Monet's day. He always chose to visit in the cold months of the year, complaining one March morning of his fear that the weather had turned fine: 'On getting up I was terrified to see that there was no fog, not even the shadow of a fog. I was devastated and saw all my canvases ruined, but little by little, the fires kindled, and the smoke and fog returned.'

Monet was not the only artist to find the thickened air and hazy light attractive. Whistler had painted a series of crepuscular Thames scenes in the 1870s, finding a similar pleasure in obscurity and

Nobody that Knows them could Doubt the Respectability of these Two Gentlemen, yet you would hardly Credit the unnecessary Panic their Imaginations caused them the other Night in the Fog!

171
'Nobody that knows them could doubt the respectability of these two gentlemen, yet you would hardly credit the unnecessary panic their imaginations caused them the other night in the fog!'
Cartoon in *Punch*, 1870

muffled harmonies. Using a very restricted palette and provocatively giving his work musical titles to stress the relative unimportance of the subject, Whistler's pictures, like Monet's later work, show a concern for the decorative (172). The similarity was noted by contemporary observers, and Monet's London scenes were even described as 'harmonies on a theme' by the critic Gustave Kahn. The location and the glaucous, tinted air are the same in the work of both artists, but Whistler's pictures seem dainty and muted in comparison with Monet's searing purple and viridian towers, shooting up through the murk of the Thames (173). The force of these paintings by an artist in his sixties suggests the astonishing energy which Monet derived from the act of painting; the London pictures were produced in a veritable frenzy, canvas after canvas pulled out and touched for

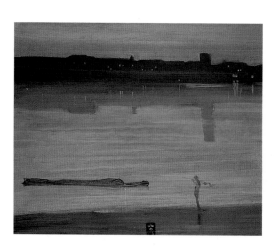

172
**James
McNeill
Whistler**,
*Nocturne in
Blue-Green*,
1871.
Oil on panel;
50·2×59·1 cm,
19³⁄₄×23¹⁄₄ in.
Tate Gallery,
London

173
*Houses of
Parliament,
Reflections on
the Thames*,
1905.
Oil on canvas;
81×92 cm,
31⁷⁄₈×35³⁄₄ in.
Musée
Marmottan,
Paris

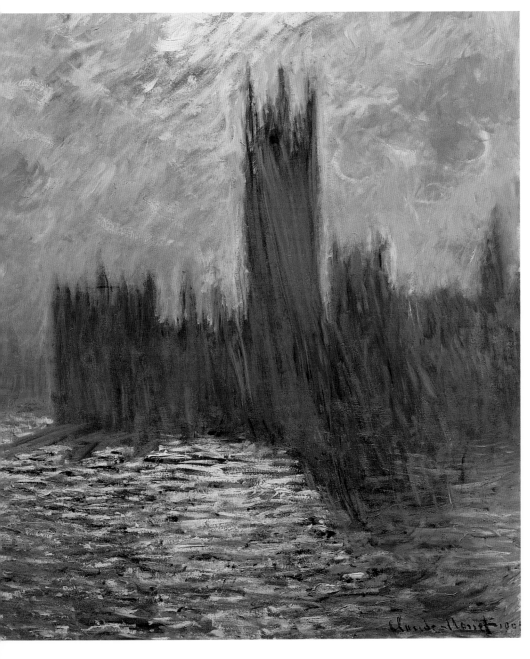

a few minutes before the light changed. He complained to Alice, 'This is not a country where one can finish anything on the spot; the effect can never be found twice.' At one point he claimed to be working on fifty pictures simultaneously. The rush of activity in which the paintings were begun, the rapid attempt to seize the fleeting effects as they melted and metamorphosed in front of his eyes, was followed by a far more contemplative process of 'finishing' in the studio. It was not until 1904 that Monet considered the series ready for exhibition, three years after his final trip to London. By this stage the work in front of the motif was only a preparation for the harmonizing and tuning of the series as a whole. Back in Giverny, he had used a photograph – provided by Sargent – to help him remember the structure of the Houses of Parliament. When in 1905, however, he was accused of abandoning the great principle of natural observation, he replied angrily:

It simply doesn't matter; whether my Cathedrals, my London pictures, or indeed any others are painted after nature or not is no one's business but my own. I know a lot of artists who paint from nature and produce nothing but rubbish … It's the result that counts.'

Plein-air painting and the myth of the artist without a studio were no longer essential to Monet; he had become the established leader of the French school of landscape.

The London pictures brought Monet's series paintings of the 1890s to a triumphant conclusion. When they were unveiled in 1904 Monet was in his sixties and about to launch into a new set of paintings as demanding as any of his previous work. For the next twenty years he was chiefly occupied by an immense series of panels depicting his garden at Giverny and concentrating on the lily pond. In some ways the relentless repetition, the intensity and the emotionalism of the London pictures served as a starting point for this work that was to push his vision to the limits, both literally and metaphorically.

For over a quarter of his life Monet was in fact a twentieth-century artist; he lived until 1926, painting up to the last. Starting his career in the 1860s, he had been in the company of such painters as Millet and Courbet; he died when Pablo Picasso (1881–1973), Henri Matisse (1869–1954) and Georges Braque (1882–1963) were already familar names. He survived long enough to savour fully the pleasure of seeing the establishment which had rejected him for so long fall at his feet, never allowing this tardy recognition to obscure his recollection of the years of struggle. Unlike Renoir, who accepted a state decoration in 1900, Monet refused to join the French Legion of Honour, and continued to consider himself a rebel.

Monet's withdrawal from public life became more marked in the years after 1900. He remained exceptionally healthy and active well into his seventies, but the same could not be said of his entourage. Alice Hoschedé's death in 1911 was followed by the premature death of Monet's elder son, Jean, who succumbed to a degenerative disease – probably syphilis – in 1914. Jean moved back to Giverny to die and his wife Blanche, Monet's stepdaughter and daughter-in-law, remained with the artist as housekeeper and companion. Deeply affected by the loss of his wife and son and feeling increasingly isolated as his old Impressionist colleagues predeceased him one by one, he became reclusive, leaving Giverny seldom and with reluctance.

174
The Artist's House, Seen from the Rose Garden
(detail of 201)

Despite his celebrity he had little contact with new artists. Some young painters who admired his work sought him out at Giverny and to them he was unfailingly hospitable; Pierre Bonnard (1867–1947) and Édouard Vuillard (1868–1940) both became regular visitors, and Matisse may have come to the house in 1917. Monet seldom went to Paris, and by the turn of the century his domestic world at Giverny had developed into an all-encompassing support system, dedicated to the needs of the Master. His estate was not only his home and refuge but also his subject matter.

Monet claimed – inaccurately – that: 'Everything I earned has gone into these gardens.' While much of his money was salted away in stocks and shares, caring for Giverny was certainly an expensive business; in the 1920s a gardener was delegated to wash the dust off the aquatic plants every morning before Monet sat down to paint. The 40,000 francs spent annually on the garden was equivalent to the interest that accrued on his bank account over the same period. Gardening was clearly a source of great pleasure to Monet, but it could also be seen as a shrewd investment. He no longer needed to make expensive and arduous painting trips, finding all his material just outside his front door (175). Between 1900 and the end of his life he painted over 250 pictures of the gardens and the lily pond, pricing some of the larger paintings at 30,000 francs each. The wages of half a dozen gardeners could legitimately be claimed as a work-related expense.

From the 1890s onwards the Giverny garden increasingly became a kind of three-dimensional trial or sketch for paintings, with the flowers massed in blocks of colour. New pieces of land extended the canvas and allowed freedom for experimentation. The planting was arranged not only to vary according to the season but also to follow the changing light during the day, as if the whole garden were an enormous sundial. Thus orange flowers, such as poppies, wall-flowers and brilliant tulips were planted in the west-facing areas, intensifying the glow of the last rays of the sun (176). In 1933, when Blanche Monet was keeping the gardens going after the artist's death, Stephen Gwynn, an English writer, described the way in which the

garden was planted with patches of flowers, 'not grouped in large contrasting masses, as is the usage in France, but scattered broadcast', to produce broken colour – 'the flicker and brilliance of innumerable tiny points' – just as in the artist's pictures.

The writer Marcel Proust (1871–1922), who never saw Giverny, lyrically and accurately described it as 'a garden of tones and colours rather than flowers'. Monet used one area of the garden, the thirty-eight 'paintbox beds', to try combinations of colours; Vivian Russell has suggested that this idea came to him on his second trip to Holland in 1886, when he painted the fields of commercial tulip-growers (177).

176
The west-facing borders at Giverny

177
A Field of Tulips in Holland, 1886. Oil on canvas; 65·5×81·5 cm, 25³⁴×32¹⁸ in. Musée d'Orsay, Paris

Gradually the garden developed into a subject in its own right. By the start of the new century Monet had lived at Giverny for seventeen years. He knew it so intimately that he was able to alter his method of working, changing from regular outdoor work throughout the year to a seasonal rhythm of painting *en plein air* in the summer and working in the studio during the winter months. By the 1910s he had ceased to paint winter scenes, choosing to depict the garden only during the flowering months between May and September. Some areas became veritable obsessions – the Japanese bridge (178), the rose-alley and, above all, the water-lily pond. The 'eastern' or water garden attracted him most. He had designed the whole thing from

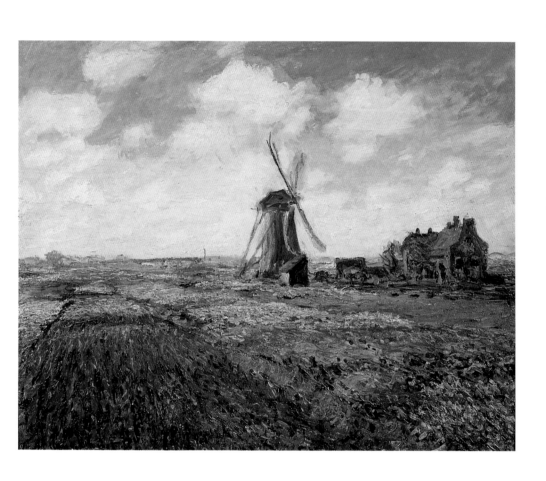

scratch, unlike the 'western' flower garden around the house itself.
He may have liked the supposed orientalism of the garden, the touch
of exoticism in the planting, and the sculptural shape of the bridge
which was gradually draped in wisteria. The main attraction,
however, was the lily pond. Once the 'Raphael of water' had aban-
doned the sea, the Seine and the Thames, he found all that he needed
in the reflective surface of the pond.

In the 1910s and 1920s this restriction of his subject matter was
combined with formally innovative and very bold work. As in the
earlier series, concentration on a single motif freed the artist to

178
The Japanese
bridge in the
water garden
at Giverny

179
Water-lilies,
1907.
Oil on canvas;
100×73 cm,
39³⁄₈×28³⁄₄ in.
Musée
Marmottan,
Paris

180
Overleaf
*Water-lilies –
The Cloud*,
1903.
Oil on canvas;
74·6×105·3 cm,
29³⁄₈×42¹⁄₂ in.
Private
collection

experiment with the means of representation, permitting stronger
colours and more expressive, sweeping brushwork (179). In some
of the paintings, even those from the 1900s, it is almost impossible
to make out a motif. This is especially striking when confronting
the pictures 'in the flesh'; the vigorous brushstrokes and the texture
of the paint, less evident in reproduction, seem to mask rather
than reveal the ostensible motif. This fascination with surface had
long been a feature of Monet's painting; it can be traced from the
flat patterns of *Women in the Garden* (see 36) through the La
Grenouillère scenes of the 1860s, the Saint-Lazare pictures and the
Rouen Cathedral series of the 1890s, to its consummation in the

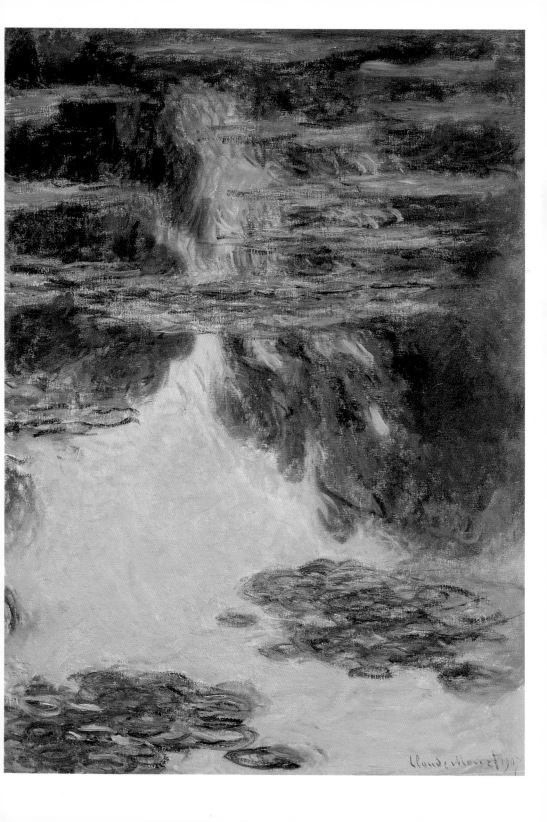

Claude Monet 08

287 Monet in the Twentieth Century

water-lilies, which take as their subject the surface of the pond. More than any other aspect of his art it was this that passed into the mainstream of twentieth-century painting – especially in the United States, where so many of his pictures were to find homes. Questions which came to preoccupy artists in the mid-twentieth century were all explored by Monet in his Giverny cycles; multiples, seriality, flatness, the representation of three dimensions in two, the notion of originality residing in style rather than subject. Despite his relative isolation and advanced age, his work continued to evolve in a manner which sometimes startled even his oldest supporters.

Monet's first major group of garden pictures followed the method of the series, taking a single subject and studying it intensively. Between 1904 and 1908 he started over 150 paintings of the lily pond in the Japanese garden, which had been recently extended. Each year he began a new group with a different viewpoint. He said that he wished these 'water landscapes' (*paysages d'eau*) to be 'works of no weather and no season'. Having shorn his paintings of references to contemporary life, he was now obliterating the last remnants of specificity.

The process of universalization could not go much further; all that is left in the last generation of Giverny paintings is water, plants, earth and sky (180). As the subjects become more abbreviated and the canvases grow in size, the viewer's attention is diverted from the subject to the surface of the picture. Monet was essentially depicting a surface without depth; he was looking both at and into the pool, simultaneously aware of the transparent and weedy depths and the deceptively bright reflections bobbing above them. In conversation with the writer François Thiébault-Sisson, he explained:

The essence of the motif is the mirror of water whose appearance changes at every moment because areas of sky are reflected in it … The passing cloud, the freshening breeze, the seed which is poised and then falls, the wind which blows and suddenly drops, the light which dims and again brightens – all … transform the colour and disturb the planes of water.

'Water landscapes' is a good name for these paradoxical paintings, which could also be called water skyscapes, for the land is reduced to a rim or is entirely absent. The horizon has disappeared and if there is sky it is below the land, inverting the normal relationship; often the water fills the whole of the foreground. Monet's occasional use of circular canvases serves further to distort the perceptions of the spectator; the pictures are oddly disorienting in their refusal to provide the usual firm viewpoint of Western painting (183).

Monet's fascination with lilies was widely shared by fine and decorative artists. Their flatness and simple curves appealed to the practitioners of Art Nouveau and even Art Deco (181). They also appear in Salon paintings, as a backdrop for cavorting nymphs or illustrating the Greek legend of Narcissus, a young man who fell in love with his

181
Jean Dunand,
Lacquer, gilt
and mother of
pearl bed.
Private
collection

own reflection. Monet has been interpreted as a Narcissus figure himself, gazing in endless rapture at the depths of the hole that he had dug in his own garden – the ultimate in navel gazing (182). In his pictures, however, he seems concerned to efface himself completely – in these late works land and air vanish to leave only water, lapping up to the edges of the canvas.

The 'oriental' qualities of Monet's water-lilies were often mentioned by visitors and reviewers, although in fact the flowers were African, not Asian hybrids. The way that the blooms floated, however, on the water and on the canvas, suggested the depthless prints of the Japanese, of which a Hokusai actually owned by Monet (184) is typical. Monet's similar treatment of space prompted the critic

182
Monet's
shadow in the
water-lily
pond

183
Water-lilies,
1908.
Oil on canvas;
diam. 90 cm,
35¹₂ in.
Musée
Municipal
Alphonse-
Georges
Poulain,
Vernon

Louis Gillet to decry the Water-lilies as nothing less than an attack on the Western notion of a man-centred universe, replacing it with 'oriental' self-effacement, and when the 'water landscapes' were exhibited at Durand-Ruel in 1909 (185, 186), they did not receive an unconditional welcome. While many critics considered the show a triumph – an English critic, Robert Dell, described the pictures as 'beautiful to a degree which one can hardly express without seeming to exaggerate' – Monet's work was also attacked from two different directions. Conservative critics found the works formless and without substance, while some members of the avant-garde now considered them inadequately radical. As the once-fashionable notion of

184
Katsushika Hokusai, *Convulvulas*, c.1830. Woodblock print; 25·6×38·3 cm, 10×15 in. Musée Guimet, Paris

185
Paul Durand-Ruel
c.1909

186
Announcement of the Water-lilies exhibition at Durand-Ruel, 1909

decoration became a derogatory label, Monet was increasingly described as over-emotional and superficial. His pictures were seen as too easy on the eye and insufficiently intellectual. For the first time he was compared unfavourably with Cézanne, whose reputation had begun to rise after his death in 1906.

For the younger generation of painters, it was Cézanne rather than Monet who pointed the way forward. Monet's interest in colour harmonies and the surface of the picture was replaced, in Cézanne, by an obsession with the structure of the objects depicted. Both artists had rejected the illusionistic conventions which had been

used by Western artists since the Renaissance, and both attempted to find a new way to solve the problem of showing three dimensions in two. As Monet's work grew flatter and shallower, so Cézanne concentrated on 'deep' views which he broke up into separate, faceted planes, giving a sense of the physical solidity of the subject (188). Cézanne's comment on the work of the artist he had admired all his life sums up the difference between their approaches: 'Il n'était qu'un oeil, mais quel oeil' ('he is only an eye, but what an eye'). Cézanne's work engaged the mind as well as the senses.

By 1900 Paris had become the undisputed capital of art. It retained this position for half a century until the global balance of power shifted irretrievably at the end of World War II and New York took the lead. In the 1910s and 1920s the Parisian art schools were filled

GALERIES DURAND-RUEL
16, Rue Laffitte

Les Nymphéas
Série de Paysages d'eau
PAR
CLAUDE MONET

EXPOSITION
du 6 Mai au 5 Juin 1909, de 10 heures à 6 heures
(Dimanches et fêtes exceptés)

with a cosmopolitan mix of young painters and sculptors, among them Picasso and Braque. In their hands Cézanne's manner of viewing the world developed into Cubism, and such works as an early Braque landscape (189) are clearly related to the work of the older artist. Others, such as Picasso's *Demoiselles d'Avignon* (187), were abruptly different.

Les Demoiselles d'Avignon is often called the first Cubist work. Its distorted faces and bodies and deliberate crudity still hold the power to shock. What Monet had done with the landscape Picasso was doing with the figure – dispensing with the conventions that had governed the depiction of three dimensions in two. One-point perspective, the basis of European art for five hundred years, has been banished; the figures in this paintings are seen from different

angles, denying the validity of a single fixed viewpoint. The picture does, however, have points of contact with innovative works of the previous century, including Manet's *Olympia* and Monet's own *Women in the Garden*. The flatness which became an increasingly important element of Monet's painting is still very evident in the *Demoiselles*, but the uniform perspective has been replaced by jagged discontinuities. In the words of the mid-twentieth-century critic Clement Greenberg, '[Monet] arrived at a shadow of the traditional picture, the Cubists arrived at a skeleton.'

While the readiness to experiment with alternatives to illusionistic perspective unites both artists, the violence of Picasso's work marks it as the product of a painter with no desire to charm. In the early years of the twentieth century Picasso and his Cubist colleagues were working in relative obscurity, while Monet had become the public face of French art. They had no contact; when the older artist visited Paris he did not seek out their studios, while they probably did not feel that the Impressionist master had anything more to offer them. In 1926, when Monet was shown some photographs of Cubist work, he pushed them aside, saying 'It doesn't do anything for me.'

The young painters Monet liked, such as Matisse, Bonnard and Vuillard, shared his interest in large-scale decorative schemes. Such projects were in a sense the continuation of the European tradition of mural painting. In 1908 Monet and Alice visited Venice; this trip to the city of light reflected on water seems to have rekindled his interest in architecture (190); it also reinforced his enthusiasm for working on a grand scale. He admired the work of the great sixteenth- and seventeenth-century artists of Venice, and the immense wall-paintings that decorated not only churches, but also the palaces of the nobility, dwarfing the spectator and making furniture unnecessary (191). Increasingly, he was drawn to the notion of producing a painted room in which his work would surround the spectator completely. In this he was closer to the art of the late twentieth century than even the great innovator Picasso; the Water-lily series at the Orangerie in Paris is both the culmination of that ancient tradition and the predecessor of the 'installations' of the period after 1960.

187 Left
Pablo Picasso,
Les Demoiselles d'Avignon,
1907.
Oil on canvas;
244×234 cm,
96×92 in.
Museum of Modern Art,
New York

188 Below left
Paul Cézanne,
The Sea at L'Estaque,
1883–6.
Oil on canvas;
73×92 cm,
28³⁄₄×36¹⁄₄ in.
Musée Picasso,
Paris

189 Below right
Georges Braque,
Houses at L'Estaque,
1908.
Oil on canvas;
73×65·1 cm,
28³⁄₄×23⁵⁄₈ in.
Kunstmuseum,
Berne

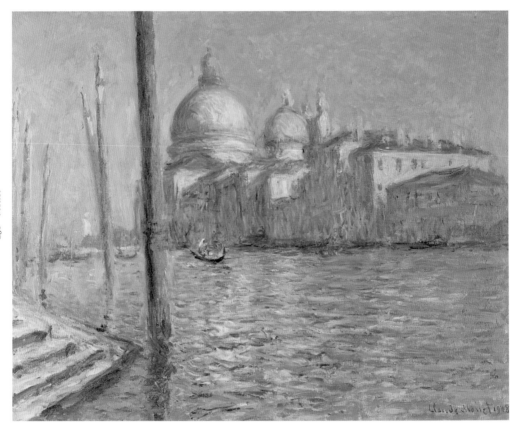

The difference between a room adorned with paintings and a room where the paintings create an entire environment is essentially the difference between art as decoration and art as an emotional experience. The overwhelming effect of Monet's paintings, exhibited as an ensemble, had been noted ever since the beginning of the series shows. The 1909 exhibition drove several critics to lament the works' inevitable fate:

I cannot think without sadness about the coming dispersal of these ravishing works, which constitute only a single work; made so as to be completed one by the other, they will have been brought together but one time … in order to furnish the entire idea and the entire feeling of the poem which they develop.

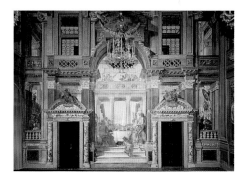

190
The Grand Canal and Santa Maria Della Salute, 1908. Oil on canvas; 73×92 cm, 28³⁄₄×36¹⁄₄ in. Private collection

191
Palazzo Labia, Venice. Frescos by Gianbattista Tiepolo, *c.*1745–50

This comparison of the pictures to a poem, disembodied but profoundly moving, signifies a shift in the status of the pictures from enjoyable artefacts to spiritual experience. Repeatedly, critics lamented the coming dispersal of the paintings and with a shrewd estimation of their market value called for a 'millionaire' to buy or commission a complete set. In 1914 Clemenceau said to the artist, 'Monet, you ought to hunt out a very rich Jew who would order your water-lilies as a decoration for his dining-room.' In the 1870s, at the Hoschedés' Château de Rottembourg, Monet had worked on panels for the dining-room; the association between art and gastronomy was not a new one for him, and indeed he is one of the few artists to have his household recipes honoured by publication. Clemenceau's idea of art to eat by appealed to him; Arsène Alexandre, critic for the journal *Comoedia*, wrote of Monet: 'the painter would have liked to

have a circular room of modest, well-calculated dimensions to decorate … nothing but a central table in the room, which would be a dining-room, surrounded by these mysteriously seductive reflections.' Unlike the American artist Mark Rothko (1903–70), who aborted a lucrative commission for New York's Four Seasons restaurant because he objected to catering for 'the swinish luxury of the rich', Monet liked to live well himself and saw no reason why the twin sensual pleasures of food and art should not be combined.

Eventually, however, the projected scheme developed into a public monument, a secular chapel, not a private dining-room. In an article by Roger Marx in the *Gazette des Beaux-Arts*, Monet is described as saying:

For a time I was tempted to use the water-lily theme for the decoration of a room; carried the length of the walls, enveloping all the wall panels in its unity, it would have produced the illusion of an endless whole, of a wave without horizon or shore; nerves taxed by overwork would relax there, in accord with the restful example of these still waters, and for the person who might have lived there, this room would have offered an asylum of peaceful meditation in the centre of a flowering aquarium.

Matisse had similarly claimed that he wanted his art to be like a comfortable armchair for a tired businessman, 'a soothing mental calmative'. Monet went further, aiming to both lull and overwhelm the viewer. By 1914 he had decided to start a series of immense garden pictures, using canvases on the scale of a state commission. He called them his 'Grandes Décorations', and right from the start there seems to have been some idea that they would end up in a public collection. Monet began work around the time of the outbreak of World War I in the summer of 1914, and his original intentions soon became even more grandiose.

Monet was in his mid-seventies and embarking on a vast and ambitious series. He had recovered from the immobilizing depression that had seized him after the death of Alice in 1911 and had found a new source of encouragement and companionship in Georges

Clemenceau (192). The relationship was an old one – they had first met at the Brasserie des Martyrs in Paris during the 1860s. At that stage Clemenceau was studying medicine, but his main interests were writing and politics. Their paths crossed very little over the next couple of decades; Clemenceau rose up the political ladder to become the leader of the left-wing Parti Radical, while Monet was absorbed in painting. They had friends in common – Mirbeau,

192
Georges
Clemenceau,
Claude Monet
and Lily
Butler on the
Japanese
bridge, 1921

Geffroy, Zola, even Manet – but it was not until a hiatus in Clemenceau's political career that he and Monet began to see each other regularly. In 1900 Clemenceau bought a country house at Bernouville, not far from Giverny, and after the deaths of Alice and

Jean he became a kind of father figure for both Monet and Blanche. Although he was actually slightly younger than Monet, it was to Clemenceau that Monet turned whenever he felt ill, distressed, discouraged or simply lonely. Clemenceau's faith in his friend's talent was indestructible, and his personal interest in Monet's work and his larger preoccupation with his country's good coincided in a scheme to acquire a major work for France. What might have been just a private commission eventually developed into a national monument. It is entirely possible that this would never have taken place without Clemenceau, who pushed and cajoled both the artist and the authorities until finally an agreement was reached. This was not formally resolved until 1922, but from 1914 onward Monet was almost completely occupied with the 'Grandes Décorations'.

Clemenceau's involvement in the conflict, as minister of war and as prime minister, did not diminish his interest in Monet, nor his willingness to devote time and resources to assisting the artist. The resources were not only his own; on occasion the transport of military supplies was disrupted in order to allow materials to be taken to Monet's studio at Giverny. It is an indication of the depth of Clemenceau's belief in the importance of art, its ability to heal and unite the nation, that he did everything to promote the project. The progress of the 'Grandes Décorations' was a matter of national importance.

Before this period Monet had virtually nothing to do with the state system, but in 1914 he had the distinction of being the first living artist to see his work hung in the Louvre. In June of that year the collection of nineteenth-century paintings bequeathed to the state by the banker Count Isaac de Camondo, who had died in 1911, was put on display. The bequest included fourteen pictures by Monet. The artist himself had by this time become part of the French establishment; he was what in Japan would be called 'a living national treasure'. While this status inevitably changed his attitude towards the French state, he was not a political animal, and there seems little doubt that it was largely Clemenceau's urgings that led him to think of his big Water-lily panels as a possible public monument. The other

decisive factor was the war, which changed his attitude towards France and the French in a radical manner.

The outbreak of hostilities created practical problems for all artists. The art market virtually disappeared and materials were affected by rationing. Even more significant were the moral or philosophical problems posed by the apparent irrelevance of painting to an invaded nation haemorrhaging the lives of its young men. Much of the fighting took place in northern France, close enough to Paris for a second siege to be feared, and memories of 1870–1 deeply affected French perceptions of the war. The capital and its hinterland were permanently filled with military convoys and wounded soldiers. For four years the war was inescapable, and there were few families who did not lose a man.

During the previous war with Germany Monet had departed for London. He regretted the disaster that had struck France but he did not feel personally involved, apart from worrying about the canvases he had left behind. World War I involved him much more directly. This was partly the result of practical factors; his son and stepson were in the army (193), and Giverny itself was not far from the battle-fields. But there were deeper reasons as well; Monet now saw himself, and was seen as, a member of the nation which was under atttack. Not for one moment did he consider quitting Giverny, a potentially dangerous spot; in 1914 he wrote to Geffroy:

Many of my family have left … a mad panic has seized all this area … As for me, I'll stay here all the same, and, if these savages must kill me, it will be in the midst of my canvases, in front of my life's work.

The noise of the guns could be heard in England; at Giverny, about 60 km (37 miles) away from German-held territory, it must have been oppressive but, regardless, Monet continued to paint water-lilies. He and his pictures were bound up with the fate of France. As a painter all he could do for the country was to continue working, although he was fully aware that his preoccupations might seem absurdly trivial at a time of such terrible carnage: as he explained to Geffroy:

I was able to resume work, which is the only way to avoid thinking of these troubled times. All the same I sometimes feel ashamed that I am devoting myself to artistic researches while so many of our people are suffering and dying for us.

In reality Monet's work did have a role to play as an aid to morale. As in 1870 France drew on the notion of her artistic achievements as evidence of the superiority of French civilization over the barbaric Germans. This was important as, once again, the French had little in the way of military success to pride themselves on.

193
The family's two soldiers, 1916. l to r: Blanche Hoschedé-Monet, Michel Monet, Claude Monet and Jean-Pierre Hoschedé

The importance of this perceived spiritual victory over Germany was spelt out by Clément Janin, a critic who reviewed the first Salon held since the outbreak of the war. The exhibition opened in the spring of 1916, during the ghastly battle of Verdun, where Michel Monet's battalion was stationed. In these circumstances, Janin suggested, art offered compensation and a call to optimism:

Ah! What revenge if the historian who will write about the gigantic struggle and the epic courage of our people finds here and there the masterpiece born in the tempest and acclaimed by the future! What triumph if he can cry: 'While the barbarians destroyed the cathedrals of Reims, of Louvain, of Soissons, the "Halles" of Ypres, the Belfry at Arras, France, feeling her genius aroused, repaired these disasters. She gave back to humanity what it had lost!' Our army has put up such a strong barrier against the enemy, telling him 'You shan't get any further', that the painter has confidently taken up his brushes once again … Everyone has returned to work … they have all wished to take part, in their own way, in the sacred defence and the Victory.

Although Monet would not have had much interest in Janin's artistic judgements, he shared his elevated view of the artist's role. For the first time in his life he considered working directly for the government, agreeing to paint the ruins of the beautiful Gothic cathedral at Reims which had been shelled by the Germans in the first year of war. His work at Rouen made Reims an obvious choice of subject – the two buildings were equally celebrated as expressions of the artistic genius of the French Middle Ages, and the painting would certainly have been used as anti-German propaganda. However, although Monet never began the Reims picture, by 1918 his work was clearly seen in some sense as part of the war effort.

During the war he produced over forty immense pictures, measuring 200×425 cm (79×167 in). A special studio had been built in 1915, and the pictures were kept on wheeled bases so that they could be rolled around like screens (194). In this way he could be surrounded by his painted garden when the weather was too poor to work outside. Isolated from Paris at Giverny and then isolated from Giverny in the studio, his work became an alternative world. On 12 November 1918, the day after the Armistice, he was visited by Clemenceau – the latter's first postwar engagement. Monet took the opportunity to make a formal offer of two pictures as a gift to the state. He did so in words which recall those of Janin; 'It's the only way I have of taking part in the Victory.' Significantly, he asked that they be placed not in the Louvre but in the Museum of Decorative Arts. While Clemenceau

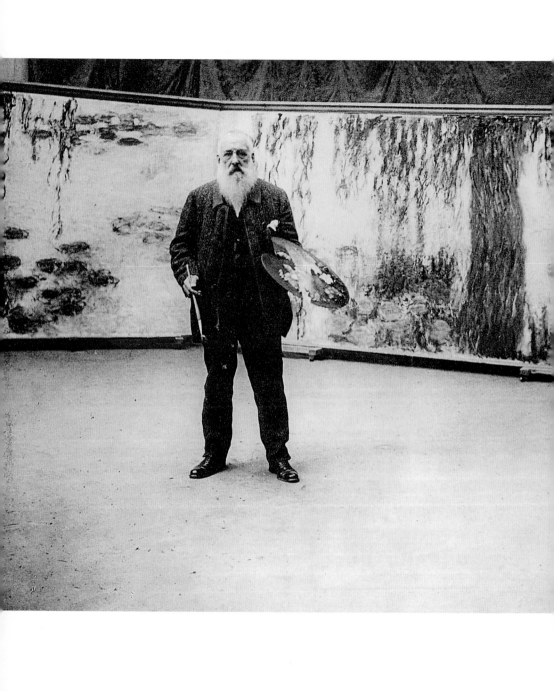

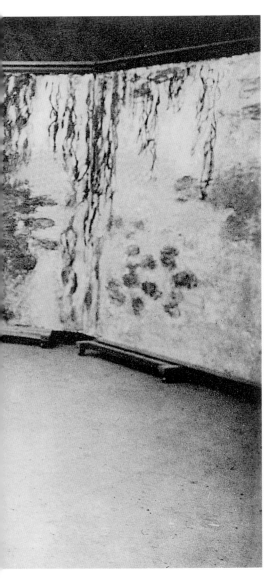

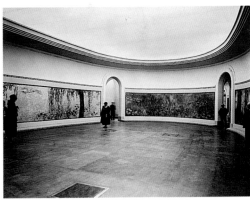

194
Monet
painting the
Water-lilies in
the studio,
*c.*1923

195
The *Water-
lilies* in the
Orangerie,
1930

196
*Grandes Décorations. The
Clouds*, left-hand panel.
Oil on canvas;
200×425 cm, 78³⁄₄×167³⁄₈ in.
Musée de l'Orangerie

197
Grandes Décorations.
The Clouds, centre panel.
Oil on canvas;
200×425 cm, 78³⁄₄×167³⁄₈ in.
Musée de l'Orangerie

198
Grandes Décorations. The Clouds, right-hand panel.
Oil on canvas;
200×425 cm, 78³⁄₄×167⁷⁄₈ in.
Musée de l'Orangerie

was delighted, the donation did not seem particularly relevant to other members of the government. The country was in the throes of an economic crisis, and the hardships and disillusionment of the war threatened to spill into a revolution like that which had recently occurred in Russia. Acquiring pictures did not seem a top priority.

As Kenneth Silver has demonstrated, the whole of the French art world was affected by the need to reassert the importance of art to the national morale and to the economy. Artists in Paris had had a difficult time during the war; spy-fever was rampant, posing a serious problem for the many avant-garde painters who were foreigners. Among them were the Spaniards Picasso and Juan Gris (1887–1927) and the Italian Gino Severini (1883–1966); they were all faced with the difficulty of producing art which satisfied their own taste without offending a public which was increasingly ready to describe any form of modernism as a foreign intrusion. Art critics saw the opportunity to unite aesthetics and patriotism by starting their own campaign against the enemy, Cubism. While there was no reason to associate Cubism with any city other than its birthplace, Paris, the foreign names of many of the artists and their dealers made them vulnerable to accusations of corrupting the purity of the French tradition. Cubism was seen as destructive and aggressive and Impressionism was also attacked in some quarters, although the complaints against it were different.

This art-world conflict was not a new phenomenon. The battle between the advocates of line and colour was indeed an old French tradition; it had its roots in the seventeenth-century conflict between the admirers of Rubens and Poussin, but during World War I it became a battle over the notion of an ideal France. The need to return to the precepts of classicism and academic rigour was described as 'le rappel à l'ordre', the return to order. Art should not be abstract; it should have a serious subject and be clear, hard-edged and linear – like the work of Poussin (see 11). Line was associated with rationality, clarity and masculinity. Colour was thought of as sensual, emotional and female. Monet and the Impressionists were clearly of the Romantic or colourist camp; Impressionism, which

had been absorbed as part of the southern French tradition of sensuality as opposed to northern realism, was thought inadequate to stiffen national resolve.

Artists had been left searching for ways in which they could prove their pro-French credentials. For example, the entire Cubist enterprise, with its aggressive splintered and broken forms, seemed inappropriate in a Paris filled with war wounded, and soon a new style began to emerge, exemplified by Picasso's return to classicism (199). This appealed to conservative critics, who saw it as part of the new, purged France which had replaced the licentiousness of the Belle Époque with the 'return to order', a phrase easily transferred from art to politics.

199
Pablo
Picasso,
*Portrait of
Ambroise
Vollard*,
1915.
Pencil on
paper;
46·4×31·7 cm,
18³⁄₈×12¹⁄₂ in.
Metropolitan
Museum of
Art, New York

In the postwar artistic environment, Monet's work could seem not only old-fashioned but dangerously enfeebling. While the Grandes Décorations (196–198) were in one respect a war memorial, intended to be a rallying point of national unity, not everyone saw the scheme in that light, and Clemenceau had to take it upon himself to sell the increasingly elaborate donation of Water-lilies to a cash-strapped state that would have to meet the immense cost of housing the works in a special building.

From the original two panels the project swiftly grew to twelve and then to nineteen. As the number of paintings grew, the cost soared; although the Water-lily panels were officially a gift, an extra clause was added to the Act of Donation stating that *Women in the Garden* would have to be bought by the state at the same time. The price-tag for this picture, at one time rejected, was 200,000 francs – an immense sum, further inflated by the fall of the franc. Then there was the matter of a suitable building. At first it was planned to install the pictures in a specially built pavilion at the Hôtel Biron, Rodin's old house, but the parliamentary committee thought this over-extravagant.

Money was not the only problem. Monet's painting was by no means universally popular, and these late works, incoherent and apparently doomed to remain unfinished, seemed unworthy objects for such attention. They were popular with foreign buyers, however, espe-cially Americans and Japanese. As before, the spectre of losing works abroad stiffened the resolve of the French state. The same threat had been used by Monet over *Olympia* in 1889, but by the 1920s the situation was more acute than it had been thirty years earlier, and the government was more conscious than ever of the importance of their assertion of spiritual superiority through the arts. They might wish the Water-lilies had never been painted but they could not afford to let them leave the country.

Delivery of the pictures was delayed partly by Monet's long-standing reluctance to consider any work finished and also by grave problems with his sight. He had first noticed a change for the worse in 1908, but he continued to paint untreated for fourteen years. He was suffering from cataracts and his eyes were deteriorating gradually – the worst nightmare of a painter. Degas and Cassatt, two of his colleagues from the Impressionist days, ended up blind, and the famous caricaturist Daumier had undergone unsuccessful surgery for the same condi-tion. The procedure for cataracts was well established, and Monet's doctor, Monsieur Coutela, was a famous specialist; nevertheless, the artist dreaded the operation and put it off until he could really see no more; he was even choosing his colours by deciphering the names on

the tubes. Even then, when he had nothing left to lose but ten per cent vision in one eye, he had to be cajoled and coaxed by Blanche and Clemenceau before he would submit to surgery.

Having a cataract removed nowadays is quick and easy; a new, plastic lens is inserted into the eye, and the patient is able to see within a few hours. In the 1920s, however, the operation was difficult, the recuperation agonizing and vision slow to return. In order to allow the wound to heal, Monet had to lie still on his back, with his arms flat by his sides, his eyes completely bandaged and his head held in place by sandbags (200). This ordeal lasted for ten days, during which he was allowed no nourishment except herbal tea and clear soup. When the bandages were removed, he was given glasses.

Eighty years old and of a cantankerous temperament, Monet found the process of adjusting to glasses almost unbearable. There were two main problems – distortion of form, which gradually lessened as he grew accustomed to the glasses, and distortion of colour, far more serious for the artist. As the cataract had grown slowly, thickening and becoming opaque over more than a decade, it had become like a piece of dirty glass, yellow and then brown. By degrees Monet's perception of colours had been affected – this is very obvious in the garden paintings of the early 1920s, just before the operation (174 and 201). He had been aware that he was 'seeing falsely', but he had not realized the degree to which his perception of colour had changed to compensate for the yellow lens blocking the blue spectrum. When the cataract was removed, the scale of colours inevitably took some time to readjust:

I see everything blue. I no longer see red or yellow. This annoys me terribly, because I know that these colours exist, because I know that on my palette there is some red, some yellow, a special green and a certain violet. I no longer see them as I saw them previously, and I recall very well the colours that they gave me.

The House Seen from the Rose Garden (202) is typical of the pictures that survive from this period – he claimed to have destroyed many others. Monet's involuntary 'blue period' lasted for a few months,

200
Monet in bed
after his
cataract
operation in
1923

201
*The Artist's
House, Seen
from the Rose
Garden,*
1922.
Oil on canvas;
89×92 cm,
35×36¼ in.
Musée
Marmottan,
Paris

after which a new pair of glasses, with yellow-tinted lenses, helped to correct the colour distortion. However, since both Monet's eyes had been afflicted by cataracts and he had only consented to have one eye operated on, he could no longer paint with binocular vision. He began to work covering one eye with a piece of paper, losing some perception of depth as a result. Monet's eye problems have often been called on to explain his style of painting, but the extreme boldness and simplification of the late Water-lily canvases are not a symptom of eye disease. It is the culmination of a lifetime's artistic experimentation.

The canvases destined for the Orangerie were not the only pictures Monet worked on during his last years. The garden provided other subjects – he painted over twenty versions of the rose-alley and a similar number of the Japanese bridge (203). While the dominance of red in these pictures may be attributed to cataracts, the extraordinary treatment of the paint is entirely the result of Monet's fascination with surface texture. Powerfully emotional, these pictures give a sense of the artist's physical engagement with the materials that looks forward to the work of such painters as Jackson Pollock (1912–56), whose work (204) has a clear affinity with the late garden subjects.

For many years Monet had presented himself as the standard-bearer of true Impressionism; once the movement became accepted it was increasingly difficult for critics and viewers to look at the very marked changes in his work and see anything except the continuity they expected. His work in the twentieth century, however, holds a pivotal position in the development of modern art, linking the avant-garde of the nineteenth century with stylistic trends which were not to appear fully until the mid-twentieth century. This is especially true of the very late works. Clemenceau acutely remarked that if Monet had continued working for another ten years there would no longer be any paint on the canvas; his subjects had grown increasingly immaterial, as he moved from people and cities to fields and rivers, and then to flowers, clouds and ponds. Finally he was painting only light on water, the most fleeting and insubstantial

202
The House Seen from the Rose Garden, 1922–4. Oil on canvas; 89×100 cm, 351$_6$×393$_8$ in. Musée Marmottan, Paris

203
*The Japanese
Bridge*,
1918–24.
Oil on canvas;
89×116 cm,
35×45³⁄₄ in.
Musée
Marmottan,
Paris

204
**Jackson
Pollock**,
Tondo,
1948.
Oil and
enamel on
metal;
diam. 58·7 cm,
23¹⁄₈ in.
Private
collection

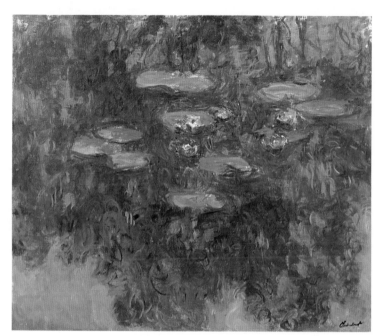

205
Water-lilies,
1916–19.
Oil on canvas;
130×152 cm,
51¹⁄4×60 in.
Musée
Marmottan,
Paris

206
**Christo and
Jeanne-
Claude,**
*Surrounded
Islands,
Biscayne Bay,
Greater
Miami,
Florida,*
1980–3

of motifs. The Monet rooms at the Orangerie are at once a mimicking of the garden, on a life-size scale, and an admission of the impossibility of the whole enterprise of painting the world. It is both the last of the dioramas and the first installation; the installations of Christo and Jeanne-Claude (b. 1935) can be seen as a gargantuan, real-life tribute to the Water-lilies (205, 206).

Lengthy negotiations over the details of the Grandes Décorations, the exact number of canvases and their location, were finally concluded in 1922. The original idea of a single circular space was abandoned. Two specially shaped windowless rooms were constructed in the basement of the Orangerie (see 2), an outbuilding of the Tuileries Palace which had been wrecked during the Commune in 1871. It was a perfect location, right in the heart of Paris, near the Louvre and next to the Seine. From 1947 to 1989 the twin building to its left, the Musée du Jeu-de-Paume, housed the national collection of Impressionist paintings, including *Olympia* and *Women in the Garden*. These buildings became two great shrines to Impressionism.

Plagued up to the last minute by problems and uncertainties, the pictures – twenty-two in all – were delivered only after Monet's death. Mistrustful to the last, he ordered the canvases glued to the walls so that they could never be removed. They were finally installed in 1927, and they seemed outdated (195). There were few visitors, and of those who came on a day when he happened to be viewing the monument he had done so much to create, Clemenceau complained that forty-four out of forty-six were 'lovers in search of a quiet place'.

Monet died in his bed at Giverny on 5 December 1926. By this time, he had not been fashionable with the avant-garde for over a decade. His pictures seemed 'over-pretty'; they were compared to stage backdrops and colour photographs. In 1928 Jacques-Émile Blanche wrote of the Grandes Décorations, 'The pictures would be virtually the same upside-down, they would have the same decorative qualities; while a rigorously organized work by Picasso, of around 1912, cannot be read except when presented as the painter intended.' The same critic commented 'His works sell well to lawyers and surgeons.' The painter who had been the exclusive preserve of the

artistic minority now represented wealthy popular taste.

Living so long, Monet had survived early hardships to enjoy the full
fruits of his success – and to continue painting when he was no
longer universally respected. His reputation dipped a little during
the first half of the twentieth century but began a seemingly unstop-
pable rise in the mid-1950s, when the American critic Clement
Greenberg wrote a serious appraisal of his work. Greenberg was the
great defender of the American postwar movement known as
Abstract Expressionism, and it was through his interpretation of
Monet that the artist began to appear once again as a central figure
in the development of modern art. Now his appeal seems universal;
not only is he a respectable topic for academic study, but his name
is guaranteed to secure record exhibition attendances.

207
Roy
Lichtenstein,
Haystack 6,
1969.
Lithograph;
34·1×59·7 cm,
13$\frac{1}{2}$×23$\frac{1}{2}$ in.
National
Gallery of Art,
Washington,
DC

Monet had always been a manipulator of the media, and had willing-
ly collaborated with dealers and critics to create a cult image. The
great creator and 'natural' artist, in his last years Monet's mystique
was not diminished by his seclusion, and he began to command
respect for his venerable historic status. Journalists, buyers and
admirers continued to seek him out at Giverny; books and articles
appeared regularly throughout the 1920s. From the end of World
War I until his death, accounts of 'the pilgrimage to Giverny' took
on a hushed and awestruck tone. In 1927, just after Monet's death,
the dealer René Gimpel described the studio as if it were a shrine,
listing with veneration the number of brushes and tubes of paint:

A scrupulous order reigned in the studio. About forty cardboard boxes were neatly arranged on large trestles. They contained great tubes of colour, all intact and all about the same length. In a glazed earthenware jar were more than fifty very clean brushes, in a second jar about thirty and about forty more still ranged on the benches – all 2 or 3 cm in width. He has two palettes, both scrupulously clean – so well-kept that they are just like new. Only one of them had paint on it – separate mounds of cobalt, of marine blue, of violet, of vermilion, of ochre, of orange, of dark green, of another green, not light, however – just a few colours, and in the centre of the palette mountains of white, snowy white. Impressionism sprang from this pile of white.

Perhaps the most startling thing about this 'laundry-list' approach is that the existence of the studio had finally been admitted – and in print. For Gimpel, however, it was the contrast between the physical modesty of the materials and the spiritual immensity of the product, the alchemy of art. The dealer was writing an article for a lucrative market, the art-loving American public, and it was clearly in his interests to treat Monet as a magician rather than an ageing artisan, but one should not be too cynical about his motives. The visit was clearly moving, and the paintings are spectacular.

208–209
Monet
merchandise

Little has changed today. Monet is probably the best-loved artist in the world. His work is recognized by people who have never seen any of his actual paintings; it has become a kind of corporate logo for Impressionism, the West's most popular artistic movement (207). His pictures command immense prices and a seemingly endless stream of studies and monographs appear every year. The pilgrimage to Giverny has become a mass pursuit, with thousands of visitors thronging the gardens and modest house and looking at photographic copies of his pictures in the studio; they take home relics, in the form of jewellery, key-rings, computer mouse pads, T-shirts and jigsaws, all with designs from Monet's paintings (208, 209). The artist André Masson (1896–1987) once described the Orangerie as 'the Sistine Chapel of Impressionism'; it is a telling comparison, as the worship which was once directed towards religion seems increasingly turned towards art. The paintings of Michelangelo

(1475–1564) were venerated for their sacred subject and for the holy function of the chapel they adorn; the Orangerie is revered because it contains Monet. Virtually contentless, his images hold nothing to distract from their importance as paintings. It is in some ways a fitting end for the man who once explained, 'I want to paint the air … that is, nothing less than the impossible' (210).

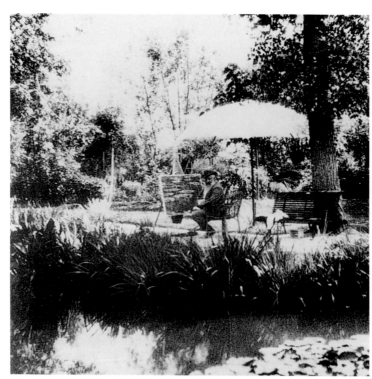

210
Monet painting by the water-lily pond, *c.*1920

Glossary

Academy of Fine Arts (Académie des Beaux-Arts) Founded originally in 1648, the Academy played a central role in the visual culture of the French state until well into the nineteenth century. It made appointments to the **Salon** jury, distributed prizes, ran art competitions and advised on state purchases and commissions. It was also influential in the administration of the École des Beaux-Arts, which admitted around 500–600 art students each year.

Barbizon School Group of painters associated with the village of Barbizon in the Forest of Fontainebleau about 100 km (60 miles) southeast of Paris, c.1830–70. They specialized in low-key rural landscapes; their greatest success was during the first decade of the **Second Empire**. Artists associated with the school include Jean-François Millet, **Charles-François Daubigny**, Narcisse Virgile Diaz de la Peña and Théodore Rousseau.

Cubism Art movement which developed in Paris during the early years of the twentieth century, taking as its starting point the enquiry into the nature of form begun by **Cézanne**. Pablo Picasso and Georges Braque are the painters associated with the initial birth of the Cubist style, which is often considered to be the most radical development of Western art in the twentieth century.

Divisionism Technique of painting developed by **Georges Seurat**, in which patches of colour are laid side by side on the canvas instead of being blended on the palette. It was intended to produce an 'optical mix' in accordance with scientific studies of perception by contemporary colour theorists and to place painting on a more objective basis than the supposedly 'instinctual' **Impressionism**.

Dreyfus Affair One of the most socially and politically divisive incidents in the history of nineteenth-century France. In 1894 a Jewish army officer, Alfred Dreyfus, was convicted of spying for Germany and sent to a penal camp in French Guiana. Over the next few years a campaign for his release found evidence that he had been framed and the real criminal was exposed. The French establishment, especially the Army and the Catholic Church, was very reluctant to accept the evidence of corruption and anti-Semitism within its ranks. The battle for his release was long and arduous. The publication of 'J'Accuse', an article by **Émile Zola**, in 1898 was instrumental in securing a re-trial and, eventually, in 1906, his rehabilitation.

High Art Term used to describe the type of painting or sculpture most highly prized by academic theorists during the seventeenth, eighteenth and nineteenth centuries. High Art generally depicts elevated subjects, often taken from classical mythology or the Bible, and treats them in an idealizing manner. High Art was often intended to educate and improve the viewer.

Impressionism A term referring to the work of the artists who made up the core group of exhibitors at the eight 'independent group shows' held in Paris between 1874 and 1886. Monet, **Renoir**, **Sisley**, **Pissarro**, **Morisot**, **Degas**, **Cassatt** and **Caillebotte** are usually considered the principal members; **Gauguin** and **Cézanne** are also sometimes included, although their work is generally considered to belong to **Post-Impressionism**. Visually, Impressionism is characterized by some or all of the following: bright colours, visible brushstrokes, rapid execution, **plein-air** work, modern-life subjects and a desire to capture fleeting effects of light.

Neo-Impressionism A term introduced by the critic **Félix Fénéon** in 1886 to describe the work of **Seurat** and his followers who used **divisionism**.

Plein Air Applied to painting, it describes the practice of landscape painting outdoors directly in front of the motif. This had long been established as a useful way of training the eye and preparing pictures which would be worked on in the studio; the invention of the collapsible lead paint-tube in 1841 made it physically simpler for artists to do more and more work outdoors. Monet generally did much, if not all, of his landscape painting directly in front of the motif, although as he grew older he spent more time finishing in the studio and working from memory.

Post-Impressionism Loose term used to describe the work of independent artists during the 1880s and 1890s; **Gauguin**, van Gogh and **Cézanne** are seen as central figures. Their work bears some relationship to that of the earlier Impressionists in its freedom of execution but with a greater stress on the subjective and individual quality of the artist's perception.

Realism A term used to describe a movement in painting during the nineteenth century, Realism refers to the belief that the artist's task is the accurate representation of the visible world, without idealization. This often implied the choice of 'low-life' subjects, previously excluded from **High Art**.

Salon Annual or biennial exhibition open to all artists. The **Academy of Fine Arts** had a key role in its administration by providing members of the selection jury, until the state relinquished control to the Society of French Artists in 1881. The majority of the works were for sale.

Second Empire Established by **Louis-Napoleon Bonaparte** in 1852 with himself as Emperor. It was a period of economic growth, when Paris was remodelled, combined with repression of political dissent and highly centralized decision making by the Emperor. Military campaigns in the Crimea and northern Italy, intended to restore French prestige, culminated in the Prussian attack on France in 1870. This led to the collapse of the empire, the declaration of the Third Republic and the exile of the Emperor in England.

Sketch Normally a rapid and spontaneous drawing, executed in pencil, crayon, chalk, or paint. Sometimes but not always intended as preparation for a larger or more precisely finished work. In French, several terms are used – esquisse (sketch), étude (study) and ébauche (lay-in) – which have different shades of meaning. Monet was frequently criticized for the 'sketchy' appearance of his work.

Symbolism In the visual arts, Symbolism was a fashionable style during the 1880s and 1890s. Influenced by contemporary music and literature, it emphasized the individual imagination and the mystic. In reaction to **Realism**, Symbolist artists saw their aim as the creation of 'a harmony parallel to Nature', not the duplication of the visible world; they were essentially opposed to the scientific spirit and materialism of the nineteenth century.

Third Republic (1870–1940) Period of parliamentary government established after the defeat of **Napoleon III** at the hands of the Prussians; it came to an end with the German occupation of Paris in 1940. Although shaky at first, with the return of some form of royal rule a constant threat during the 1880s, by the 1890s the Third Republic was secure and France had become a secular, republican state. In the arts the censorship and close control of the imperial period was replaced with a more liberal government attitude and encouragement of a free market.

Universal Expositions A series of international trade fairs, which displayed the products of various exhibiting nations. The first, the Great Exhibition, was held in London in 1851. Paris hosted magnificent and spectacular exhibitions in 1855, 1867, 1878, 1889, 1900, and in 1925 the Exposition Internationale des Arts Décoratifs et Industriels Modernes, from which the term Art Deco derives.

Brief Biographies

Frédéric Bazille (1841–70) Born into a wealthy family of wine producers in Montpellier, southern Frence, Bazille originally studied medicine. Moving to Paris in 1862, he attended Gleyre's studio, where he met Monet, **Renoir** and **Sisley**. They all became friends, Monet and Renoir using Bazille's studio for a period. Bazille also assisted Monet by buying *Women in the Garden* when it was rejected by the **Salon** and frequently lent him money. He was killed in action during the Franco-Prussian War.

Louis-Napoleon Bonaparte, Napoleon III (1808–73) Nephew of Napoleon I, he was elected president of France in 1848. Forbidden by the constitution from being re-elected, he seized power in a *coup d'état* in 1851 and the following year declared the **Second Empire** with himself as emperor. One of his first acts was the appointment of Baron Haussmann to remodel the capital. In the early years he kept tight political control but by the late 1860s this had relaxed. In 1870 he led the country into a calamitous war with Prussia and was forced to abdicate. He died in exile in England.

Eugène Boudin (1824–98) Born in Honfleur on the Normandy coast, the son of a mariner, Boudin specialized in seascapes and beach scenes. He worked as a stationer before he decided to become a professional painter, moving to Paris in 1847. In 1851 he was given a three-year scholarship by Le Havre Municipal Council. He met Monet around 1856 and encouraged him to paint outdoors directly from the motif. Boudin exhibited regularly at the **Salon** from 1863 to 1897 and took part in the first Impressionist group show in 1874.

Gustave Caillebotte (1848–94) An artist of independent means, Caillebotte exhibited at five of the eight Impressionist group shows. He organized the 1877 show and persuaded Monet to exhibit in 1879. He also bought his contemporaries' work and left his collection to the state; its acceptance was contested since many of the Impressionist pictures were considered not worthy enough to enter the national collection. Finally, thirty-eight were taken and form the nucleus of the Impressionist collection now in the Musée d'Orsay, Paris.

Mary Cassatt (1844–1926) Born into a wealthy American family, she settled in Paris in 1874. **Degas** invited her to exhibit with the Impressionists and she participated in four of their group shows. Her work increasingly concentrated on the subject of mother and child. She encouraged rich American friends such as the Havemeyers to buy the work of her contemporaries.

Jules-Antoine Castagnary (1830–88) Critic. In 1863 he introduced the term 'naturalism', which he defined as 'truth balanced with science'. He was a supporter of the **Barbizon** artists and **Courbet**, whom he admired as 'naturalists', but he found it harder to accept the lack of 'finish' in the paintings of the Impressionists. A member of the left-wing opposition during the **Second Empire**, he was rewarded with the position of Directeur de l'Administration des Beaux-Arts the year before his death.

Paul Cézanne (1839–1906) The son of a banker in Aix-en-Provence. Under the influence of his childhood friend, **Émile Zola**, Cézanne went to Paris in 1861, where he entered the Académie Suisse and soon met the future Impressionists. He exhibited at two group shows – 1874 and 1877 – where his work was harshly criticized. Thereafter his style moved away from that of the Impressionists, concentrating more on form and structure. He was accepted at the **Salon** for the first and only time in 1882 and from that year he lived in Provence, inheriting his father's fortune in 1886. He fell out with Zola in 1886 after the publication of the novel *L'Oeuvre*, believing himself to be the model for the failed painter Claude Lantier. It was only at the end of his life that the great power and originality of his work won recognition beyond the narrow circle of artists who had long admired his pictures. He was a formative influence on twentieth-century artists, in particular the Cubists.

Georges Clemenceau (1841–1929) Politican and writer who trained as a doctor in Paris, where he probably first met Monet in the early 1860s. After spending the years 1865–9 in the USA, he became active in left-wing politics and was mayor of Montmartre and a member of the national assembly during the Franco-Prussian War. Thereafter he was a member of the chamber of deputies and a leading political critic. He founded and edited the radical papers *La Justice* and *L'Aurore*; the latter published Zola's article 'J'Accuse' in 1898. Clemenceau was prime minister in 1906–9 and 1917–20 and was president of the 1919 Versailles peace conference. He was Monet's closest friend during the last years of his life and was instrumental in persuading him to embark on and complete the Grandes Décorations now installed in the Orangerie, Paris.

Gustave Courbet (1819–77) A painter from the Jura region of eastern France, he established himself as leader of the Realist school with his scenes of everyday life, such as *A Burial at Ornans*. He befriended Monet in the 1860s, and his work outdoors influenced the younger artist. He posed for one of the figures in Monet's *Déjeuner sur l'herbe* and acted as a witness to Monet and Camille's wedding. His involvement in the Paris Commune and implication in the destruction of the Vendôme Column led to his exile in Switzerland, where he died.

Charles-François Daubigny (1817–78) A member of the **Barbizon** school of painters, his method of **plein-air** painting and using a studio boat were influential on Monet. He introduced Monet and **Pissarro** to **Durand-Ruel** in London during the Franco-Prussian War.

Edgar Degas (1834–1917) Wealthier and more aristocratic than Monet, **Pissarro** and **Renoir**, Degas's training at the École des Beaux-Arts seemed to destine him for a career as an academic painter. However, contact with **Manet** and the Impressionists in the 1860s led to his exhibiting at seven of the eight group shows. He strongly disliked the term 'Impressionist' and he led a 'Realist' tendency within the group. He concentrated almost exclusively on indoor scenes of modern urban life and especially on female figures – laundresses, ballet dancers, singers and bathers. His sight deteriorated towards the end of his life and he moved from painting to sculpture.

Paul Durand-Ruel (1831–1922) Born into a family of art dealers, he began his career selling works by Delacroix and the **Barbizon** artists. After meeting Monet and **Pissarro** in London in 1870 he began to buy works by the Impressionists and was an invaluable, if inconsistant, source of financial support for them. His business became increasingly international and from 1886 he did a great deal of trade in the United States. His three sons took over much of the business from 1888.

Théodore Duret (1838–1927) Financially independent, he was able to pursue a career as a writer and art collector. In 1865 he met **Manet**, writing about him in his first book, *Les Peintres français en 1867*, and soon met all the Impressionists. In his first **Salon** review of 1870 Duret defended their work and in 1878 he published his *Histoire des peintres impressionnistes*. He was a patron of their work and also collected Japanese prints. He had to sell much of his collection – including Monet's *Turkeys* – in 1894 because of difficulties in the family business.

Félix Fénéon (1861–1944) Co-founder of *La Revue indépendante* in 1884, he was a friend of **Seurat** and **Signac**. In 1886 he coined the term **Neo-Impressionism** to describe their work, comparing it favourably to the work of Monet. He shared their anarchist views, for which he was tried in 1894. As well as being an art critic, he was a dealer and collector, and organizied the first Futurist exhibition in Paris in 1912.

Paul Gauguin (1848–1903) Originally a stock-broker who painted as a hobby, he exhibited at the Impressionist group shows from 1880. The 1882 stock-market crash meant he took up painting full time. He worked in Brittany, with van Gogh at Arles and in the South Seas, searching for exotic and 'primitive' subjects which he depicted in a deliberately naïve manner, using bright, non-representational colours and flat, stylized forms. His work is often considered as part of the Post-Impressionist or Symbolist movements. Monet was always hostile to him.

Ernest Hoschédé (1837–91) Owner of a department store whose primary interest was art, he and his wife Alice Raingo entertained an artistic circle of friends at her Château de Rottembourg at Montgeron near Paris. Hoschédé was an important patron of the Impressionists and in 1876 both **Manet** and Monet stayed at the château, for which Monet was commissioned to paint four panels. In 1877 Hoschédé was declared bankrupt and at the ensuing sale of his collection Monet's pictures averaged only 155 francs each. The following year the Hoschédés and their six children set up home with the Monet family at Vétheuil, but Hoschédé soon moved to Paris. Thereafter he worked as an arts journalist, seeing his wife and children only occasionally. At the request of his children he was buried at Giverny and the year after his death Alice married Monet.

Johan Barthold Jongkind (1819–91) A Dutch artist, specializing in land- and seascapes and city scenes, who was resident in France for much of his life. The brightness and sensitivity of his pictures with their minute attention to changing light were an important influence on Monet and the development of Impressionist landscape.

Édouard Manet (1832–83) A member of the Parisian upper-middle classes and originally destined for the law, he trained as a painter with Thomas Couture (1815–79). Manet combined admiration for the Old Masters with an interest in modern-life subjects. His *Déjeuner sur l'herbe* (shown at the 1863 Salon des Refusés) and *Olympia* (Salon of 1865) established him as a rebel against artistic conventions. As such he was a model for the Impressionists, but he never exhibited with them. His friendship with Monet was of mutual benefit to their work. Monet was the only Impressionist to act as a pall-bearer at Manet's funeral and in 1889 he led the campaign to buy *Olympia* for the state.

Berthe Morisot (1841–95) A founder member of the Impressionist group, she exhibited at seven of the eight group shows. She was particularly close to **Manet** and in 1874 married his brother Eugène. She concentrated on figure scenes, often set outdoors,

which were painted with bright colours and fluid brushwork.

Georges Petit (1856–1920) He inherited a highly successful picture gallery from his father in 1877 and moved from dealing with the academic artists who had built up the fortunes of the firm to less conventional artists. He began buying works of the Impressionists when he acted as valuer at the 1878 sale of the **Hoschedé** collection. Starting in 1882 he held glamorous group exhibitions, at which Monet, **Pissarro**, **Renoir** and Sisley all exhibited during the 1880s. He also arranged the important 1889 Monet and Rodin shared retrospective. He was an important source of income for Monet.

Camille Pissarro (1830–1903) Born in the West Indies, he trained at the Académie Suisse in Paris, where he probably first met Monet. While he was in London during the Franco-Prussian War his house in Louveciennes was ransacked by Prussian troops and both he and Monet lost many paintings stored there. He helped to organize the first Impressionist group show in 1874 and was the only painter to exhibit at all eight group shows. He worked with **Cézanne** in the 1870s and was an important influence on **Gauguin** in that period. In 1885 he met **Seurat** and **Signac** and for a time worked in the Neo-Impressionists' pointillist style. A committed anarchist, many of his paintings show scenes of peasant labour.

Pierre-Auguste Renoir (1841–1919) From a working-class background, he was originally apprenticed to a painter of porcelain. He worked in Gleyre's studio, where he met Monet, **Bazille** and **Sisley**, and later attended the École des Beaux-Arts. He worked closely with Monet in the 1860s. He took part in the first three Impressionist group shows and **Durand-Ruel** included him in the 1882 show, but from 1878 he exhibited regularly at the **Salon**. In the 1880s the work of Monet and Renoir diverged in style and subject matter as Monet concentrated on landscapes and Renoir became increasingly interested in figure studies.

Georges Seurat (1859–91) Born into a middle-class Parisian family, he studied at the École des Beaux-Arts where he became interested in the scientific colour theories of Michel-Eugène Chevreul and Ogden Rood. He attempted to put their ideas into practice and to paint according to a system which would give an accurate rendition of the relationship between different colours. This led him to develop the technique known as **divisionism** or pointillism. His *Sunday Afternoon on the Island of La Grande Jatte* (1884–6), exhibited at the eighth Impressionist group show, was clearly related to earlier Impressionist studies of urban pastimes, but its startling technique established him as the leader of a new avant-garde.

Paul Signac (1863–1935) He was inspired to paint after visiting Monet's exhibition at the offices of *La Vie Moderne* in 1880 and after he met **Seurat** in 1884 he began to employ the **divisionist** technique. He was close to both **Pissarro** and **Félix Fénéon**, and was an influence on van Gogh, whom he visited in Arles in 1889. Following Seurat's early death, Signac helped to publicize **Neo-Impressionism**. In 1899 he wrote the influential book, *D'Eugène Delacroix au néo-impressionnisme*, which placed Neo-Impressionism firmly in the tradition of French art.

Alfred Sisley (1839–99) Born in Paris but of British nationality, he trained at Gleyre's studio, where he met Monet, **Renoir** and **Bazille**. He exhibited at five of the Impressionist group shows. Principally a landscape painter, he specialized in quiet rural scenes of the areas to the west and southeast of Paris where he lived.

James McNeill Whistler (1834–1903) Born in the United States, he studied with Gleyre in Paris and moved to London in 1859. He was an important link between the art worlds of Europe and the USA, associating with **Courbet**, **Manet** and Monet, as well as the English Pre-Raphaelite artists. In the 1860s he began to give his pictures titles that stressed their visual qualities and downplayed the importance of subject matter; his 'arrangements' and 'harmonies' may have influenced Monet.

Zola, Émile (1840–1902) Born in Aix-en-Provence, he was a childhood friend of **Cézanne**. As a writer in the Realist tradition, he defended **Manet** and the Impressionists, whose work he considered to be the visual equivalent of his 'scientific' study of contemporary society. His novel, *L'Oeuvre*, published in 1886, upset many of his artist friends who suspected that they had been used as models for the story of an unsuccessful painter. In 1898 his article 'J'Accuse' attacked the French establishment's conduct of the **Dreyfus Affair**. As a result, Zola was briefly imprisoned, but the article had the desired effect of focusing public attention on the iniquities of the Dreyfus trial.

Key Dates

Numbers in square brackets refer to illustrations

The Life and Art of Claude Monet

A Context of Events (primarily French, unless otherwise noted)

1840 Oscar-Claude Monet born at 45 rue Lafitte, Paris, 14 November

1840 Birth of Émile Zola and Auguste Rodin. Britain: Rowland Hill introduces penny postage

1842 Honoré de Balzac begins *La Comédie humaine* series of novels

1845 The Monet family moves to the port of Le Havre in Normandy. Monet's father joins the business of his brother-in-law, Jacques Lecadre, a ship's chandler and grocer

1847 Britain: Charlotte Brontë, *Jane Eyre*

1848 Revolution leads to abdication of the king, Louis-Philippe. Second Republic established. Louis-Napoleon elected president.
Henri Murger, *Scènes de la vie de Bohème*.
Germany: Karl Marx and Friedrich Engels, *The Communist Manifesto*.
Britain: The Pre-Raphaelite Brotherhood is formed

1851 *Coup d'état* of Louis-Napoleon.
Britain: Great Exhibition at the Crystal Palace, London. Death of J M W Turner

1852 Napoleon III proclaims the Second Empire. Baron Haussmann begins redevelopment of Paris.
USA: Harriet Beecher Stowe, *Uncle Tom's Cabin*

1853 Napoleon III marries Eugénie de Montijo, a Spanish aristocrat

1854 Crimean War begins (to 1856).
USA: Henry David Thoreau, *Walden*

1855 Begins to sell his caricatures in a frame and print-shop near the harbour

1855 Universal Exposition in Paris. Gustave Courbet organizes his own exhibition and publishes his *Realist Manifesto*

1856 Meets Eugène Boudin, a landscape artist who introduces him to *plein-air* painting

1857 His mother dies

1857 Charles Baudelaire, *Les Fleurs du mal*. Gustave Flaubert, *Madame Bovary*

1858 A landscape, *View of Rouelles* [17], is shown at a public exhibition in Le Havre – his first oil-painting to be formally exhibited

1859 Applies for (and is refused) a scholarship from the town of Le Havre to enable him to study painting in Paris. Settles in Paris anyway

1859 War between France and Austria. Britain: Charles Darwin, *The Origin of Species*. J S Mill, *On Liberty*. Charles Dickens, *A Tale of Two Cities*

The Life and Art of Claude Monet	A Context of Events
1860 Attends the Académie Suisse	**1860** Nice and Savoy annexed by France
1861 Draws an unlucky number in the lottery for military service. Enlists in a cavalry regiment and goes to Algeria	**1861** Italy: Victor Emmanuel becomes king of united Italy. USA: Start of Civil War (to 1865)
1862 Invalided back to France after an attack of typhoid, his aunt buys him out of the army. Convalescing in Le Havre, works with Boudin and the Dutch artist Jongkind. Together they practise *plein-air* painting. Returns to Paris and enrolls in the studio of Charles Gleyre, where he meets Pierre-Auguste Renoir, Alfred Sisley and Frédéric Bazille	**1862** France buys Menton and Roquebrune from Monaco. Victor Hugo, *Les Misérables*. Britain: International Exhibtion is held in London
	1863 Salon des Refusés includes Édouard Manet's *Déjeuner sur l'Herbe* [24] and James McNeill Whistler's *Symphony in White, No.1: The White Girl*. Charles Baudelaire, *The Painter of Modern Life*. Death of Eugène Delacroix
1864 Leaves Gleyre's studio and spends some months painting in Normandy	**1864** Trade unions legalized. Switzerland: Red Cross is founded in Geneva
1865 *The Mouth of the Seine at Honfleur* and *The Pointe de la Hève at Low Tide* [26] are first works shown at the Salon. Begins an enormous *plein-air* scene with figures, *Déjeuner sur l'herbe* [28, 30–1], which he never finishes. His companion Camille Doncieux and his friends Bazille and Courbet pose for the figures	**1865** Britain: Lewis Carroll, *Alice's Adventures in Wonderland*
1866 *Camille*, or *The Green Dress* [33], well received by the Salon. Begins a second outdoor scene with figures, *Women in the Garden* [35–6]	**1866** Prussian defeat of Austria results in a major shift in the European balance of power. Russia: Dostoevsky, *Crime and Punishment*
1867 *Women in the Garden* rejected at the Salon. Penniless, he goes to stay with his family at Sainte-Adresse, near Le Havre. The pregnant Camille remains in Paris, where their son Jean is born on 8 August	**1867** Universal Exposition in Paris. Courbet and Manet display their work in independent pavilions. Plans for political liberalization announced. Death of Baudelaire. Mexico: Execution of Maximilian, Napoleon III's puppet emperor. Sweden: Alfred Nobel invents dynamite
1868 *Boats Setting Out from the Port of Le Havre* exhibited at the Salon	
1869 Submits two paintings to the Salon. Both refused. Moves to Saint-Michel. Paints at La Grenouillère, near Bougival on the Seine, working side by side with Renoir [56–7]	**1869** Suez Canal opened by the Empress Eugénie. First department store in Paris. Russia: Tolstoy publishes *War and Peace* in book form
1870 *The Luncheon* [52] and the now lost *La Grenouillère* rejected by the Salon. Marries Camille. They spend the summer in the Nomandy resort of Trouville, where he paints beach scenes [60]. They go to London where Charles-François Daubigny introduces him to the dealer Paul Durand-Ruel	**1870** France declares war on Prussia. French defeat at Sedan. Collapse of the Second Empire. Third Republic proclaimed. Paris besieged by the Prussian army. Bazille killed in the war. USA: Foundation of the Metropolitan Museum of Art in New York
1871 His father dies. Returns to France, spending some months in Zaandam in Holland on the way. Settles in Argenteuil on the Seine northwest of Paris	**1871** Paris capitulates. Parisians declare an independent, socialist Commune on 18 March, which is bloodily supressed in May by the government of Adolphe Thiers, based in Versailles. Franco-Prussian peace treaty agreed in May in which France cedes Alsace and Lorraine. Britain: George Eliot, *Middlemarch*

The Life and Art of Claude Monet	A Context of Events
1872 Depicts his surroundings in paintings such as *Path in the Vineyards, Argenteuil* [70]	
1873 Paints many images of his own home and its garden [72]. Foundation of the independent exhibiting body, the 'Société Anonyme des Artistes Peintres, Sculpteurs, Graveurs, etc.' in which Monet is a leading figure	**1873** The Prussian army of occupation leaves French territory. Elections replace Thiers with the right-wing Marshal MacMahon as president. Napoleon III dies in England
1874 The first exhibition of the Society meets with a mixed reception. Monet's *Impression, Sunrise* [62, 77] is widely discussed and the artists become known as the 'Impressionists'	
1876 In April the second Impressionist exhibition is held at Durand-Ruel's gallery; includes eighteen pictures by Monet. Invited by Ernest and Alice Hoschedé to their château at Montgeron, for which he paints four panels of the estate [84]	**1876** Stéphane Mallarmé, *L'Après-midi d'un faune.* Germany: First complete performance of Richard Wagner's *Ring of the Nibelung* at Bayreuth. USA: Alexander Graham Bell invents the telephone
1877 Works on twelve pictures of the Gare Saint-Lazare in Paris [83], using a rented studio nearby paid for by fellow-painter, Gustave Caillebotte. Seven of the paintings are among thirty Monet works displayed in the third group show in April. Ernest Hoschedé declared bankrupt	**1877** Death of Courbet. USA: Thomas Edison invents phonograph
1878 Birth of his second son, Michel, on 17 March. Camille is gravely ill and the family is in financial trouble. They set up a joint household in Vétheuil with the Hoschedés. Maintains a Paris studio at 20 rue Ventimille (until 1882)	**1878** Death of Daubigny
1879 Caillebotte organizes Monet's contribution of twenty-nine works to the fourth group show in April–May. Camille dies on 5 September and he depicts her on her deathbed [92]. Paints Vétheuil [93] and still lifes [91]	**1879** Elections bring in a firm Republican majority. MacMahon is replaced by Jules Grévy. Parliament returns to Paris. In July Grévy outlines a new state policy towards the visual arts, favouring *plein-air* painting and modern-life subjects. Norway: Ibsen, *A Doll's House*
1880 The severe winter and spring of 1879–80 provide him with subject matter [95–6, 99]. Does not participate in fifth group show in April. In May exhibits a painting [98] at the Salon for first time in ten years (it is also for the last time), causing a rift with some Impressionist friends. Exhibition of his work in June at the offices of the magazine *La Vie Moderne*	**1880** New political liberalism becomes apparent in France; an amnesty is declared for the remaining Communards
1881 Does not participate in sixth group show. Makes painting trips to the Channel coast. Durand-Ruel starts to buy his work again; the average cost of a canvas is about 300 francs. In December moves with Alice and the eight children to Poissy	**1881** Free primary education is brought in and freedom of the press established. Control of the Salon passes from the state to the Society of French Artists. Spain: Birth of Pablo Picasso. USA: Henry James, *The Portrait of a Lady*
1882 Paints in Pourville, near Dieppe [105, 107]. Has thirty-five pictures in the seventh group show held in March	**1882** First Exposition Internationale at Georges Petit's gallery in the rue de Sèze
1883 Spends time painting at Etretat in early part of the year [109, 111]. In March Durand-Ruel shows fifty-six of his pictures in Paris in a	**1883** Death of Manet. Britain: Machine gun patented by American-born Hiram S Maxim

one-person show, and commissions a series
of decorative door-panels [120]. Moves in
April to Giverny, where he rents Le Pressoir.
Goes to the Riviera with Renoir in December

1884 Painting trip to Bordighera and Menton on
the Mediterranean coast [118]

1885 Exhibits at Georges Petit's fifth Exposition
Internationale. In the autumn goes to Etretat
[124]

1886 In Etretat in the spring [123]. Visits Holland in
April. Does not participate in eighth group
show in May, exhibiting at Petit's in June
instead. Travels to Brittany in the autumn
and produces a series of wild coastal
landscapes [126, 130]

1886 Durand-Ruel holds his first exhibition
in New York. Zola publishes L'Oeuvre,
upsetting many of his artist friends who
see themselves in its unattractive and
unsuccessful hero, Claude Lantier

1888 Travels to Antibes in the spring [8, 131]. Sells
ten of the paintings to Theo van Gogh for a
total of 11,900 francs

1888 Durand-Ruel opens a gallery in New
York.
USA: George Eastman introduces the Kodak
camera

1889 Paints in the Creuse valley [112, 132–3] in the
Massif Central in the spring. Major
retrospective exhibition in June of 145 works
at Petit's gallery in conjunction with France's
most famous sculptor, Auguste Rodin. Starts
campaign to buy Manet's Olympia for the
state

1889 Centennial of the French Revolution is
marked by a Universal Exposition in Paris.
The Eiffel Tower is its lasting symbol. General
Boulanger, a right-wing politician, fails in his
attempt to seize power and flees to Brussels.
The Third Republic becomes stronger and
more confident

1890 In November buys Le Pressoir at Giverny for
22,000 francs

1890 Death of Vincent van Gogh

1891 The first of his 'series', the Grainstacks [157],
is shown at Durand-Ruel's gallery in May, to
great acclaim. Starts the Poplars series [18,
163]. Death of Ernest Hoschedé

1891 Deaths of Johan Barthold Jongkind,
Georges Seurat and Theo van Gogh. Paul
Gauguin arrives in Tahiti

1892 The Poplars are shown at Durand-Ruel in
February. Starts to paint Rouen Cathedral. In
July marries Alice Hoschedé. Her daughter
Suzanne marries the American painter
Theodore Butler

1892 Zola, La Debâcle, his study of the 1871
Franco-Prussian War.
Russia: Tchaikovsky, The Nutcracker

1893 Continues the Cathedral series at Rouen.
Buys land to build the water garden at
Giverny

1893 Norway: Edvard Munch paints The
Scream

1894 The Turkeys [84] sells for 12,000 francs at the
sale of the critic Théodore Duret's collection.
Paul Cézanne and Mary Cassatt visit Giverny

1894 The army officer Alfred Dreyfus is
convicted of espionage and deported to
Devil's Island in French Guiana.
Gustave Caillebotte dies, leaving his
collection of paintings to the French state

1895 In January goes to Norway for three months,
visiting his stepson Jacques Hoschedé. Stays
at Bjornegaard [169] and paints Mount
Kolsaas [167]. Cathedrals [165] and Norwegian
scenes are shown at Durand-Ruel in May.
Builds the Japanese bridge at Giverny

1895 Death of Berthe Morisot. Lumière
brothers invent the first cine camera and
projector.
Germany: Wilhelm Röntgen discovers X-rays.
Britain: H G Wells, The Time Machine.
Oscar Wilde, The Importance of Being Ernest

1896 Paints at Pourville on the Normandy coast
and starts series of Mornings on the Seine

1896 Britain: Death of William Morris

1897 At Pourville again Janurary–April. Continues
Mornings on the Seine series. Jean Monet
marries Blanche Hoschedé in June

The Life and Art of Claude Monet	A Context of Events
1898 Mornings on the Seine shown at Georges Petit's gallery in June	**1898** Zola publishes 'J'Accuse' in Georges Clemenceau's paper *L'Aurore*. This defence of Dreyfus helps to bring about a retrial the following year. Death of Eugène Boudin
1899 Starts to paint the Japanese bridge and the water-lily pond in his garden [1]. Travels to London in September and starts to paint views of the Thames from the Savoy Hotel. Death of Suzanne Hoschedé-Butler. Makes a second studio in the grounds	**1899** Dreyfus is released. Death of Alfred Sisley
1900 In London February–April. Marthe Hoschedé marries Theodore Butler in October. First Exhibition of first series of Giverny garden at Durand-Ruel in November	**1900** Death of Georges Petit. The Paris metro system opens. Britain: Joseph Conrad, *Lord Jim*. Austria: Sigmund Freud, *The Interpretation of Dreams*
1901 February–April, third and final trip to work in London; three years pass before he considers the pictures fit to exhibit. Enlarges the water garden. Buys a car	**1901** Britain: Death of Queen Victoria. Monet watches her funeral in London. Rudyard Kipling, *Kim*. Marconi transmits first radio signals across the Atlantic
1903 Begins second series of Giverny garden, concentrating on the lily pond	**1903** Deaths of Camille Pissarro, Gauguin and Whistler. USA: Wright brothers make first powered flight
1904 London pictures exhibited at Durand-Ruel in May [170]. Travels to Madrid with Alice in October	**1904** Entente Cordiale between Britain and France is established. Russia: War with Japan. Anton Chekhov, *The Cherry Orchard*
	1905 Germany: Die Brücke Expressionist group formed in Dresden Switzerland: Albert Einstein formulates his special theory of relativity
	1906 Alfred Dreyfus is finally rehabilitated. Clemenceau becomes prime minister (to 1909). Death of Paul Cézanne
1908 Visits Venice with Alice, September–October, where he paints the palazzi and the canals [190]	
1909 In May the exhibit of the Giverny water-lily series [179, 183] opens at Durand-Ruel's	**1909** Louis Blériot flies across the English Channel. Italy: Marinetti publishes the Futurist manifesto
1910 Enlarges water garden for second time	**1910** Britain: Roger Fry organizes Post-Impressionist exhibition in London
1911 Alice dies in May. He resumes work in the autumn	**1911** Germany: Die Blaue Reiter group formed in Munich
1912 Venice pictures exhibited at Bernheim-Jeune gallery in Paris. Cataracts are diagnosed	**1912** Marcel Duchamp paints *Nude Descending a Staircase*. *Titanic* sinks in the North Atlantic
1913 Travels to Switzerland	**1913** Marcel Proust, *Swann's Way*, the first part of *Remembrance of Things Past*. USA: Armory Show in New York
1914 Death of elder son Jean, whose widow, Blanche, moves into Monet's house	**1914** Outbreak of World War I. The Germans invade Belgium and northern France. Battle of the Marne. Britain: Vorticist group formed in London

The Life and Art of Claude Monet	A Context of Events
1915 Starts to build a large new studio in the garden for his enormous last Water-lily paintings – the Grandes Décorations	1915 Ill-fated Allied landings at Gallipoli
	1916 Battle of Verdun results in immense losses on both sides. Battle of the Somme. Tanks are used for the first time. First Zeppelin raids on Paris. Switzerland: Dada manifestations at the Cabaret Voltaire in Zurich
	1917 Clemenceau becomes prime minister (to 1920). Death of Degas and Rodin. USA enters the war. Netherlands: Piet Mondrian and Theo van Doesburg found *De Stijl*. Russia: Revolution in Russia. Abdication of the Tsar. Lenin becomes First Commissar of Russia and signs an armistice with Germany
1918 Presents eight of his pictures to France in celebration of the armistice. Over the next few years the number of pictures grows and the scheme becomes increasingly complex	1918 Armistice is signed between Germany and the Allies in November. About 8·5 million people have been killed and 21 million wounded during the conflict
	1919 Peace conference at Versailles. Death of Renoir. Germany: Walter Gropius founds the Bauhaus school of art and design in Weimar
1922 Officially agrees to present Water-lily paintings to France, to be housed in specially built roooms at the Orangerie in Paris	1922 Death of Paul Durand Ruel. James Joyce, *Ulysses* published in Paris. Italy: Benito Mussolini takes power. Britain: T S Eliot, *The Waste Land*. Egypt: Discovery of Tutankhamen's tomb
1923 Cataract operation, partially successful	1923 Germany: Failed putsch by Adolf Hitler in Munich
1925 Continues to paint the Grandes Décorations [196–8]	1925 Exposition Internationale des Arts Décoratifs et Industriels Modernes in Paris. First Surrealist group exhibition also in Paris. Germany: Franz Kafka, *The Trial*. Britain: Death of John Singer Sargent. Russia: Serge Eisenstein films *Battleship Potemkin*. USA: F Scott Fitzgerald, *The Great Gatsby*
1926 Dies on 5 December, aged 86. Buried at Giverny	1926 Death of Mary Cassatt. Britain: John Logie Baird makes first television transmission. Birth of Princess Elizabeth, future Queen Elizabeth II
1927 The Grandes Décorations open to the public, 17 May	

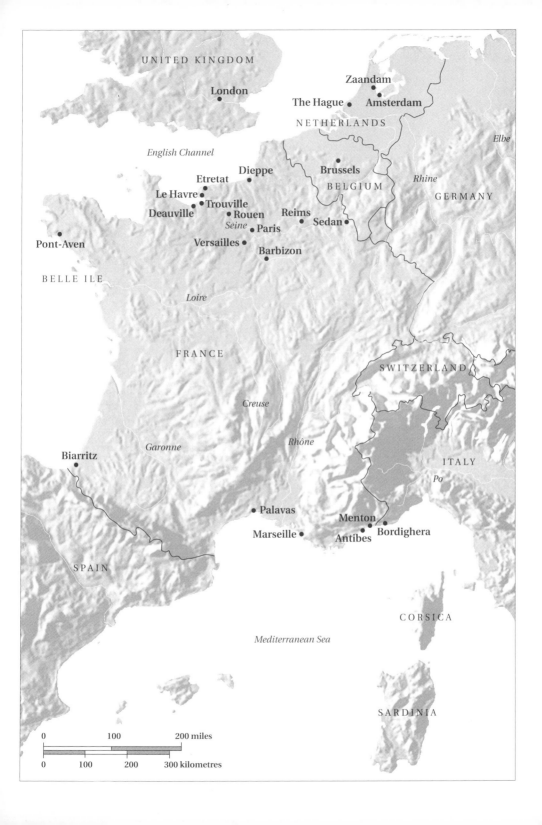

UNITED KINGDOM

London

Zaandam

The Hague Amsterdam

NETHERLANDS

Elbe

English Channel

Dieppe Brussels

Etretat *Rhine*

Le Havre Trouville BELGIUM GERMANY

Deauville Rouen

Seine Reims

Versailles Paris Sedan

Barbizon

Pont-Aven

BELLE ILE

Loire

FRANCE

Creuse

SWITZERLAND

Garonne *Rhône*

Biarritz ITALY

Po

Palavas

Menton

Marseille Antibes Bordighera

SPAIN

CORSICA

Mediterranean Sea

SARDINIA

0 100 200 miles

0 100 200 300 kilometres

Further Reading

Works on Monet

Hélène Adhémar et al., Hommage à Claude Monet (exh. cat., Grand Palais, Paris, 1980)

Geneviève Aitken and Marianne Delafond, La Collection d'estampes japonaises de Claude Monet à Giverny (Paris, 1983)

Jacques-Émile Blanche, Propos de Peintre (Paris, 1928)

Claude Monet au temps de Giverny (exh. cat., Centre Culturel du Marais, Paris, 1983)

Claude Monet, Nymphéas (exh. cat., Kunstmuseum, Basel, 1986)

Georges Clemenceau, Claude Monet. Les Nymphéas (Paris, 1928)

Denise Delouche, Monet à Belle-Ile (Rennes, 1991)

Théodore Duret, Le peintre Claude Monet (preface to catalogue of the exhibition at La Vie Moderne, Paris, 1880)

Jean-Baptiste Durosell et al., Georges Clemenceau à son ami Claude Monet. Correspondence (Paris, 1993)

Gustave Geffroy, Claude Monet: sa vie, son temps, son oeuvre, 2 vols (Paris, 1924)

René Gimpel, 'At Giverny with Claude Monet', Art in America, 15:4 (June 1927), pp.168–74

Robert Gordon and Andrew Forge, Monet (New York, 1983)

Robert Gordon and Charles F Stuckey, 'Blossoms and Blunders: Monet and the State', Art in America, 67:1 (January-February 1979), pp.102–17

Clement Greenberg, 'The Later Monet', Art News Annual, 1957 (repr. in Collected Essays and Criticism, Chicago, 1986)

Steven Gwynn, Claude Monet and his Garden (London, 1934)

Robert L Herbert, 'Method and Meaning in Monet', Art in America, 67:5 (September 1979), pp.90–108

—, Monet on the Normandy Coast: Tourism and Painting, 1867–1886 (New Haven and London, 1994)

Jean-Pierre Hoschedé, Claude Monet, ce mal connu (Geneva, 1960)

John House, Claude Monet, Painter of Light (exh. cat., City Art Gallery, Auckland, New Zealand, 1985)

—, Monet: Nature into Art (New Haven and London, 1986)

—, 'Time's Cycles: Monet and the Solo Show',

Art in America, 80:10 (October 1992)

Joel Isaacson, 'Monet's Views of Paris', Allen Memorial Art Museum Bulletin, 24 (Fall 1966), pp.5–22

—, Monet: Le Déjeuner sur l'herbe (London, 1972)

—, Claude Monet: Observation and Reflection (Oxford, 1978)

Claire Joyes, 'Giverny's Meeting House, The Hôtel Baudy', in Americans in Brittany and Normandy 1860–1910 (exh. cat., Phoenix Art Museum, 1982)

—, Claude Monet: Life at Giverny (London, 1985)

Richard Kendall (ed.), Monet By Himself (London, 1989)

Steven Z Levine, 'Monet's Pairs', Arts Magazine, 49 (June 1975), pp.72–5

—, Monet and his Critics (New York, 1976)

—, 'Décor, Decorative, Decoration in Claude Monet's Art', Arts Magazine, 51 (February 1977), pp.136–9

—, Monet, Narcissus, and Self-reflection: The Modernist Myth of the Self (Chicago, 1994)

Roger Marx, 'Les "Nymphéas" de M Claude Monet', Gazette des Beaux-Arts, 4:1 (June 1909), pp.523–31 (trans. in Stuckey, 1985)

Monet in Holland (exh. cat., Rijksmuseum Vincent van Gogh, Amsterdam, 1986)

Monet in Norway (exh. cat., Rogaland Kunstmuseum, Stavanger, 1995)

Charles Merril Mount, 'New Materials on Claude Monet: The Discovery of a Heroine', Art Quarterly (Winter 1962)

Lynn Orr et al., Monet: Late Paintings of Giverny from the Musée Marmottan (New York, 1995)

Joachim Pissarro, Monet's Cathedral: Rouen 1892–1894 (New York and London, 1990)

—, Monet and the Mediterranean (New York, 1997)

James Ravin, 'Monet's Cataracts', Journal of the American Medical Association, 254:3 (July 1985), pp.394–9

John Rewald and Frances Weitzenhoffer (eds), Aspects of Monet: A Symposium on the Artist's Life and Times (New York, 1984)

Claude Roger-Marx, Claude Monet (Lausanne, 1949)

Vivian Russell, Monet's Garden: Through the Seasons at Giverny (London, 1996)

Grace Seiberling, *Monet in London* (exh. cat., High Museum of Art, Atlanta, 1988–9)

William C Seitz, *Claude Monet* (New York, 1960)

Douglas Skeggs, *River of Light: Monet's Impressions of the Seine* (London, 1987)

Virginia Spate, *The Colour of Time: Claude Monet* (London, 1992) pub. in USA as *Claude Monet: Life and Work* (New York, 1992)

Charles F Stuckey (ed.), *Monet: A Retrospective* (New York, 1985)

—, *Monet: Water Lilies* (New York, 1988)

—, *Claude Monet, 1840–1926* (exh. cat., Art Institute of Chicago, 1995)

Émile Taboureux, 'Claude Monet', *La Vie Moderne*, 12 June 1880, pp.380–2 (trans. in Stuckey, 1985)

François Thiébault-Sisson, 'Art et curiosité. Un don de M Claude Monet à l'Etat', *Le Temps*, 14 October 1920 (trans. in Stuckey, 1985)

—, 'Un nouveau musée parisien. Les Nymphéas de Claude Monet à l'Orangerie des Tuileries', *La Revue de l'art ancien et moderne*, 52 (July 1927), pp.40–52 (trans. in Stuckey, 1985)

Paul Hayes Tucker, *Monet at Argenteuil* (New Haven and London, 1982)

—, *Monet in the 90s, The Series Paintings* (exh. cat., Royal Academy of Arts, London, 1990)

—, *Claude Monet: Life and Art* (New Haven and London, 1995)

— *et al.*, *Monet: A Retrospective* (exh. cat., The Bridgestone Museum, Tokyo, 1994)

Louis Vauxelles, 'Un après-midi chez Claude Monet', *L'Art et les artistes*, 7 December 1905, pp.85–90

Daniel Wildenstein, *Claude Monet: biographie et catalogue raisonné*, 5 vols (Lausanne and Paris, 1974–91; 2nd revised edn, *Monet, or the Triumph of Impressionism*, 4 vols, Cologne, 1996)

Historical and Artistic Background

Steven Adams, *The Barbizon School and the Origins of Impressionism* (London, 1994)

Charles Baudelaire, *The Painter of Modern Life and Other Essays* (London, 1964, 2nd edn, 1995)

Albert Boime, *The Academy and French Painting in the Nineteenth Century* (London, 1971)

David Bomford *et al.*, *Art in the Making: Impressionism* (exh. cat., National Gallery, London, 1990)

Richard and Caroline Brettell, *Painters and Peasants in the Nineteenth Century* (Geneva, 1983)

Richard R Brettell *et al.*, *A Day in the Country: Impressionism and the French Landscape* (exh. cat., Los Angeles County Museum of Art, 1984)

Jules Castagnary, *Salons (1857–1879)* (Paris, 1892)

T J Clark, *The Painting of Modern Life: Paris in the Art of Manet and his Followers* (New York and London, 1985)

Anne Distel, *Impressionism: The First Collectors* (New York, 1990)

Georges Duby, *L'Histoire de Paris par la peinture* (Paris, 1988)

Théodore Duret, *Les Peintres impressionnistes* (Paris, 1878, repr. as *Critique d'avant-garde*, Paris, 1885)

Derek Fell, *The Impressionist Garden* (London, 1994)

Frédéric Bazille et ses amis impressionnistes (exh. cat., Musée Fabre, Montpellier, 1992)

Francis Frascina *et al.*, *Modernity and Modernism: French Painting in the Nineteenth Century* (New Haven and London, 1993)

Nicholas Green, 'Dealing in Temperaments: Economic Transformation of the Artistic Field in France during the Second Half of the Nineteenth Century', *Art History*, 10:1 (March 1987), pp.59–78

—, *The Spectacle of Nature: Landscape and Bourgeois Culture in Nineteenth-Century France* (Manchester and New York, 1990)

Robert L Herbert, *Impressionism: Art, Leisure, and Parisian Society* (New Haven and London, 1988)

Alastair Horne, *The Fall of Paris* (London, 1965, 2nd edn, 1989)

John House *et al.*, *Landscapes of France: Impressionism and its Rivals* (exh. cat., Hayward Gallery, London, 1995)

The Impressionists and the Salon (exh. cat., Los Angeles County Museum of Art, 1974)

Robert Jensen, *Marketing Modernism in Fin-de-Siècle Europe* (Princeton, 1994)

Alan Krell, *Manet and the Painters of Contemporary Life* (London and New York, 1996)

Katherine S Macquoid, *Through Normandy* (London, 1874)

Roger Magraw, *France 1815–1914: The Bourgeois Century* (Oxford, 1986)

Patricia Mainardi, *Art and Politics of the Second Empire: The Universal Expositions of 1855 and 1867* (New Haven and London, 1987)

—, *The End of the Salon: Art and the State in the Early Third Republic* (Cambridge, 1993)

Stéphane Mallarmé, 'The Impressionists and Édouard Manet', *Art Monthly Review*, 1 (30 September 1876), repr. in Moffett, 1986

Michael Marrinan, *Painting Politics for Louis-Philippe: Art and Ideology in Orleanist France 1830–48* (New Haven and London, 1988)

Charles S Moffett *et al.*, *The New Painting: Impressionism 1874–1886* (exh. cat., The Fine Arts Museums of San Francisco, 1986)

Pierre Nora (ed.), *Les Lieux de la mémoire* (Paris, 1992)

D H Pinkney, *Napoleon III and the Rebuilding of Paris* (Princeton, 1972)

John Rewald, *The History of Impressionism* (4th revised edn, London and New York, 1973)

Jane Mayo Roos, *Early Impressionism and the French State* (Cambridge and New York, 1996)

Mark Roskill, 'Early Impressionism and the Fashion Print', *Burlington Magazine*, 112:807 (June 1970), pp.391–5

Robert Rosenblum, *Modern Painting and the Northern Romantic Tradition: Friedrich to Rothko* (London, 1978)

The Second Empire: Art in France under Napoleon III (exh. cat., Philadelphia Museum of Art, 1978)

Kenneth Silver, *Esprit de Corps: Art of the Parisian Avant-Garde and the First World War, 1914–25* (London, 1989)

Debora L Silverman, *Art Nouveau in Fin-de-Siècle France: Politics, Psychology, and Style* (Berkeley, 1989)

Paul Smith, *Impressionism* (London, 1995)

Gary Tinterow and Henri Loyrette, *The Origins of Impressionism* (exh. cat., Metropolitan Museum of Art, New York, 1994)

Martha Ward, 'Impressionist Installations and Private Exhibitions', *Art Bulletin*, 73:4 (December 1991), 599–622

Eugen Weber, *Peasants into Frenchmen: The Modernisation of Rural France, 1870–1914* (London, 1977)

Harrison and Cynthia White, *Canvases and Careers: Institutional Change in the French Painting World* (New York, 1965)

Theodore Zeldin, *France 1848–1945: Intellect and Pride* (Oxford, 1980)

Émile Zola, *Mon Salon, Manet, Ecrits sur l'art* (Paris, 1970)

Index

Numbers in **bold** refer to illustrations

Acknowledgements

Like most writers on Monet I am immensely indebted to Daniel Wildenstein, whose magisterial catalogue raisonné has become the authoritative source on the artist since its publication between 1974 and 1991. In this book, which is intended for readers new to the subject, I have also drawn on some of the exciting recent research on the artist; I should especially like to acknowledge the work of John House, Paul Tucker, Robert Herbert, Virginia Spate and Debora Silverman, whose books and exhibition catalogues have done much to deepen our understanding of the man, his time and his art. I would like to thank all those who read and commented on the manuscript, and among those who saw it through the transformation into a book, I am especially grateful to Julia MacKenzie at Phaidon Press.

C R

This book is dedicated to my children, without whom it would have been finished much sooner, and to the rest of my family, without whom it would never have been finished at all.

Photographic Credits

AA Photo Library, London: 149, 178; AKG London: 63, 92, 113, 124, 128, 30, 172, 188, 189, 202; Allen Memorial Art Museum, Oberlin College, Ohio: R T Miller Jr Fund (1948) 45; Alinari, Florence: 191; Artephot, Paris: photo Toulgouat 152; Art Institute of Chicago: Helen Birch Bartlett Memorial Collection (1926) 125, Mr and Mrs Lewis Larned Coburn Memorial Collection (1933) 107, gift of Mr and Mrs Carter H Harrison (1933) 6, Mr and Mrs Potter Palmer Collection 51, 133, 157, Mr and Mrs Martin A Ryerson Collection 72; Artothek, Peissenberg: 78; Ashmolean Museum, Oxford: 114; Bibliothèque Forney, Paris: 39; Bridgeman Art Library, London: 3, 83, 168, 177; British Museum, London: 49; Fundação Calouste Gulbenkian, Lisbon: 129; Jean-Loup Charmet, Paris: 38; Christies Images, London: 181; courtesy of Christo and Jeanne-Claude, New York: photo Wolfgang Volz: 206; Country Life Picture Library, London: 135; Courtauld Institute Galleries, University of London: 8; Dallas Museum of Art: 180, Munger Fund 98, the Wendy and Emery Reves Collection, photo Tom Jenkins 67; Archives Durand-Ruel, Paris: 120, 185, 194; Mary Evans Picture Library, London: 175; courtesy of Dr S H Floersheimer, Switzerland: 97, 190; Galerie Nichido, Tokyo: 89; Galerie Schmit, Paris: 21; Getty Images, London: 75; J Paul Getty Museum, Malibu: 15, 53; courtesy of Thomas Gibson Fine Art Ltd, London: 70; Photographie Giraudon, Paris: 11, 12, 13, 19, 32, 77, 93, 122, 143, 145, 167, 169, 173, 179, 201, 203, 205; Hamburger Kunsthalle: photo Elke Walford 92; Hill-Stead Museum, Farmington, Connecticut: 158; The Illustrated London News Picture Library, London: 65, 68; courtesy of the Earl of Jersey: photo Robin Briault 66; Kharbine-Tapabor, Paris: 23, 34, 55, 69, 155; Kimbell Art Museum, Fort Worth: photo Michael Bodycomb 26; Kunsthalle, Bremen: 33; Kunsthaus, Zurich: 159; Manchester City Art Galleries: 9; courtesy of Matsuzakaya Department Store, Tokyo and the Maranuma Art Park, Japan: 17; Jason McCoy Inc, New York: 204; Metropolitan Museum of Art, New York: purchased with special contributions and purchase funds given or bequeathed by the friends of the Museum (1967) 50, bequest of Julia W Emmons (1956) 100, bequest of Mrs H O Havemeyer (1929) the H O Havemeyer Collection 56, 163, Mr and Mrs Henry Ittleson Jr Fund (1959) photo Malcolm Varon 81, bequest of William Church Osborn (1951) 111, bequest of Lillian S Timken (1959) 161, the Elisha Whittelsey Collection, the Elisha Whittelsey Fund (1947) 182; Minneapolis Institute of Arts: given by Anne Pierce Rogers in memory of John DeCoster 91; Mountain High Maps © 1995 Digital Wisdom Inc: p.341;

Musée d'Angers: 94; Musée d'art et d'histoire, Neuchâtel, Switzerland: 79; Musée des Beaux-Arts de Lyon: photo Studio Basset 109; Musée des Beaux Arts de Quimper: 127; Musée des Beaux Arts de Rouen: photo Didier Tragin, Catherine Lancien 104; Musée Eugène Boudin, Honfleur, 16; Musée Fabre, Montpellier: 29; Musée d'Unterlinden, Colmar: photo O Zimmermann 132; Museum of Art, Rhode Island School of Design: gift of Mrs Murray Sanforth, photo Del Bogart 64; Museum of Fine Arts, Boston: 1951 Purchase Fund 82, Juliana Cheney Edwards Collection 118, bequest of Arthur Tracy Cabot 131; Nasjonalgalleriet, Oslo: photo J Lathion 46, 123; National Gallery, London: 1, 60, courtesy of David Bomford 61; National Gallery of Art, Washington, DC: Ailsa Mellon Bruce Collection 102, Chester Dale Collection 103, collection of Mr and Mrs Paul Mellon 48, 142, gift of Benjamin B Smith, photo Bob Grove 207; Philadelphia Museum of Art: the John G Johnson Collection 80, bequest of Mrs Frank Graham Thomson 105, Mr and Mrs Carroll S Tyson Collection 116, the William L Elkins Collection 147; Photothèque des Musées de la Ville de Paris: 44; Phoenix Art Museum: gift of Mr and Mrs Donald D Harrington 150; Collection Philippe Piguet, Paris: 85, 134, 136, 137, 140, 182, 192, 199; photo by Presentation Colour, London, with thanks to the National Gallery, London for the loan of merchandise: 208, 209; Punch Cartoon Library, London: 171; RMN, Paris: 2, 5, 7, 14, 22, 24, 27, 30, 31, 36, 37, 59, 84, 88, 95, 96, 110, 117, 126, 160, 165, 170, 183, 184, 196, 197, 198; Roger-Viollet, Paris: 4, 25, 40, 42, 58, 90, 108, 166, 195; Scala, Florence: 28, 76; Shelburne Museum, Vermont: photo Ken Burris 99; Smith College Museum of Art, Northampton, Massachusetts: gift of the Honorable and Mrs Irwin Untermyer in honour of their daughter Joan L Untermyer (1940), photo Stephen Petegorsky 141; Harry Smith Horticultural Photographic Collection, Wickford: 176; Staatsgalerie, Stuttgart: 47, 144; Stadelsches Kunstinstitut, Frankfurt: 52; Statens Konstmuseer, Stockholm: 57; Tate Gallery, London: 18; J M Toulgouat, Giverny: 20, 86, 193; courtesy of the Trustees of the Victoria & Albert Museum, London: 164; Wadsworth Atheneum, Hartford, Connecticut: bequest of Anne Parrish Titzell 71; courtesy of Yoshino Gypsum Co Ltd, Tokyo and Yamagata Museum of Art, Japan: 146

Phaidon Press Limited
Regent's Wharf
All Saints Street
London N1 9PA

First published 1997
© 1997 Phaidon Press Limited

ISBN 0 7148 3500 5

A CIP catalogue record for this book is
available from the British Library.

Typeset in Utopia

Printed in Italy

Cover illustration Claude Monet, *c.*1923